JIM HENSON AND PHILOSOPHY

JIM HENSON AND PHILOSOPHY

Imagination and the Magic of Mayhem

**Edited by Timothy M. Dale
and Joseph J. Foy**

Foreword by Craig Yoe

ROWMAN & LITTLEFIELD
Lanham • Boulder • New York • London

Published by Rowman & Littlefield
A wholly owned subsidiary of The Rowman & Littlefield Publishing Group, Inc.
4501 Forbes Boulevard, Suite 200, Lanham, Maryland 20706
www.rowman.com

Unit A, Whitacre Mews, 26-34 Stannary Street, London SE11 4AB

Distributed by NATIONAL BOOK NETWORK

British Library Cataloguing in Publication Information Available

Library of Congress Cataloging-in-Publication Data

Jim Henson and philosophy : imagination and the magic of mayhem / edited by Timothy M. Dale and
Joseph J. Foy ; foreword by Craig Yoe.
pages cm
ISBN 978-1-4422-4664-5 (pbk. : alk. paper) — ISBN 978-1-4422-4665-2 (electronic)
1. Henson, Jim—Criticism and interpretation 2. Creative ability—Philosophy. 3. Puppeteers—United
States. 4. Television producers and directors—United States. 5. Motion picture producers and direc-
tors—United States. 6. Muppets (Fictitious characters) I. Dale, Timothy, editor. II. Foy, Joseph J.,
editor.
PN1982.H46J55 2015
791.5'3092—dc23
2014048935

Printed in the United States of America

CONTENTS

PART II: THINKING LIKE A MUPPET: EPISTEMOLOGY AND LOGIC

FOREWORD

The Foolish Philosophy of Jim Henson That All Smart People Should Embrace

Craig Yoe

My first day on the job as a creative director at Jim Henson Productions I got a call from The Man himself.

Jim was in LA at that time and not at the beautiful wonderland, the Victorian brownstone on the Upper East Side of New York City that housed the headquarters of the Muppet operation. The tall, bearded, celebrated puppeteer wanted to warmly welcome me to the team, but he apologized that he had to do so long-distance.

The voice on the other end of the phone took me by surprise. It oddly didn't sound like a man at all to me!

The voice sounded like a beloved frog. Yes, *that* beloved frog: *Kermit himself!*

Actually, Jim's natural voice was an ever-so-slightly lower-pitched version of the emerald amphibian, that love of Miss Piggy and of many, many fans around the world, including me and you.

He was quite calming, always creative, positive, encouraging, gentle. His Kermit-y voice in a very soft way loudly proclaimed all of these wonderful, endearing attributes.

And the stupendous thing about Jim is he didn't just speak.

Jim listened.

Intently.

With ideas in my little hand scrawled or sketched on a yellow legal-sized pad, I'd pop into his office a few steps across the hall from mine after he had promoted me to creative director/vice president general manager. I was always struck by how Jim would give me, and anyone and everyone, from leaders of the world to the janitor at the Muppet studio, his undivided and complete attention when they had a thought or idea they wanted to share.

John Denver may have just left Jim's office after discussing a public-service commercial with him and Kermit to promote environmental awareness. And Barbara Bush might be arriving in a second to brainstorm with Jim on how they could work together to foment children's literacy. But when you would slip into his office between those visits, Jim was in the moment and carefully listened to and considered . . . Your. Every. Word.

One time, Jim gathered a group around the beautiful dark mahogany Muppet conference room table and began the meeting by proclaiming, "Let's think of an idea that will bring peace to the world in our lifetime." Maybe that was Jim's philosophy boiled down to the essence. Totally unrealistic. Naive. Foolish. But as Jim contributed and listened that day, the warm, fuzzy world of *Fraggle Rock* was created. A valiant attempt toward world peace!

A cherished moment I remember of interaction with Jim: The puppet master added to my responsibilities by having me head up the Creature Shop in New York, where über-talented folks sewed and glued fur and feathers to make the Muppet puppets. A creature had just been created for a movie we were working on, and Jim and I walked from the Victorian townhouse a couple of short blocks to the nearby shop to see the newborn.

The designers explained their thoughts that went into the bunch of cloth and ping-pong balls lying on the table as Jim listened intently. The designers concluded.

There was a pause.

Jim slowly picked up the puppet, turning it around as his intense, sparkling eyes examined it. He then slid his large hand into the concoction. He tried some movements and a voice and . . . like breathtaking magic . . . *the creature came to life*! I'm telling you, this assemblage of faux fur and dyed feathers lived and breathed! My jaw dropped! I gasped a little. This experience had caught me so off guard! Two and a half

decades later, I'm still astounded by what this amazing Wizard of Ahs did at that moment!

At noon on May 15, 1990, Jim and I had a lunch scheduled. Outside the offices there was a torrential downpour. Jim had a bad cold and cough, but we braved the spring storm anyway. I didn't have an umbrella, so Jim shared his little and slightly beat-up one. Jim being tall and me not-so-much, and sheets of rain and trying to shield ourselves with this crappy bumbershoot—we made quite a sight. And we didn't do so great avoiding the flood coming down from the sky. We arrived at the Italian bistro soaking wet from head to feet.

At a table in the back, over our pasta, Jim expressed affection for the people he had gathered around him and, between his sneezes and coughs, talked excitedly about future directions and projects the company was going to undertake.

In a few short hours Jim Henson was gone.

The life was taken from him.

When I'm working late at night in my studio, I can almost hear his soothing voice gently pushing for creativity, humor, and quality, and expressing words of encouragement . . .

It's not easy, him being gone.

Peace,
Craig Yoe

Craig Yoe, former creative director and manager of the Muppets, now creates books collecting classic comic material (including the work of cartoonist Walt Kelly, which Jim loved) and contemporary positive-message comic books for kids in twenty-three countries that are foolish attempts to bring peace to the world in our lifetime. His creations with his partner, Clizia Gussoni, can be seen at YoeBooks.com.

ACKNOWLEDGMENTS

The editors would like to thank each of the contributors to this volume for their essays and insights, as well as everyone at Rowman & Littlefield for supporting this project. A special thank you to Craig Yoe for sharing his experiences and giving us a glimpse into the creative genius inspired by Jim Henson.

Timothy: I would like to thank hmy colleagues at the University of Wisconsin–La Crosse for their friendship and support. I am thankful to work at an institution that values both teaching and research, and encourages scholarly work that aims to be meaningful as well as accessible. I also thank my students, who inspire me by asking profound questions about the world, and then help me look for answers. Most especially, I appreciate the support, patience, and love of Amy, Ellia, and Ian.

Joseph: I would like to thank my colleagues and friends throughout the University of Wisconsin Colleges for their many contributions, insights, and encouragement. I am so proud to work for an institution that has such tremendous scholar-educators, and with individuals who remain so committed to access and empowerment through education. A special thanks to Dean Harry Muir at UW-Waukesha and Provost and Vice Chancellor Greg Lampe for helping mentor and support me in my various roles. Thanks also to my parents, my siblings, and all of my extended family. At a very early age you helped me explore the world and gave me the tools to appreciate difference. Dr. Sue, I will always remember the *Sesame Street* books that would end up in our shopping cart at the store.

Most of all, thank you to my partner, Kristi, and our three wonderful children. Connor, Keira, and Gavin: You are my light.

INTRODUCTION

Timothy M. Dale

Jim Henson once walked into a room and demanded of his creative team, "Let's think of an idea that will bring peace to the world in our lifetime." As described in the foreword by Craig Yoe, former creative director and general manager of the Muppets, the result of that meeting was *Fraggle Rock*. We can imagine that this is the way all of Henson's productions were inspired. Incredibly gifted as a puppeteer and storyteller, Jim Henson wanted most of all to change the world. If the belief that ideas can change the world is what makes a person a philosopher, then Jim Henson has to be counted as one of the great philosophers of our time.

Jim Henson liked to think big. Unrivaled in his creative energy, Henson also deeply cared about the world and wanted to make an impact on it. Henson believed that people should live their lives thoughtfully and creatively, treat each other with respect, and take responsibility for the world around them. He also really liked to entertain. Henson's life was dedicated to creating entertainment, and also to communicating meaningful ideas through this entertainment. The result is a lifetime of works that continue to have a profound impact on people around the world.

Jim Henson's creations have inspired generations with characters that are among the world's most recognizable cultural icons. From Kermit the Frog, Miss Piggy, and their Muppet friends to the legendary *Sesame Street* and Children's Television Workshop, Henson has immeasurably impacted the growth, development, and substance of children's educational programming and entertainment for all ages. Combining live action and puppeteering into fantastical narratives like *The Dark Crystal* and

Labyrinth, and the whimsical *Fraggle Rock* and *The Storyteller*, Henson transformed imagination into reality, weaving powerful philosophical messages on identity, community, diversity, love, death, and friendship. Henson's legacy endures because he never shied away from exploring deep questions, nor did he underestimate the ability of children (or adults) to grapple with profound social, cultural, epistemological, and metaphysical questions. Anyone who grew up with his stories or has fallen in love with his characters will enjoy this book's exploration of the entertaining, educational, and profound world of Jim Henson.

Jim Henson thought of himself primarily as a puppeteer, and puppeteering as an art form presents unique opportunities for philosophical reflection. Puppets are created as inanimate objects and fictional characters, but they come to life through the skill of the puppeteer. Interacting with each other and other actors on the stage, in the hands of an expert puppeteer like Jim Henson, puppets challenge the line that is typically drawn between what is real and what is artificial. To what extent can a fictional character be said to "exist"? How can we distinguish between the real world and the world of fiction? Are we all puppets being controlled by forces that cannot be seen?

Henson's creations and stories, especially the ones we find on *The Muppet Show*, provide a particularly appropriate context in which to ask these questions. *The Muppet Show* is a story about a stage performance group preparing for a show, and the Muppets regularly break the boundaries between audience and performance. The puppets of *The Muppet Show* not only are performers on the stage but also interact with live actors backstage, and they depart the theater to have regular adventures in the "real" world. Through these explorations Henson's characters expose many philosophical issues, including metaphysical questions about existence and epistemological questions about how it is that we can know the world.

Henson's puppets also have complex relationships with each other, and in these relationships they experience community, love, friendship, betrayal, and redemption. Through these experiences Henson's work presents unique perspectives on ethics and social philosophy. Henson's recognition of the social and philosophical power of puppeteering also led him to create the educational children's programming for which he is best known. Because of this, a discussion of the philosophy of Jim Hen-

son must include consideration of the many ways in which puppets, and Henson's creations in particular, are distinctively philosophical beings.

This book begins with a collection of chapters examining the social and political philosophy of Jim Henson, or, as that section is titled, what it is like to "live with Muppets." A large number of Henson's works explicitly present a social philosophy, and his productions promote messages of tolerance, diversity, friendship, and peace. These messages are particularly evident in the work of *Sesame Street* and *Fraggle Rock*, but they are also present in Henson's other television shows and films. His characters frequently deal with social philosophical issues, including the subjects of gender, environmentalism, leadership, and the power of community to solve conflicts. The chapters in this section explore relationships that Henson's characters have with each other, and the way that individual identity and life in community has an impact on these relationships.

The next section of the book is about the approach to knowledge and logic that is present in Henson's work. Epistemology is the philosophical study of knowledge, and in this collection of chapters we learn what it is like to "think like a Muppet." Many of Henson's creations are intended to teach their audiences, and, in line with this goal, they contain approaches to knowledge and logic, and also include an underlying philosophy about how meaningful lessons should be passed from teacher and storyteller to audiences.

The third section in this book is dedicated to exploring the ethical themes that are commonly found in Henson's work, including the morality advanced by Henson's characters (and arguably Henson himself). Chapters in this section examine the heroes and villains in Henson's stories and what they tell us about living a good life, or avoiding living a bad one. It should also be noted that a primary feature of Henson's characters is a distinctive kind of "weirdness" that relates to their identity and their relationship with the world. To be ethical, for Henson, is to be compassionate, but this compassion does not imply conformity.

In the final section of the book, the chapters ask one of the most basic questions in philosophy: What does it mean to exist? This is a particularly interesting question for Jim Henson's characters because of the strange existence led by puppets. Henson's creations are fictional, but they are usually living in the real world and interacting with real people. The branch of philosophy interested in the question of the nature of being, and

what exists, is known as metaphysics. It turns out that the metaphysics of Henson's philosophy—that is, what it means to "be" a Muppet—involves interesting and complicated philosophical questions.

Overall, the chapters in this book are written and collected to be enjoyed as remembrances of our favorite Henson creations, and as highlights of the philosophically profound ideas and values that are at the heart of Henson's work. So, as you read this book, think about your favorite Henson characters and stories, enjoy the chapters exploring their philosophies, and appreciate anew the inspirational, sensational, and celebrational genius of Jim Henson.

Part I

Living with Muppets: Social and Political Philosophy

I

MUPPETS, MONSTERS, AND MISFITS

The Social and Philosophical Significance of Difference

Timothy M. Dale

Entering the backstage area of *The Muppet Show* or taking a walk down Sesame Street, one of the first things that would strike us is just how different all of the creatures are from each other. We are so accustomed to conformity in our everyday experience that a person with a slightly different hairstyle, form of dress, or unusual tattoo might draw a noteworthy observation. Compare that to the Jim Henson universe, in which a pig and a frog have a romantic relationship, gaping-mouthed monsters regularly interact with humans, and a giant yellow bird is likely to be the friendliest being we will ever meet. Why did Henson imagine worlds containing such radical diversity?

The answer to this question is a doorway into the philosophy of Jim Henson. The monsters he created are as relatable and empathetic as they are different from each other. Differences among them also make the community or group stronger. His society lacks a notion of what it means to be "normal," and in this context his characters explore questions of identity and authenticity free from the superficiality of conformity. Through the radical diversity of his characters, Henson suggests that differences should be more than simply tolerated. Differences are good for us and for the world, and our closest friendships and most meaningful learning experiences happen in relationships with those who are different from us.

Throughout this book you will read chapters about the ways in which Jim Henson expands and challenges philosophical conversations on a range of ideas and concepts. In every case, at the core of this philosophy are the characters that Henson created, and the relationships they have with each other and their world. These relationships are built on differences between the characters, and on what the characters can learn from each other. In this way, Henson's philosophy is built on the idea that we can learn a lot from monsters, and that the acceptance of diversity and differences as good things is the first step in this learning process.

MAKING MONSTERS LESS SCARY

Before Jim Henson, monsters were almost always associated with the sources of fear. In mythology monsters were the evil beings that posed a threat to human life, and stories about monsters were created to give a concrete image to the fear that people experienced when contemplating the unknown. Psychological study of children has also shown that children begin to imagine monsters when they develop enough to become aware that there are things in the world that can hurt them.[1] The imagination of monsters, then, is one way the brain deals with unfamiliar and possibly dangerous realities. According to the purpose that monsters typically serve in our imaginations and our stories, they have two primary characteristics: first, they are completely different from us, and second, they mean us harm. Jim Henson changed this.

Henson chose to turn monsters into the relatable heroes of his stories. From the lovable characters on *Sesame Street* to the strange creatures that made up the gang on *The Muppet Show*, Henson's worlds are filled with monsters. These weird characters are sometimes identified as belonging to a creature species known specifically as "monsters" (Cookie Monster, Telly Monster, Elmo, and Grover belong to this group), while other creatures, like Snuffleupagus, Gonzo, and Big Bird, are creatures that do not seem to belong in a category with any other creatures. And then there are the talking animals, who belong to the species of animals with whom they are identified, but who can talk and regularly interact with humans. Jim Henson's worlds are thus filled with strange creatures who could perhaps be from our nightmares, but who instead become friends with us through

the action of their stories, and cause us to fall in love with their distinct personalities.

Henson's creatures are intentionally created to overcome our fear of monsters, and he turned creatures once identified as scary into our friends and neighbors. The philosophy behind the use of monsters in his productions is based on the idea that if we make things that were once scary more familiar, then these things will no longer be a source of fear. Playing on this philosophy, one of the most popular *Sesame Street* children's books is *The Monster at the End of This Book*, "starring lovable, furry old Grover." Throughout the book Grover speaks directly to the reader, warning that there is a monster at the end of the book, and that readers should stop turning the pages. Grover becomes more and more adamant that the readers not proceed, until at the very end it is revealed that the monster at the end of the book is Grover himself. The readers and Grover thus both learn that monsters are not scary.

Even though the communities that Henson created are filled with monsters, like Grover, they are all friendly and do not mean children harm. On the contrary, from Henson's perspective we should encounter strange things as opportunities for learning. Henson's monsters do not threaten people, but they make people better through the lessons that they teach. Even the classic mythological vampire is friendly in Henson's universe, spending all of his time teaching people how fun it can be to count.

After watching television and movies containing these creatures, children are allowed to be less afraid of monsters. According to Henson, people (and monsters) different from us should be considered potential friends rather than possibilities for apprehension. Philosophically speaking, we can say that the experience of "otherness" (the idea that something different from me is something that I cannot understand) is challenged through the relatable nature of Henson's monsters. There is no more radical way to counter the idea that the different and unknown is a threat than to turn monsters into our friends.

THE PHILOSOPHY OF THE "MISFIT"

A community full of strange creatures challenges the social ideal of "normal" as much as it challenges the fear of things that are different. Accord-

ing to most conceptions of community, we are held together with others because we are similar to them in some way. At a basic level, a community is made up of people who share a common space, but having relationships with others usually means that we also share values and other characteristics in common. The idea that community requires people to be just like others is the basis for the idea of what is "normal." If I am normal, it simply means that I have conformed to others around me. A community, then, might only comprise people who are "normal."

The communities created by Jim Henson contain no such normal creatures. Each of Jim Henson's Muppet creations is remarkably different looking, sounding, or acting from what we expect to see in our everyday lives. In this way, they are intentionally created as "misfits," characters who are set apart from others in conspicuous ways. A misfit usually makes us uncomfortable, but Henson's world is full of misfits who cause us to confront the idea that being different means that one is not relatable.

The existence of the misfits that Henson creates exposes our expectations for what is normal, and shows us that these expectations are overly narrow. If we judged by appearance and avoided creatures that looked or acted different, we would never gain the benefit of knowing Gonzo, Grover, Big Bird, or Telly Monster. Once we get to know them, misfits are some of our best friends, and we also learn things when we interact with misfits. In fact, misfits can be particularly useful for teaching us lessons because being exposed to things that are different is an essential part of learning.

Jim Henson's collection of misfits also answers the question about whether a community of characters who do not "fit" with each other can exist as a community at all. What happens if your entire community is made up of misfits? In Henson's worlds the answer is obvious, and the radical diversity among the characters becomes part of the fabric of the community. It is actually *because* of the differences between the characters that the community of the Muppets is so rich and interesting. Henson's portrayal of community as a collection of differences is reflective of the description of community by philosopher Jean-Luc Nancy, who argues that the true meaning of community is found in the experience of others who are different from us, and not in the sharing of similarities with people who are like us.[2] Nancy also recommends that forming a community should not be viewed as becoming a singular collective of

like-minded people, but rather as sharing experiences with a diverse group of people.[3]

Messages about diversity are implicitly in all of Henson's creations, but lessons about diversity are also explicitly present in several of Henson's stories. In an early episode of *Sesame Street* a polka dot family visits the community.[4] In this case, a community of people who are all very different from each other still have to learn that it is better to welcome and accept people who are different coming from outside the community. Rather than being an argument for excluding people, in Henson's worlds misfits are exactly the kind of characters we want to count among our friends. Jim Henson's community of misfits suggests that it is possible to live together in relative harmony with characters that do not actually "fit" together.

THE SIGNIFICANCE OF DIVERSITY

In part, Henson filled the world with a diverse set of characters to make it easier to find a character to which each of us can relate. Some people might see themselves in Kermit, others in Miss Piggy. We may find ourselves relating more to Big Bird, or we could discover that we are much more like Oscar the Grouch. Henson created a wide range of characters to give a wide variety of people different access points to relate to his productions. The pitch Henson used to sell *The Muppet Show* admitted to this effort to appeal to a wide audience through his characters, humor, and approach. In it the narrator announces, "Young people will love the fresh, innovative comedy. College kids and intellectual eggheads will love the underlying symbolism of everything. Freaky long hair, dirty, cynical hippies will love our freaky long hair, dirty, cynical Muppets."[5] There is something to love for everyone. After we are drawn into the show, however, even more profound points about the significance of diversity are presented. (Eagerly analyzed below by the intellectual egghead who loves the underlying symbolism of everything.)

All of these different characters are able to live together peacefully, celebrating their differences. In this way we could describe the world of the Muppets as one of pluralism, wherein diversity is something to be embraced and promoted. "Pluralism" in political philosophy is the recognition that diversity exists within a society, and it is often coupled with

the further belief that this diversity is good.[6] Henson believed in pluralism, as is evident by the persistent celebration of diversity in all of his work. *The Muppet Show* contains a pluralism of characters that all bring something unique to the show. Because each contributes something special, we recognize that the show would be lacking if it were missing such a wide array of characters. Similarly, in *Sesame Street* the diversity of its residents is an essential characteristic of its community, and it is designed to teach viewers that diversity is good. Furthermore, when the diversity on Sesame Street itself is not enough, the writers are willing to send characters away from Sesame Street to experience the rest of the world. In season 9, for example, Big Bird went to Hawaii so that the stories could intentionally focus on cultural diversity. Jon Stone, *Sesame Street* director and Henson friend, said that "going to Hawaii was very good for us because it is a multi-ethnic society."[7]

One reason that diversity is valuable for Henson is that it makes life more interesting. Part of the humor and enjoyment audiences take from Henson's work is due to the wide range of colorful personalities that populate the world. The interaction between these different characters and their competing motivations are the source of story lines and laugh lines throughout. The philosophy behind this presentation of diversity is captured well in an episode of *Bear in the Big Blue House*, a television series produced by the Jim Henson Company for the Disney Channel. In this episode, a mouse at Mouse School wonders why it is that some mice have different colors from others. The teacher responds with the question, "What would you think if all of the mice in our school were purple like you?" To which the mouse answers, "I guess it wouldn't be as colorful . . . or as interesting."[8]

For Henson, however, diversity is not just valuable because it makes life more interesting. The further significance of diversity present in Henson's work reflects the philosophical arguments in favor of diversity made by political philosopher Iris Marion Young, who argues that democracy requires the inclusion of a wide range of voices, and that communities should do all that they can to protect and promote the diversity within them. One implication of this idea is that we should avoid social practices that promote conformity. Another implication is that we should work on becoming less centered on ourselves, and better listeners to others who offer different viewpoints on the world.

On a surface level, diversity seems to undermine the idea of community, since the root of what it means to be a community is to have something in common. Young, however, describes a community as one that is actually rooted in the experience of diversity of ideas and voices. The key to understanding the way that community can be built on differences is to recognize that differences themselves are always undergoing changes, and that they only matter when we make assumptions about these differences as relating to who we are in essence. When we start listing all of the differences we have from each other, these lists can become very long, but the lists would not hold together very well. All of the things that make us different are linked to cultural understandings, perspectives, and power relationships that are themselves created through our relationships with others.[9] The meaning that we assign to diversity in our community is actually a practice that takes place in our community.

Encouraging diversity in communities is a response to the idea that there is such a thing as "normal" that exists prior to our relationship with others. Philosophically speaking, this means that the promotion of pluralism in a community is counter to the belief that communities can be built around a predetermined set of goals and values. A community of pluralism is built cooperatively as a result of the interactions of those within it. From this perspective, a community that does not seek to promote or protect diversity is not as democratic as a community that does. This is because a lack of diversity means that a whole range of ideas and values have been excluded from the start.

It is important to note, however, that the promotion of diversity does not mean giving up on the pursuit of what is good in our community. This is particularly important for Henson's philosophy, since the purpose of his creations is to make the world a better place. As Iris Marion Young puts it, our understanding of our shared goals is "an achievement of democratic communication" that can only occur when our differences are allowed to exist, flourish, and interrelate.[10] This suggests that determining the goals of society, or any group of people, is an ongoing product of social interaction.

Accordingly, Jim Henson's productions promote diversity in society for three basic reasons. First, diversity makes life more interesting, unpredictable, and enjoyable. Second, diversity allows us to ensure that we are not excluding people unjustly from our communities. Third, including a diversity of voices is more likely to result in a productive conversation.

For all of these reasons, Henson's philosophy of diversity requires that we recognize that it is good when we are different from those around us, and when society contains within it many different people. This is the same lesson Cookie Monster teaches to Elmo and Zoe when he encounters them arguing about each other's toys. Elmo claims that toy cars are the best toys to play with, while Zoe disagrees and says that playing with airplanes is better. Cookie ends the argument by explaining to the friends that "different people and monsters like playing with different kind of toys, and that OK." Zoe and Elmo then want to know which of the toys Cookie likes best, and he proceeds to eat the toys and announces that "me can't decide which toys me like better, they are both delicious."[11] Accepting diversity of viewpoints on Sesame Street also means accepting that Cookie Monster settles disputes by eating stuff.

MUPPETS AND THE PHILOSOPHY OF DIFFERENCE

Jim Henson's world is more colorful than ours, and it is filled with a wider diversity of creatures and characters than we often find in our everyday lives. Fortunately for us, Henson's worlds continue to come to life through the wide array of beloved characters that came from his imagination. The number and variety of the different creatures he created communicate part of Jim Henson's philosophy. According to Henson, some of the most exciting and inspirational experiences occur when we encounter something unusual and fantastic. We find entertainment, learn something, and become better people when we interact with new and different people and creatures.

In order to be ready for a lifetime of learning, Henson's creations suggest that we should be open to having adventurous experiences. Accomplishing this means facing our fears, and especially those that prevent us from meeting people who are different from us. It also means seeking out friendships with those who do not quite fit in. (Our most memorable adventures will probably happen when we are with them.)

The diversity of Henson's creations also suggests that we commit ourselves to making our communities inclusive and accepting of differences. The world is a diverse place, and we are enriched if we allow ourselves the benefit of enjoying and learning from this diversity. We become accustomed to conformity in our everyday experience, but Hen-

son reminds us that the pressing philosophical question is whether we will accept this conformity or be a part of the solution to it.

2

MISS PIGGY'S FEMINISM

Redefining Human Relationships through Martial Arts

Samantha Brennan

Talk about Miss Piggy to women of a certain age, and many of us will smile. There weren't a lot of strong female characters on television in the 1970s—the Bionic Woman, Charlie's Angels, and the girls and women of *The Brady Bunch* and, of course, *Three's Company*—but for some reason Miss Piggy stood out. Now, as an adult, there's rather a lot Miss Piggy and I have in common. We're big, strong women with a love of martial arts. Miss Piggy karate chops her way around backstage at the Muppet Theater, and I try to blend my practice of the martial art of aikido with days spent in the ivory tower. I aspire to her level of glamour and self-confidence. As a woman in a very male-dominated field, the academic study of philosophy, I am often, like Miss Piggy, noticeable as the only woman in the room. And while I lack her acting skills and stage presence, in front of large classes I've been known to channel my inner Pig.

Some women didn't connect with the character of Miss Piggy at the time but came to appreciate her virtues later. She really was written for women, not girls. On *Thought Catalog*, Sarah Pacella writes,

> When I was a kid, like many children of the 1970s and 1980s, I loved the Muppets. My favourite characters were Gonzo, Animal and Rowlf the Dog. Although I enjoyed the show I somehow felt that there was always something missing from my Muppet experience: I longed for a female character that I could relate to and the two most prominent female leads annoyed me. I couldn't quite articulate why I was neither

Team Janice or [*sic*] Team Piggy. I mean really, was I supposed to embrace the burn out hippy or the overbearing boar who isn't complete without her man? Miss Piggy really got under my skin in a way that Janice was just incapable of . . . she was bossy, overbearing, desperate, loud, aggressive and self-centred: everything that little girls aren't supposed to be. And the faux French, come on! I soon came to the conclusion that Miss Piggy wasn't written for little girls, she was written for women everywhere, flaws and all, because she's real, maybe even in a Carrie Bradshaw kind of way. Sure she can be misguided and desperate at times (she still makes me cringe a little), and there are some rage issues, but nobody's perfect. [1]

I think of Miss Piggy as a feminist icon of her day, though I know that's a controversial claim. She is certainly a feminist icon from my youth. In many ways Miss Piggy is an unlikely feminist icon. First, she's over-the-top feminine in her self-presentation: heels, fancy hats, a lot of lipstick, and a lot of pink. Often even a feather boa or two. Second, she's one of very few women, most often *the* only one, in a male-dominated cast. Feminists sometimes call heavily male workplaces and events veritable "sausage fests." (Of course, that's just a bad metaphor in this case.) Third, she's romantically attached to the lead male character of the Muppets, Kermit the Frog, though she's anything but his dutiful sidekick. I'm with the feminist science blog *Skepchick*: "As far as I am concerned, Ms. Piggy is one of the strongest female characters in popular culture in the past 50-odd years. Piggy proves, time and again, that she is a strong, confident woman who can go toe-to-toe . . . or snout-to-snout with anyone else." [2]

The character of Miss Piggy is that of a show biz career woman in a time when women's role in society, particularly in the workplace and in romantic relationships, was changing fast. She is a beacon of bright, brash, outspoken femininity amid a sea of almost entirely male Muppets. She is also the dominant personality in her relationship with Kermit the Frog. But then there's the "Miss" factor and the fact that her main role is that of the love interest of the main male character. This chapter argues that despite Miss Piggy's role in her relationship with Kermit and the fact that she is frequently the butt of jokes on the show, Miss Piggy is indeed a character of which feminists can be proud. She's clearly strong, capable, and physically fit. Her martial arts prowess is one of the reasons I think girls and women can look up to Miss Piggy. Miss Piggy is chubby, sure,

but she's also a fighter. Her fatness is not an impediment to her physical fitness and competence, nor is it an impediment to her looks. She wears glamorous outfits and is beautiful and sexy, but she is also as tough as nails.

Certainly Miss Piggy was a Feminist Pig ahead of her time. The 1970s were the era of second-wave feminism. Consider your second-wave feminist options. The liberal feminism of the 1970s suggested that the only obstacles to women's equality were formal and legal barriers. With those removed, women were free to join the ranks of men in the courtrooms, board rooms, and university classrooms. But often the women we think of as liberal feminist heroes took on the garb and style of successful men, trading dresses and purses for suits and briefcases.[3] Radical feminists, on the other hand, viewed women's oppression primarily in terms of domestic violence, rape, and pornography. While the former saw solutions in greater inclusion for women in society as it stood, the latter argued for separatist solutions that placed value on women's distinct culture and contribution. The heroes of radical feminism abandoned traditionally feminine attire and garb, too. No makeup, pantyhose, or heels for them. And then there's Miss Piggy. She wanted success on her own terms. Yes, she desired stardom, but she was not giving up glamour. Following in the footsteps of divas past, Miss Piggy wanted career success and fame, along with a healthy dollop of glitz and glamour.

A THIRD-WAVE FEMINIST IN SECOND-WAVE TIMES?

Miss Piggy's version of feminism had not come around quite yet. Indeed, in "It's Time to Get Together for Some Sex and Violence on the Muppet Show," Kathleen Kennedy writes that Miss Piggy would be a perfect poster child for third-wave feminism: "Feminists in the early 21st century might argue that a feminist who likes sex and diamonds could fit comfortably in Third Wave feminism (and that it is perhaps unfortunate for Miss Piggy it did not exist yet)."[4] Miss Piggy fits in much better in today's pluralist, third-wave feminist ethos. She's powerfully feminine, size positive, and sex positive as well. In answer to the question of how far one should go on a first date, she answers, "Tucson." "Unless you're from Texas, then you can go further."[5]

So what makes Miss Piggy a feminist icon? What makes any woman a feminist icon, really? The feminist blogger Jo Breeze weighs in on feminist icons and who counts:

> It can't just be someone who succeeded in a male-dominated field. It has to be someone who has had some success in intentionally improving the lives of other women. A woman who's succeeded where no other woman succeeded before can be inspiring, certainly, but not necessarily feminist. Sadly, for all the names we list as feminist icons, it can sometimes feel like they keep having to be struck off the list. Ill-judged jokes at the expense of other minority groups, ignoring one's own privilege, thoughtlessly writing off the lived experiences of other women in favour of an ideology. Who can we list as a feminist icon that all feminists can agree on and who has never spoken unthinkingly or caused any offence?
>
> (Clue: I can't think of any.)
>
> Everyone makes mistakes, and public figures get to make them more obviously than the rest of us. How you respond to making mistakes and causing offence matters, a lot—if someone points out that your use of language was upsetting, for example, it takes no effort at all to say "I'd never thought of it like that, thank you, I'll try and avoid doing that in future" rather than "god this is so hard, I'm trying to be an ally, why are you being so picky?" But I'd far prefer to have a public space full of opinionated intelligent verbose women who get it wrong than a public space full of people who are over-cautious of causing offence and never speak boldly.[6]

The category of intelligent, verbose women speaking boldly, occasionally getting it wrong, but more often getting it right, seems tailor made for Miss Piggy. What would Miss Piggy herself say about her iconic status? Miss Piggy was interviewed in *Toronto Life* magazine recently on this very topic. It's not just feminists who have claimed Miss Piggy as an icon. Reports the *Life* article, "She's a gay icon, diva icon, style icon, feminism icon, journalism icon. You name it. The divine swine is an icon to all. 'I am everyone's icon,' she told a roomful of reporters. 'I am an icon to all who will have moi.' When asked about her influence on young women, who may look to her as a strong and independent feminist role model, Miss Piggy said she's just happy to be worshipped."[7]

In what follows I describe some ways in which Miss Piggy stands out on television and in the movies as a role model for girls and women.

MISS PIGGY: FAT, FEMINIST, AND FABULOUS

Miss Piggy was ahead of her time in terms of fat politics. When Miss Piggy first entered the world of television, the academic field of "fat studies" had yet to be born.[8] It was not until the early 2000s that fat studies conferences were first held. Shortly thereafter, readers and anthologies were published, and after that courses in fat studies were held at university campuses across North America. But Miss Piggy came first. She stood out as a beacon of fat positivity in an era of enforced female thinness and Scarsdale dieting. She's larger than life and no less beautiful for it. In her bestselling *Miss Piggy's Guide to Life*, she writes, "Beauty comes in all shapes and sizes. Therefore, the bigger you are the more style you have." The diet chapter of her guide to life includes before and after pictures of her, which are, of course, identical. Miss Piggy explicitly resists conventional beauty norms around body shape and size. She refuses to diet. When Kermit steps in at one point during the show to check on what she's eating, Miss Piggy takes his head and smashes it into a large cake. Her one piece of diet advice: "Never eat more than you can lift."

In "It's Not Over Until the Fat Lady Sings: Comedy, the Carnivalesque, and Body Politics," Angela Stukator writes, "From a feminist perspective, we might examine Miss Piggy as an unruly woman who acquires oppositional power from her ambivalence: she is the object of disgust and desire, being both repellent and attractive, strong and delicate, friendly and hostile, and most significantly, woman and animal."[9] Stukator continues: "Miss Piggy signals the radical potential of the unruly fat woman to produce herself as spectacle: she puts on femininity with vengeance that hints at the masquerade's ability to 'act out' the dilemmas of femininity."[10]

Compare Miss Piggy's embodiment to the "tyranny of slenderness" described by feminist phenomenologist Sandra Bartky:

> Under the current "tyranny of slenderness" women are forbidden to become large or massive; they must take up as little space as possible.

The very contours of a woman's body takes on as she matures—the fuller breasts and rounded hips—have become distasteful. The body by which a woman feels herself judged and which by rigorous discipline she must try to assume is the body of early adolescence, slight and unformed, a body lacking flesh or substance, a body in whose very contours the image of immaturity has been inscribed. The requirement that a woman maintain a smooth and hairless skin carries further the theme of inexperience, for an infantilized face must accompany her infantilized body, a face that never ages or furrows its brow in thought. The face of the ideally feminine woman must never display the marks of character, wisdom, and experience that we so admire in men. [11]

Miss Piggy was a fat, feminist, femme role model at a time when awareness about the politics of body size and the tyranny of slenderness was a very new idea.

Writes Denise Jolly, "There was one large bodied high femme that represented a pin up like aesthetic in mainstream media during my most informative years, one sexy fat being . . . Miss Piggy. Oh, how I loved Miss Piggy. She was bossy. She was high femme. She had a subservient adoring Kermit the Frog, who loved her eternally. Then the reality hit me, my greatest feminine influence as a large bodied young woman, was a Pig Muppet." [12]

Now consider Miss Piggy's super-confident beauty advice, from *Miss Piggy's Guide to Life*: "Start out perfect and never change a thing. Always accentuate your best features by pointing at them. And conceal your flaws by sucker punching anyone who has the audacity to mention them."

FAT, FIT, AND FEMALE: TOGETHER AT LAST

The sucker-punching brings us to another one of Miss Piggy's positive features. She is fearless and strong. Miss Piggy's physicality is striking not just in her size but also in her sheer athleticism. Miss Piggy is one of the larger Muppets, but unlike the stereotypical portrayal of a fat woman as nonathletic and out of shape, Miss Piggy is usually portrayed as tremendously physically capable. Many of the cast express fear of her karate chops, and if the cast ever needs physical defense, it is Miss Piggy they call for. Yes, she's portrayed as an expert in martial arts, but she's also

seen as excellent at running, horse riding, and roller skating. Before "fat and fit" was ever a thing, there was Miss Piggy.

Clearly she's physically fit. In "The Uniquely Strong but Feminine Miss Piggy," Maryanne Fisher and Anthony Cox describe the ways in which Miss Piggy stands out.[13] Typically in comedy, writers and actors exaggerate traits usually associated with a given role; thus Beaker is even more nerdy and shrill than your typical lab-coat-wearing scientist, and Fozzie Bear takes the role of stand-up comedian to a whole new level. But Miss Piggy is different. Fisher and Cox note that she plays counter to many of the stereotypes of women in movies and on television: "She is unique in that she is incongruent with the stereotypical portrayal of women in mainstream media."[14] Other than her beginning as Piggy Lee, Miss Piggy has always been Miss Piggy, fully formed since the early days of the show. Fisher and Cox compare Miss Piggy to women in science fiction shows and movies of the 1970s, such as Uhura in *Star Trek* and Princess Leia in *Star Wars*, but also to Xena the Warrior Princess and Wonder Woman. They, too, are a mix of the competent and the incompetent and play second-in-command roles.[15]

In an interview with Miss Piggy and Kermit, Piggy responded to a question about her martial arts skills in the 2011 film *The Muppets* and how often she practices: "Yes, I did all my own stunts in the movie. I trained at and continue to be seen frequently at Master Chang's Karate Dojo and Chinese restaurant."[16] Again, the food reference is, of course, a comment on Miss Piggy's size. Piggy's being both fat and fit is a rarity on mainstream television. Sure, she's teased about her weight and portrayed as eating too much, but there are never any doubts raised about her strength. How rare is that in television and movie culture? She served as a size-positive feminist preaching body acceptance before that was even a thing. Yes, she engages with beauty, but it's never judgmental and it's seen as being far from an ideal—instead, it's something that is available to every woman.

MISS PIGGY IS A FEMINIST ICON, BUT WHAT ABOUT THE MUPPETS?

So Miss Piggy herself is a feminist icon, it seems to me, but what about the show and the movies in which she appears? Are they feminist? Inevi-

tably, when thinking and talking about Miss Piggy, feminism, and *The Muppet Show*, one thing that comes up is that she's the only recognizably female Muppet who is a regular member of the cast. (I say "recognizably" because for many of the Muppets we might claim not to be clear just what they are.) But Miss Piggy stands out as the only female Muppet. In her 1991 column for the *New York Times*, feminist essayist Katha Pollitt lamented the lack of female characters for her young daughter to watch and she dubbed the rule that says shows can only have one woman: the Smurfette Principle.[17] It seems true that for any series not aimed solely at females, odds are high that only one female will be in the regular cast. Often the only woman in the cast of characters will be romantically attached to one of the main male characters, and it's true that for Miss Piggy her main connection to the Muppets is through her romantic partnership with her beau, and the show's main star, Kermit the Frog.

Feminist pop culture critic Anita Sarkeesian writes,

> What do *Inception*, the Transformers, and the Muppets all have in common? They all suffer from a trope called the Smurfette Principle. As defined by TVTropes, "The Smurfette Principle is the tendency for works of fiction to have exactly one female amongst an ensemble of male characters, in spite of the fact that roughly half of the human race is female. Unless a show is purposefully aimed at a female viewing audience, the main characters will tend to be disproportionately male." . . . Even Jim Hensen [*sic*] didn't seem too keen on the women, along side Kermit, Gonzo, and Fozzie the Bear, Miss Piggy was the only female muppet.[18]

Sarkeesian writes that in addition to there only being one woman, on shows that follow the Smurfette Principle the one woman will have a narrow and stereotypically female personality. Men can come in different shapes and flavors, but women will always be The Chick. She writes that "thus, by The Law of Conservation of Detail, you only need one." That aspect of the trope is less suited to Miss Piggy and the Muppets because Miss Piggy is such a strong character, larger than life, and her personality often dominates the show. In many ways, she's not The Chick.

Feminist pop culture critics might also wonder whether *The Muppet Show* would pass the Bechdel test. Here I think the show and the movies are on much firmer ground. What's the Bechdel test? In short, it is a simple test that names the following three criteria in order for a movie to

pass: (1) it has to have at least two women in it, who (2) talk to each other about (3) something besides a man. The test was popularized by Alison Bechdel's comic *Dykes to Watch Out For*, in a 1985 strip called "The Rule" (http://bechdeltest.com/).

On the web page for the Bechdel test there is controversy over whether 2011's *The Muppets* passes the test. Originally listed as only meeting one criteria (there are a least two women), viewers debated the content of Miss Piggy's conversations. On my reading of the discussion and watching of the film, it passes. Miss Piggy talks about fighting with Miss Poogy and she banters with her assistant at *Vogue*, and Mary (the other female lead) chats with Sarah Silverman in her role as a waitress at the restaurant. (Miss Poogy is a boar version of Miss Piggy, and though she is listed as a female Muppet on the Muppet Wiki, there is discussion on the Bechdel site about possible transphobia.) Putting the movies aside, *The Muppet Show* itself would pass the Bechdel test when there were female guests, as Miss Piggy had significant interactions with the female human visitors to the set.

Although *The Muppet Show* and the movies that followed are not great for the numbers and representation of women, I think Henson's Miss Piggy is a Feminist Pig ahead of her time, a body-confident role model for women and swine of all shapes and sizes.

3

KERMIT AND LEADERSHIP

Believing in the Dream

Amanda Cawston

Imagine a community of individuals who don't share a common geographic history, ancestry, or even the same language. They have a broad range of talents and interests, incredibly diverse ideological views, and a wide range of individual needs. Moreover, most are, shall we say, "unresponsive" to authority, unmotivated by power, uninterested in rules, and unstructured by any hierarchy. In many ways, this group represents both the anarchist ideal and the liberal challenge. Since at least the writings of John Stuart Mill (1806–1873), liberal political theory has sought a way to accommodate diverse ideological views while avoiding enforcing any particular way of life. Conversely, anarchists have struggled to find a way to achieve solidarity and accomplish collective goals without resorting to problematic hierarchies or power structures.[1] Organizing and directing pluralistic actors under such conditions is definitely a challenge, to say the least.

The problem is how we might achieve collective aims while avoiding hierarchy. How can such a diverse group be motivated without force, coercion, subterfuge, or illusion? More generally, we can see this challenge as asking whether one can be a leader, in the sense needed for a shared direction and focus, without authority or hierarchy. This marks a deep and ideologically charged problem, one that Jim Henson's Muppets (and Kermit the Frog in particular) have answered nicely.

Kermit is clearly the voice of the Muppets. In both *The Muppet Show* and the various Muppet movies, Kermit often plays a sort of leadership role. Equally clear is that the Muppets are a prime example of the above wildly diverse and unruly group that poses a particular problem for political philosophers. There are, however, two features of Kermit's leadership that make it uniquely suitable for this challenging group, and therefore of interest for political theorists. First, I will discuss how Kermit's position as "leader" is determined not because he possesses any special qualities or skills, but rather because his leadership is derived from his having a dream and his openness to sharing it with others. The Muppets come together, stay together, and work together because they each also "believe in the dream." Second, because of Kermit's reluctance to lead in the traditional sense, he resists imposing "solutions." Frequently, when the going gets tough for the Muppets, Kermit is just as much at sea as everyone else—he does not know what to do, and he is uncomfortable with everyone looking to him to sort it out. Because Kermit doesn't simply solve their problems, this makes the Muppets turn to each other, thereby pulling them together and reaffirming their shared dream. Together, these two features allow Kermit to realize the liberal aim of retaining the diversity of the Muppets and the anarchist aim of providing some modicum of guidance while avoiding hierarchy and authority.

IS KERMIT THE LEADER?

Kermit the Frog isn't your traditional leader, and I don't mean in virtue of his being made of felt and foam rubber. For one, there's no recognizable mechanism by which he became leader; there are no Muppet elections, Muppets do not compete with each other for leadership positions, and Kermit has no real power, in theory or in practice, over group members. His attempts to give rousing speeches to rally the troops nearly always fail, and are treated by Henson more as an opportunity for a joke.[2] In the common understanding of the term, therefore, Kermit isn't a true leader.

Despite these limitations, Kermit is often considered to be the "leader" of the Muppets. He often speaks for the group, is the one the others turn to when deciding what to do, and often is the one that has to offer suggestions or solutions to various problems. Some of this portrayal as "leader" comes from his role as emcee of *The Muppet Show*. While he is

not administratively in charge—Scooter is the manager, after all[3]—he sets the tone of the show and is often responsible for rescuing it when something (inevitably) misfires (sometimes literally). This role as leader continues through the various Muppet movies. Kermit becomes the voice for the group, proposing realistic plans for action—at least compared to some of the others on offer—and focusing the Muppets' various efforts. For all intents and purposes, Kermit *is* the leader.

One might think that this distinctly non-leadership role that Kermit plays is appropriate because the Muppets are really just a group of friends. While it is true that the Muppets are not a political entity, they are an acting troupe trying to accomplish something. Whether it's getting to Hollywood to become movie stars, producing a variety show, or catching a thief, there is always an effort to pull off collective action toward a common goal.[4] And as anyone who has ever tried to accomplish something with her group of friends knows, some sort of leadership role is often required. Therefore, Kermit can be viewed as the leader of the Muppets. It is the unique way in which he is the leader that warrants a closer look, particularly because of his humble and unassuming style, which belies a substantial political view.[5]

MAKING PEOPLE HAPPY

An important feature of Kermit's leadership is how he came to acquire his "position," a topic that is addressed in the 1979 film, *The Muppet Movie*. Following a series of setbacks, the Muppets find themselves stranded on the side of a lonely road, camped out under the desert night sky. It seems clear that they will fail in their attempt to reach Hollywood by the following day to audition for the chance to make movies. Kermit wanders off on his own and, via a conversation with himself, is reminded of why he embarked on this journey, what is important, and, ultimately, what ties the Muppets together. The scene unfolds as a "dialogue" between Kermit and his conscience (KC). As he walks away from the campfire, Kermit both denies that he made any promises and considers the situation to be his fault. KC reminds him, as he is now faced with failure, that Kermit would be just as miserable if he hadn't left the swamp to pursue his dream. Kermit agrees, but worries that this pursuit has made

the others miserable, too, and that they only came along because of him. We then get the following exchange:

> KC: Still, whether you promised them something or not, you gotta remember, they wanted to come.
>
> Kermit: But that's because they believed in me.
>
> KC: No, they believed in the dream.
>
> Kermit: Well, so do I . . .
>
> KC: You do?
>
> Kermit: Yeah, of course I do!
>
> KC: Well then?
>
> Kermit: I guess I was wrong when I said I never promised anyone; I promised me.[6]

There are several points to discuss regarding this scene. The first is the role of Kermit's dream, both in motivating and driving Kermit's decisions and in explaining why the group forms in the first place. The scene reminds us (and Kermit) that Kermit's obligation to pursue the dream is one he has to himself, rather than as a consequence of any promise he made to the others. Further, as KC points out, a shared belief in the dream is the reason why the Muppets find themselves together. It wasn't Kermit's personal charisma or ability to convince the others, nor any promises of a better life if they came along. Instead, Kermit simply shares his dream with others and invites them to join him. And in doing so, the dream grows, becoming bigger than just Kermit.

THE LOVERS, THE DREAMERS, AND ME

This is a good place to say a few words about the nature of the dream itself, as its content is important for explaining Kermit's unique leadership role. First, simply having a dream is not enough. Some dreams are better suited than others for serving as the basis for Muppet-style solidarity. To see this, note that, later in *The Muppet Movie*, Kermit confronts the movie's villain, Doc Hopper, who has a "dream" of owning a thousand frog-leg restaurants (and believes having Kermit as the chain mascot

is the key to realizing that dream). In response, Kermit offers the following:

> Well, I've got a dream too, but it's about singing and dancing and making people happy, the kind of dream that gets better the more people you share it with. And well, I've found a whole bunch of friends, who have the same dream, and that kind of makes us like a family. You have anyone like that, Hopper? I mean, once you get all those restaurants, who are you going to share it with? Who are your friends, Doc? Those guys?[7]

The implication is that Kermit's dream is one directed at making other people happy, while Hopper's is selfish, and about making only himself happy. Selfish dreams, by their nature, cannot be *shared*; others can only be used instrumentally in pursuit of such a dream. Meanwhile, Kermit's dream of making people happy is the kind of dream that, as he says, gets better with sharing. It isn't about making Kermit or the other Muppets happy, but instead about making other people happy.[8] And such an other-directed dream *needs* to be shared, because that's the only way it can be realized.

Second, Kermit suggests that the realization of selfish dreams (which requires instrumental use of others, rather than building of friendships) is hollow or unfulfilling. This suggests that we cannot think of Kermit as being a merely representational figure, having been tasked with pursuing the desires of his group members. Kermit is not the means by which the Muppets will realize their own individual ends. He is merely the catalyst, actively pursuing his dream and inviting others to share in it. He inspires and enables the others to share in this dream and, relevant to our broader concerns, to do so *together*.

Returning to the campfire scene, this also reveals the relationship between Kermit's personal commitment to the dream and his role as leader. His conscience reminds Kermit that the others are there *because of the dream*, not because of him, and that as a believer it is his own commitment to the dream that really matters. The scene comes to us in a moment of crisis, when things are looking particularly bleak for the Muppets. What does Henson do at this point? He takes a moment to reaffirm Kermit's belief in the dream, and to remind him (and us) that his commitment is fundamentally important. And why is it important that Kermit believe? Belief in the dream is essential to belonging to the group; it

defines the Muppets and unites them in collective action. It is not a belief based on blind faith or unquestioned acceptance, but a quiet confidence, optimism, and belief in each other. Once Kermit has reestablished his belief, he can again function as a contributing, supportive, and leading member of the group.

RELUCTANCE TO LEAD

The second key feature of Kermit's leadership is his *reluctance* and what might even appear as his occasional *failure* to lead in the traditional sense. Unlike the campfire scene discussed above, where Kermit explicitly and directly considers his role and responsibilities, this feature of Kermit's leadership is illustrated indirectly through his responses and behavior. Frequently, when things are going badly, the troupe turns to Kermit as the tension builds, usually ending with Kermit boiling over in an outburst, loudly rejecting their attempts to put the responsibility on him. In such cases, Kermit is precisely *not* the stereotypical strong leader who remains focused on the goal and calmly resolves the matter. Instead, these are times when Kermit simply doesn't know what to do and he doesn't pretend otherwise by telling the others not to worry, that he will figure things out. No, in these crises, Kermit is as much at a loss as the others. He openly expresses his own flaws, almost hostilely lashing out at his friends in his rejection of responsibility. While he apologizes later for behaving badly, such apologies shouldn't be read as taking on the mantle of responsibility. The other Muppets (and friends) are often taken aback by these outbursts, and by their normally calm and optimistic friend buckling under the weight. Such outbursts help them realize they are placing too much responsibility on Kermit—he isn't solely responsible for realizing their dreams. They all are.

One such crisis occurs in the film *The Muppets Take Manhattan* (1984), where, after a stream of rejections to produce their musical, the Muppets find themselves out of money. Walking down the street, the group is following Kermit, each asking him what they should do. These demands for guidance merge into a combined sea of sound that eventually overwhelms Kermit, who turns to face them and explodes, shouting, "I don't know! How should I know! Why are you always asking me anyway? Can't you take care of yourselves!? I don't know what to do next.

We failed, okay? We tried and we failed."[9] A few minutes later, while Kermit is away trying to procure some soup for the group, the Muppets agree with each other that Kermit feels too responsible, and that they've been relying on him too much. As such, they decide it would be best if they each tried to fend for themselves for a while (telling Kermit that they all got job offers), though they stress that they still believe in the show. Importantly, they remain connected as a group and in their aims, though temporarily not located in the same place.

Interestingly, Kermit's apparent failure to lead doesn't dissolve the group. His refusal to shoulder the whole of the responsibility prompted the others to take some of the reins. Further, their doing so reinvigorates Kermit's own belief in the dream, as he then renews his efforts to sell the show, thereby bringing everyone back together. It is clear that Kermit is as dependent on the group as they are on him: he needs them to believe as much as they need him to, and their action to leave town and take care of themselves for a while helps Kermit to see what he needs to do. Though it flies in the face of leadership as it is commonly understood, Kermit's abdication of responsibility helped to empower the group to pursue their collective ends. He led without leading. Kermit is uncomfortable when the others rely on him too much; he doesn't want them to be so dependent on him. He doesn't want to make all the decisions, nor does he want others to always be looking to him for solutions. It's unclear if Kermit is aware of the radically subversive and anarchic meaning of his outburst (probably not). It is unlikely that Kermit—or Henson, for that matter— was trying to demonstrate good leadership in such moments—only that Kermit is a good person (er . . . good frog). And part of being a good frog is not being perfect, so one will occasionally behave badly. Also, it is to be uncomfortable when others are too dependent on you, when you have too much power over others' agency. So, then, a good leader is someone who isn't *trying* to be a good *leader* but is only a good frog.

THE LEADERSHIP CONNECTION

The question remains as to how these features of Kermit's leadership represent an answer to the philosophical dilemma of how to reconcile the diverse interests and needs of a rag-tag group of Muppets who will de-vour authority figures—sometimes literally—or to the question of how to

focus the efforts and activities of a diverse group without hierarchy, power, or even order. Ultimately, Kermit's position of leadership derives from his belief in a selfless dream, which reveals the means by which he provides a direction and a focus for the Muppets, in a way that does not try to subsume or overwrite the dreams or aims of others. Kermit's dream provides the focus without demanding allegiance or asking others to sacrifice their views. Most importantly, while each member may play a particular role according to her talents or interests, none are used *instrumentally* in pursuit of the dream's end. To do so would be counterproductive, given the nature of the dream.

Second, a good leader in these conditions is a reluctant leader. Kermit avoids establishing hierarchy or power structures, which might otherwise become entrenched. Kermit's refusal to lead is at times shocking for the Muppets, but it serves to make problematic dependence visible and therefore able to be dealt with. Furthermore, Kermit is a reluctant leader—indeed, leadership is likely the furthest thing from his mind, reminding us that a good leader is someone who is most interested in simply being a good person/frog. Together, these features allow Kermit to encourage, inspire, and share his dreams with the Muppets, providing the optimism and focus around which the others can perform and create. They also prevent him from relying on or endorsing any hierarchical structures or dangerous power relations. And while I won't go so far as to say this model completely satisfies the worries of our anarchist and liberal philosophers, I will say that either hallowed and esteemed tradition would do well to take a closer look at the frog with a dream.

4

GO AND FIND YOUR SONGS

Yoga, Philosophy, and *Fraggle Rock*

Laurel Ralston

Sometimes the silliest songs reflect the deepest truths.

Fraggle Rock is built on deep truths—and silly songs—about how individuals and societies are connected, and the importance of recognizing what we all have in common. Throughout the series, the inhabitants of the three worlds the show depicts—the playful Fraggles and hardworking Doozers within Fraggle Rock, the gigantic Gorgs who rule the garden just outside, and the humans and animals of Outer Space—face challenges and situations that inspire them to ponder questions that cultures and societies around the world have asked for centuries: Who are we? Why are we here? How should we relate to one another?

These same questions are at the heart of the ancient system of yoga, and in many ways the stories we witness in *Fraggle Rock* reflect the yogic journey toward peace and liberation through self-knowledge, non-attachment, and connection to the divine. Most people in the West know yoga primarily as a physical practice—a way to build flexibility and strength in the body by moving through a specific set of postures. But this aspect of yoga—*yoga asana*, the third limb of the eightfold path described in Patanjali's *Yoga Sutras*—is just one element of a system intended to address much more than our tight hamstrings. Yoga is above all a practice of the mind, deeply rooted in philosophy. Looking at *Fraggle Rock* through the lens of yogic philosophy can help us understand its important lessons even better—and understand ourselves better, too.

YOU'RE NOT JUST A SILLY CREATURE

Fraggle Rock started with Jim Henson's expressed desire to help stop war—a lofty ambition that seemed "impossible and almost grandiose,"[1] but ultimately inspiring. As an international co-production, designed to be produced and aired in multiple countries and languages, it needed to appeal and speak to children and adults around the world through universal, unifying themes. *Fraggle Rock*'s creators worked from the notion that although each individual looks at the world from her own perspective, "if you somehow reverse the perspective and [are] able take on other people's perspectives and see that in fact, even though [they may be] opposed, [they are] very similar to your own—maybe [that] would loosen those conflicts."[2]

Thus the different species in *Fraggle Rock* were created: the Fraggles, dedicated to song and play; the Doozers, dedicated to order and work; the Gorgs, who consider themselves the rulers of the universe; and the inventor Doc and his dog, Sprocket, in the human world. The moments in which the characters recognize together what they have in common are among the most powerful in the show. "By seeing how the various groups in the world of *Fraggle Rock* learn to deal with their differences," said Henson, "perhaps we can learn a little bit about how to deal with ours."[3]

GO AND FIND YOUR SONGS

In order to recognize what we have in common with others, we must first understand ourselves—which is not always an easy task. Self-knowledge is one of the goals of yoga, and yogic practices like meditation and *yoga asana* provide opportunities to know ourselves better by observing our thoughts, physical sensations, reactions, and emotions.

Such observation need not be reserved only for those times when one feels the urge to bend into a pretzel. One of Fraggle Rock's two sages, Cantus the Minstrel, uses music—the greatest of the Fragglish arts—to inspire self-inquiry and unity among Fraggles and their counterparts. But finding enough stillness for it can otherwise be a challenge, especially for boisterous Fraggles—or those of us who like to be busy doing all the time. When Cantus makes his first appearance, in "The Minstrels,"[4] Red Fraggle, perhaps the busiest and doingest of them all, volunteers herself

to lead the Fraggle Medley—all of the Fraggles singing their own songs together. Many of them hear their melodies immediately, but Cantus stipulates that the Medley can't begin until Red, too, has found her song. "You've always had a song," he tells Red. "All Fraggles have songs. Now, just listen." Impatient Red is lost. She resorts to stealing Cantus's magic pipe and hopes in vain that it will reveal her song—only to have it lead her right back to Cantus himself, who reminds her to listen within. Jocelyn Stevenson, a creative consultant and cowriter of the episode, describes Red's challenge—her yoga—as "an exploration for that particular character who wasn't going to sit down still enough. . . . She just wanted it—she didn't want to have to, kind of, *find* it."[5]

The yogic concept of *dharma*—a word often translated as "law"—takes self-knowledge further. Dharma is one of the four great desires recognized in Tantric philosophy—as yogi Rod Stryker puts it, simply, it is the desire to fulfill one's potential[6]—and in contemporary popular yogic philosophy, it frequently appears as divine purpose. But dharma can also be interpreted as a sacred order or universal intelligence. Dharma acknowledges that beings may have different interests and skills, serve different purposes, and may even appear to conflict at times, but it assures us that all comes together into balance. In the Bhagavad-Gita—a central text of yogic philosophy, which depicts a dialogue between the god-man Krishna and a distressed warrior, Arjuna, on the eve of the Mahabharata War[7]—it is clear that understanding dharma is essential to completing the yogic journey: "Swiftly he becomes a self [established in] the law (dharma) [and] attains everlasting peace."[8]

Fraggle Rock has its own sacred order and intelligence, in which we find both the universal and individual elements of dharma. Fraggles are motivated by their sense of fun, which they pursue with seemingly boundless energy and spontaneity, while Doozers—in stark contrast—are industrious creatures dedicated to building. Henson himself sums up the difference neatly: "[If] Fraggles live to play, Doozers live to work. The greatest joy in a Doozer's life is to get up in the morning, put his hard hat on, and take his place in the Doozer work crew."[9]

Because of these decidedly different priorities, Fraggles and Doozers frequently struggle to understand each other. Fraggles consider the Doozers' incessant work boring (though tasty), and Doozers consider the Fraggles lazy—Doozer legend says that a Doozer who doesn't work will turn into a Fraggle. What the two communities have in common, though, is a

deep sense of purpose and fulfillment of need. Their songs show that Fraggles and Doozers find challenge and enjoyment in their characteristic activities, and both consider themselves to be serving a higher imperative. "Workin'," sung by the Fraggles in "The Thirty-Minute Work Week,"[10] tells us that they think of play as serious business:

> Wake up in the morning,
> Get yourself to work,
> Fraggles never fool around,
> Fraggles never shirk,
> Your duty's always waiting,
> And duty must be done.
> There's ping-pong games that must be played
> And songs that must be sung,
> And you'll be workin'!

"The Doozer March Song," sung by the Doozers in "The Great Radish Famine,"[11] expresses the satisfaction and pleasure they glean from work—and how it can even be transcendent:

> Ah, dream a dream and make it true,
> That's what Doozers like to do,
> And building is the Doozer way to go (two three four).
> 'Cause every day the world is new,
> There's dreams to pay attention to,
> And building is the surest way we know.

DOOZER IS AS DOOZER DOES

Personal dharma is what makes each of us a unique expression of the divine Self and, as Stryker writes in *The Four Desires*, allows us to "honor and support the invisible web of connection that links [us] to the universe as a whole."[12] Living in accordance with dharma means taking one's place in the sacred order through individual choices and actions—as long as one can remain true to oneself in the process.

However, an individual may struggle to find an identity that feels truly authentic. The sense of not belonging and of not knowing how to make a positive contribution is a familiar problem—many of us struggle, at

multiple points in our lives, to understand where we fit in the big picture and what our most important dreams and goals are.

While the Fraggles' and Doozers' shared sense of community and shared purpose are strong, several characters in *Fraggle Rock* at one time or another find themselves wondering about identity and belonging— eventually discovering that there is space for individuality even within Fraggle Rock's sacred order. In "The Thirty-Minute Work Week," Wembley is under pressure to decide what his job is—after all, everyone else has one. Red swims and splashes to keep Fraggle Rock's water clean; Gobo explores and brings back postcards from his uncle, Traveling Matt; Boober does laundry ("Tedium and drudgery are good for the soul!"); and Mokey gathers radishes. Eventually, Wembley's love of hats, ladders, bells, and sirens leads him to become the siren for the volunteer fire department, but only after unsuccessfully trying out his friends' jobs and finding that he's not really suited for them. Even Red, arguably the most confident of the group, finds herself wishing she were someone else, in "I Want to Be You,"[13] after noticing how much more her friends seem to value kind, reflective Mokey. She tries to imitate Mokey, subduing her exuberant side and attempting to write poetry—but only ends up more unhappy and confused when she's unable to take on a persona that doesn't belong to her.

Doozers aren't immune, either. In "All Work and All Play,"[14] Cotterpin Doozer resists her fate as a builder, declaring that what makes her happy is not building, but drawing and dreaming. At first she is ostracized for her rebellion and laziness, and an elder Doozer, the Architect, tries to change her mind, remarking that "the creative joy of work is the finest thing there is!" Cotterpin seeks out Red, hoping to become a Fraggle instead, only to realize that she can't escape being a Doozer—nor does she really want to. When the Architect reveals to Cotterpin that he, too, refused to wear the helmet because he only liked to draw, she's delighted to discover that she can live out both purposes—contributing to Doozer building and expressing her creative side at the same time—by becoming the Apprentice Architect. We learn from her story that it's important to stay true to ourselves, even when that may challenge others, and that we can still find mentors and friends when we think we're alone to help guide us on our way. Or, as Krishna tells Arjuna, "Better is [one's] own-law imperfectly [carried out] than another's law well performed."[15]

ARCHITECTURE IS MEANT TO BE ENJOYED

As the Fraggles and Doozers have helped us witness, discovering one's personal dharma can lead to important insights regarding work, hobbies, and relationships (among other things). It can also help make all of these, and life in general, more satisfying by setting the foundation for karma-yoga.

Although many people associate the word *karma* with notions of what-goes-around-comes-around and afterlife, karma-yoga is quite different. Yogic philosophy identifies four spiritual paths—attitudes or approaches—to self-knowledge: *karma-yoga*, or the yoga of action; *bhakti-yoga*, the yoga of devotion; *raja-yoga*, or meditation; and *jnana-yoga*, the yoga of knowledge. All four paths are equally important, and although none are to be practiced exclusively, the yogi may find one or another more attractive according to her specific temperament.

All yogis, however, will encounter the need for karma-yoga—action performed selflessly, for the benefits of others or for its own sake—which teaches that any action can be transformed into a devotional practice through renunciation and offering. According to Swami Adiswarananda, karma-yoga as a path to self-knowledge is the central message of the Bhagavad-Gita.[16] Karma-yoga helps to transform and avoid suffering caused by attachment, the sentiments associated with personal gain or desired outcomes. Yet nonattachment must not be conflated with mere apathy: liberation in karma-yoga comes from the understanding that all experiences are actually experiences of the one common Self. Early in the Bhagavad-Gita, Krishna counsels Arjuna, "Steadfast in Yoga, perform actions abandoning attachment, O Dhanamjaya, [always] remaining the same in success and failure. Yoga is called equanimity."[17] Between renouncing results of action and recognizing that common element of Self, the yogi develops the ability to accept all outcomes with an even temperament.

Within Fraggle Rock, the most obvious example of karma-yoga is the work of the Doozers. Not only do Doozers build for the pleasure of it, because activity and building are in their nature or dharma, but they also accept that their buildings are temporary at best, given the Fraggles' insatiable appetite for them. They exemplify Krishna's admonition, "In action alone is your rightful-interest (*adhikara*), never in [its] fruit. Let not your motive be the fruit of action; nor let your attachment be to

inaction (*akarman*)."[18] When Wembley muses, in mid-snack, "Doozer constructions sure are delicious. I always have wondered why the Doozers don't mind us eating them, though," a nearby Doozer looks on with satisfaction, remarking, "Ah, yes. Architecture is meant to be enjoyed."[19]

Even Doozers occasionally fall prey to attachment and selfishness, though, and when they do the results are disastrous. In "The Doozer Contest,"[20] a competition erupts between Flange and Modem Doozer, who are trying to improve the existing building material when they overhear the Fraggles discussing which added taste—mustard or tomato—is most appealing. The Architect warns against indulging in the ancient Doozer vice of competitiveness, telling Flange, "I warn you! Nothing is gained by winning such contests except misery!"—suggesting (wisely) that suffering can come of victory as well as defeat. At first, neither the tomato-flavored nor the mustard-flavored constructions suit the Fraggles, and, as a result, the Doozers risk running out of space to build. The Doozer competition is eventually resolved when Flange and Modem realize that they must work together, combining their ideas (and flavors) and restoring balance to Fraggle Rock.

WE ARE ALL PART OF THE SONG

This theme of mutual dependence weaves through *Fraggle Rock* from the beginning to the very end of the series, perhaps because it is a lesson we need to learn over and over again. As *Fraggle Rock* writer Jerry Juhl points out, "All three of those species [the Fraggles, Doozers, and Gorgs], they are interdependent in various ways. They really need each other, and have no idea why they need each other."[21]

The only characters who seem fully aware of these connections are Fraggle Rock's sages, Cantus and Marjorie the All-Knowing Trash Heap, both of whom see the possibility of bringing all beings closer together. Cantus, of course, expresses the connection between Fraggles in musical terms: "It's really very simple," he says. "Every Fraggle has a song. All the songs sung together make a medley."[22] In "The Great Radish Famine," Marjorie conspires to bring Fraggles, Doozers, and Gorgs together by confiscating all of the radishes—which they all depend on for survival—so that "when they see they share the problem, they'll start to see how much alike they are!"

The most poignant expression of interconnectedness of the series comes toward its conclusion, just when partings appear imminent—and in the penultimate episode, "The Honk of Honks,"[23] the yogic concepts of dharma, karma-yoga, and self-knowledge converge.

Dharma as law is sometimes also interpreted as the expression of a single, great moral imperative—compassion—a principle that applies to every situation and is truly universal. This is the powerful message delivered—along with a reminder of dharma as purpose and sacred order—in a characteristically cryptic manner, by Cantus to Gobo, who wonders aloud why Doc—the Silly Creature—can't see him. The answer, Cantus says, is in the Song of Songs: "If you listen, you will hear your part, for you are all part of the song, and the song is all part of you." Cantus sends Gobo off in search of the Honk of Honks,[24] which must be sounded before the Song of Songs can be sung. "It is bigger than all of us," he says, "because it *is* all of us. So go now and find the Honk of Honks."

Gobo slowly realizes that he needs to reach all of the other communities to build the Honk of Honks, and the last frontier is the Silly Creature. Cantus commands him to touch the Silly Creature—and reminds him that one doesn't need hands to touch, or eyes to see. Gobo runs out into Doc's workshop, just in time to witness Doc's despair at the imminent departure of his good friend, Ned, and is filled with compassion. "It's losing its best friend," he says to himself. "I know how that feels." Gobo reaches out to comfort Doc, and, suddenly, Doc—much to the surprise of both—can see him.

The experience inspires an epiphany for Gobo: "I felt bad for you—that's how you touched me. Then I touched you. You're not just a Silly Creature. You're a You, aren't you? . . . A You, like me!" And when Doc demonstrates the honking party favor Gobo notices on the floor, Gobo sees the whole picture. "It honks! That's it!" he exclaims. "We're all a part of everything, and everything's a part of us!" Taking this wisdom (and the party favor) back to Fraggle Rock, Gobo completes Cantus's mission, sounds the Honk of Honks, and initiates the Song of Songs—which sums up yogic wisdom as only a Fraggle song can.

> Everybody's got their part to play,
> Everybody brought their hearts today,
> Sing about the Rock and sing it strong!
> 'Cause we belong to the song,
> And the rock goes on and on . . .

But you've read enough. Now it is time for you to listen. Go and find your songs.

5

OVERCONSUMPTION AND ENVIRONMENTALISM IN *LABYRINTH*

David R. Burns and Deborah R. Burns

Jim Henson's *Labyrinth* attracts audiences of all ages with its fairy tale narrative and lush visual effects. We explore the themes of overconsumption, relationships, and environmentalism in *Labyrinth*. Through the character development of Sarah, Hoggle, and the Junk Lady, Henson educates audiences about the deleterious effects of overconsumption on relationships and the global ecosystem. Using cinema as a site of resistance, Henson challenges audiences to resist mass media's messages of hyperconsumerism. With the anti-consumerist theme in *Labyrinth*, Henson encourages viewers to resist mass media and contemporary culture's messages of conspicuous consumption, appreciate the benefits of meaningful relationships, and act as good stewards of planetary ecology.

Labyrinth is part of Henson's exploration of ecology in his larger body of work. In *The Dark Crystal*, Henson's first feature-length fantasy film, Henson examines the importance of balance in planetary ecology. When the diametrically opposed Skeksis and Mystics are separated, the planet in *The Dark Crystal* lacks equilibrium and is both dying and dark. However, when the Skeksis and the Mystics are united, the planet is balanced and restored to its former glory of being both "green and good."[1] Similarly, in "We Are All Earthlings," a song that was performed on *Sesame Street*, Henson's Muppets explore how humans and animals must all work together to share the Earth.[2] In "Bein' Green" (perhaps better known for its more popular lyric "It's not easy being green") on both *Sesame Street* and *The Muppet Show*, Henson speaks to the challenges of

preserving our planet's delicate ecosystem.[3] Despite these challenges, the song concludes with the merits of being green: "Green can be big, like a mountain, or important, like a river, or tall like a tree."[4] Indeed, green is described as being "beautiful" and "what I want to be."[5] In fact, Henson's exploration of ecology in "Bein' Green" has enjoyed a somewhat dubious and incongruous renaissance recently with Ford's appropriation of the song for its more energy-efficient, hybrid vehicles.[6]

Labyrinth joins a long list of 1980s films that are critical of overconsumption, including *Arthur*, *Blade Runner*, *Repo Man*, and *The Toy*.[7] Like *Labyrinth*, these films expose the excessive amounts of waste and bleak realities that result from overconsumption. Broadly defined, overconsumption is the consumption of a greater number of goods and services than are necessary for a reasonable lifestyle and level of material comfort.[8] The anti-consumerist movement has criticized overconsumption as causing the erosion of meaningful relationships and contributing to ecological challenges including pollution, waste, and declining natural resources.[9] With *Labyrinth*, Henson not only adds to the existing anti-consumerist narratives in film but also uses puppets, a novel and engaging cinematic device, to enable people of all ages to better understand the negative effects of overconsumption.

OVERCONSUMPTION, THE EROSION OF FAMILY RELATIONSHIPS, AND SARAH

In *Labyrinth*, the persistent struggles that Sarah has connecting and forming meaningful relationships are associated with the overconsumption of consumer items. Sarah's family exemplifies the middle-class U.S. family's "work and spend" cyclical ideology that "undermines the daily life conditions" necessary for "reciprocal bonds" and meaningful relationships.[10] This "work and spend cycle" is pervasive among U.S. laborers who toil long hours in the labor market because they feel the pressure to keep up with rising consumption norms.[11] These norms include the customary social behaviors and rising pressure related to purchasing bigger and bigger homes and acquiring increasing amounts of consumer items. U.S. laborers spend lengthy hours at their jobs in order to meet these norms, which leaves them with diminished free time and opportunities to connect with each other.[12] As with many U.S. families, Sarah's family's

big house and overconsumption of consumer items erodes the relationships in Sarah's home.

Sarah's large home is elaborately furnished, and her bedroom is lavishly appointed with an impressive canopy bed and piles of expensive toys, books, and jewelry boxes. Her room and consumer items create a false sense of fulfillment while separating Sarah from her family. In the beginning of the film, Sarah is unable to connect with her stepmother; she accuses her stepmother of failing to pay attention to her interests when she says, "You don't even ask what my plans are."[13] Sarah's father also fails to bond with Sarah when he knocks on her bedroom door and she yells back, "There's nothing to talk about!"[14] Sarah avoids meaningful connections with her family by seeking refuge in her room and speaking to her consumer goods.

In *Labyrinth*, Henson reveals the deleterious effect that working long hours to keep up with the Joneses has on family relationships and how the large homes that people buy to keep up with the Joneses create physical and emotional distances between family members and erode meaningful relationships. Through his depiction of Sarah's relationship with her family, Henson illustrates how people use consumer goods as a replacement for social connections.[15] Rather than connecting with her parents, Sarah gazes at her reflection in her bedroom mirror and elects to talk to her toys instead of her family. It is not until later in the film, when Sarah chooses to rescue her brother, Toby, from Goblin King Jareth, that she appreciates the value of relationships. When Sarah leaves the comfort of her bedroom to enter the labyrinth in search of Toby, Henson illustrates her growing understanding of the value of relationships.

OVERCONSUMPTION, FRIENDSHIP, AND HOGGLE

Hoggle, like Sarah, is developing his understanding of the value of relationships. Sarah meets Hoggle at the entrance to the labyrinth and asks his advice on which direction to take on the two divergent paths through the labyrinth. Initially, Hoggle is not interested in helping or connecting with Sarah and responds to her query with "I wouldn't go either way." She replies, "If that's all you'll say, you can leave," to which Hoggle retorts, "You take too much for granted."[16] Sarah and Hoggle are unable to

connect; they take one another for granted and underestimate the benefits of friendship.

Indeed, as part of Henson's critique of the consumerist culture in the United States, both Sarah and Hoggle engage in the transvaluation of consumer goods; instead of viewing consumer goods as possessing extrinsic, instrumental purposes as their proper value, Sarah and Hoggle desire goods for what they perceive as their intrinsic value, where consumer goods are valued as ends in themselves. When Sarah favors interacting with her toys, inanimate objects, over engaging with her family in the opening of the film, she reveals the perversity in valuing goods for their value as ends in themselves. Her choice to interact with her toys rather than her family demonstrates her inversion of her toys' proper value; this is the distorted state where relationships with inanimate objects hold greater value than relationships with humans. Likewise, Hoggle engages in the transvaluation of consumer goods in his discussions with Sarah about her plastic bracelet and his jewelry bag. When Sarah becomes lost in the labyrinth's oubliette, Hoggle is again reluctant to help Sarah find her way, so she persuades him by pointing to her plastic bracelet and saying, "If you help me solve the labyrinth, I'll give you this."[17] Like Sarah, Hoggle desires the bracelet, an inanimate object, more than human interaction. Instead of viewing the bracelet as possessing extrinsic, instrumental purposes (its proper value), Hoggle values the bracelet as an end in itself; he seems fixated on the bracelet and driven to gain possession of it. Just as Sarah reveals the perversity of inverting the proper value of toys in the scene in her bedroom, Hoggle reveals the perversity of valuing goods as ends in themselves when he longs for and later takes possession of the bracelet. This transvaluation of consumer goods continues when, later in the film, Sarah confiscates Hoggle's jewelry bag to persuade him to assist her in her quest to reach Toby.

Sarah and Hoggle's relationship grows into a friendship when Hoggle values connecting with others more than acquiring consumer goods. Like Sarah, he eventually rejects the transvaluation of consumer goods and embraces the importance of relationships with others. When Sarah tells Hoggle that he is her friend, Hoggle replies, "I like that. I ain't never been no one's friend before."[18] Indeed, after Sarah returns the jewelry bag to Hoggle, he demonstrates his friendship with Sarah by helping her solve the labyrinth without any further consideration of consumer goods. Like

Sarah, Hoggle realizes friendship is more important than amassing consumer goods.

OVERCONSUMPTION, JARETH, AND GOBLIN CITY

The antagonist in *Labyrinth* is Jareth, the goblin king who rules Goblin City. Jareth separates families, offers and takes away commodities from characters, and represents consumerism incarnate. Jareth offers Sarah a crystal ball, a consumer item, in exchange for her baby brother, Toby. Jareth also offers Sarah everything she wants if he can gain nearly complete control over her and her actions; Jareth says, "Just let me rule you, and you can have everything that you want." In response, Sarah rejects Jareth's offer of wealth and abundance by saying, "You have no power over me."[19] By rejecting the crystal ball and not allowing Jareth to rule over her, Sarah rejects consumerism and refuses to be controlled by the desire to possess material things. Instead, Sarah embraces the importance of relationships over consumption by rescuing her brother, valuing relationships with others, and rejecting Jareth. After Sarah rejects Jareth and his consumerist offers, the crystal ball and Jareth's castle disintegrate. This disintegration reveals the emptiness of consumerism and overconsumption.

Throughout the film, Jareth's kingdom is depicted as dusty and dilapidated; it is not the inviting, green, lush environment that Sarah enjoys in the opening scenes of *Labyrinth*. Instead, Jareth's castle is a decrepit, dark, unhappy space and a shadow of a real kingdom's former glory. The castle and Goblin City reveal the emptiness and detritus of consumerism and the deleterious impact of consumerism on the environment. The environments in *Labyrinth* guide viewers' understanding of the connections between overconsumption, the erosion of relationships, and the negative impact of overconsumption on the environment. Henson further illustrates these connections when Sarah meets the Junk Lady in the junk world environment.

OVERCONSUMPTION AND THE JUNK LADY

Sarah encounters the uncomfortable truth that consumer goods contribute to the erosion of relationships and planetary ecology when she meets the Junk Lady in the garbage-filled junk world environment. The Junk Lady is unable to emotionally or physically connect with Sarah because of all the physical junk piled high upon her back. Indeed, when Sarah tries connecting with the Junk Lady by touching her, the Junk Lady barks, "Get off my back!"[20] The Junk Lady's pile of junk is an impermeable physical border of discarded consumer goods that isolate her from connecting with other living things. These consumer goods are a burden on her back that literally weighs her down and prevents her from standing upright and maintaining eye contact to connect with Sarah.

The Junk Lady represents the hyper-consumerist messages that saturate mass media. She behaves like a commercial by repeatedly advertising consumer goods to Sarah in an attempt to distract her from realizing her goal of reuniting with Toby and cultivating their sibling relationship. The Junk Lady tries to persuade Sarah that material goods are what she is looking for by leading Sarah into a junk world re-creation of her bedroom. Inside the bedroom, the Junk Lady urges Sarah to stay in her room with her piles of consumer goods and says, "Everything in the world you've ever cared about is all right here."[21] She piles consumer goods on Sarah's back in a desperate attempt to distract Sarah from fulfilling her goals of solving the labyrinth and connecting with her family by rescuing her brother.

The Junk Lady can be seen as Sarah's dark double, and the Junk Lady's reflection in the mirror foretells Sarah's future life if she continues valuing consumer goods over relationships. When Sarah gazes into her junk world bedroom mirror, she sees the Junk Lady, and the similarities between the two characters are striking: Sarah has heaps of discarded consumer goods on her back, just like the Junk Lady. Also like the Junk Lady, Sarah is bent over, unable to stand upright under the weight of her consumer items piled high on her back. Sarah's re-created bedroom, with piles of consumer goods, is similar to the Junk Lady's junk world environment of discarded consumer items. If Sarah does not transform her consumerist outlook and goes on prioritizing the acquisition of consumer items over the importance of meaningful relationships, she may transform

into the Junk Lady that she sees in the mirror of the junk world re-creation of her room.

Sarah begins to resist this possible dark consumerist future when she sees the consumer items and the Junk Lady's reflection in her junk world bedroom mirror. Looking at the reflection of consumer goods piled high on her back in her bedroom, Sarah exclaims, "It's all junk!"[22] This is a transformative moment for Sarah: she realizes the truth about the empti-ness of consumerism by viewing the junk world mirror's reflection of her bedroom piled high with consumer items. Sarah leaves the toxic, consu-merist junk world environment by throwing off the toys piled high on her back and smashing the mirror. Sarah's anti-consumerist behavior releases her from the physical and emotional weight of overconsumption and the Junk Lady's reflection. After Sarah rejects consumerism and the Junk Lady, the walls of her junk world bedroom crumble and reveal the junk world outside.

OVERCONSUMPTION, JUNK WORLD, AND THE ENVIRONMENT

Sarah's experience in the junk world environment in *Labyrinth* opens her eyes to the deleterious effects of overconsumption on communities and the environment. The junk world represents the junk mountain landfills in the United States and the socioeconomic conditions where people live in junk. Millions of the world's poor live in slums built in and around garbage dumps in places such as India, Indonesia, Mexico, and Guatema-la.[23] Henson shows audiences this grim reality where consumer waste takes up so much land that beings live in junk worlds piled high with mountains of discarded consumer goods.

The junk world environment in *Labyrinth* also provides a disturbing depiction of the deleterious effects of overconsumption on planetary ecol-ogy. The junk world illustrates the destructive effects of "consumer activ-ity on the planetary ecology," which Schor sees as one of the most critical challenges facing the world today.[24] This excessive consumer activity and its resultant waste is spreading globally and destroying the environ-ment.[25] Indeed, Humphery cautions that when overconsumption is left unhindered, nature will be subject to its "final, irrevocable destruction."[26]

In *Labyrinth*, this destruction is depicted in Jareth's dilapidated and decrepit kingdom as well as the junk world.

In fact, the junk world represents the dark underbelly of consumerism. Henson reveals the dark truth about consumerism that people do not want to acknowledge. In the junk world, Henson literally unearths the mountains of junk that can be found inside manicured, grass-covered landfills in the United States, which is the "overall largest producer" of waste. While the United States tries to render the detritus from overconsumptive lifestyles invisible, its waste remains in landfills and dumpsites.[27] These landfills and dumpsites are often located in underprivileged neighborhoods and communities.[28] Henson invites audiences to question where all of the consumerist junk goes and the environmental impact of this consumerist waste. The junk world visualizes the end result of hyper-consumerism. The junk world's inhabitants do not have one empty foot of space to enjoy. The inhabitants of the junk world live on top of each other and on top of each other's piles of junk. Henson's *Labyrinth* reveals that our discarded consumer goods eventually end up in our real and material junk world.

The junk world can be read as a metaphor for the locational dilemma of Western-style overconsumption. When Western disposal systems reach capacity, the garbage is routinely "shipped to other places, often far removed from producers and consumers."[29] The Global South habitually becomes the dumping ground for discarded Western consumer items. Indeed, the junk world in *Labyrinth* conjures up images of people living in expansive garbage dumps in cities like Mumbai in Boyle and Tandan's *Slumdog Millionaire* (2009).[30]

THINGS AREN'T ALWAYS WHAT THEY SEEM

"Things aren't always what they seem, so you can't take anything for granted."[31] Through the innovative use of puppets and visual effects in *Labyrinth*, Henson educates viewers of all ages about the deleterious effects of overconsumption on relationships and the environment. In *Labyrinth*, Henson employs cinema as a site of resistance against the dominant media's messages of overconsumption and challenges viewers to defy mass media and contemporary culture's pervasive messages of hyper-consumerism and conspicuous consumption.[32] Through his character-

ization of Sarah, Hoggle, Jareth, and the Junk Lady, Henson encourages audiences to embrace the benefits of genuine relationships over the isolation and unhappiness that are often associated with overconsumptive lifestyles. Using both character development and the dark, desolate, and dreary images of Jareth's castle, Goblin City, and the junk world, Henson encourages audiences to reflect on consumerist lifestyle choices, embrace the benefits of relationships over the accumulation of consumer goods, and think critically about the destructive impact of overconsumption on the global ecosystem.

6

WHO ARE THE PEOPLE IN YOUR NEIGHBORHOOD?

The Importance of Community on *Sesame Street*

Joseph J. Foy

We often hear the refrain that it is a good idea to "be yourself." This is an especially common phrase in children's programming, responding to the temptation that we might act differently than ourselves around others in an unhealthy attempt to conform. Like children's programming, philosophers have long been interested in the question of individual identity and authenticity (the word philosophers use to describe what it means to "be yourself"). Unlike children's programming, however, philosophical explorations of individual identity are sometimes critical of the conformist impositions of a community on people's freedom to be themselves.[1] This problem leads both philosophers and those who teach lessons to children to ask the same question: Is it possible to be authentic while also living in a community?

Jim Henson has an answer to this question for us. Through the use of puppeteering and characters that are defined by diverse identity attributes, Henson produced and developed shows that challenge the philosophical critique that community stifles authentic individual identity. Henson takes the opposite view. Rather than operating in a manner that is adverse to the individual developing and fostering a genuine sense of self, Henson's artistry suggests that community is actually essential in facilitating an individual's ability to explore and define her own authentic identity, and thereby discover what it means to "be yourself."

AUTHENTICITY: THAT'S THE WORD ON THE STREET

When it premiered in 1969, *Sesame Street* used a combination of live acting and puppeteering that brought together very unique characters into the formation of a community based on principles of mutual respect and a celebration of pluralistic difference. Themes of diversity and equality are in fact so strong in *Sesame Street* that in 1970 the state of Mississippi, Henson's birthplace, temporarily banned *Sesame Street* from the airwaves because of the strong messages of racial equality and interracial interactions on the show, arguing that such themes could confuse young people.[2] Though the show evolved from short, curricular segments to one that began to incorporate story arcs centered on the lives of people and characters living and working on Sesame Street, the goal of the show has always been to educate children through entertainment. The educational nature of the show focused on empowering children through the development of basic skills (literacy, mathematics, problem solving, etc.), as well as helping them foster a sense of personal awareness, responsibility, and value. Known as much for helping young people learn numeracy at the "Ladybug Picnic" and by following the silver ball in an animated pinball machine as it is for teaching letter recognition ("C Is for Cookie") and literacy ("Every Day Is a Reading and Writing Day"), *Sesame Street* also works to educate children on self-respect and an appreciation for diversity. Through memorable Muppet characters like Big Bird, Elmo, Grover, Cookie Monster, Bert, Ernie, Murray, Abby, and Oscar, as well as human characters like Gina, Bob, Gordon, Maria, Luis, Mr. Hooper, Chris, Leela, and others, children are exposed to concepts and introduced to values on a show that spans generations of audiences.

Research on the impact of regular viewing of *Sesame Street* on children through their development into young adulthood shows a strong correlation between the educational mission of the show and positive outcomes.[3] Citing numerous published and scholarly presented studies, Sesame Workshop touts research demonstrating that a group of Bangladeshi four-year-olds who watched *Sesame Street* had literacy scores 67 percent higher than those who did not, and frequent viewers of the show in Indonesia showed scores 15 percent higher than nonviewers on early cognitive skills tests.[4] In the United States, "American children who frequently view *Sesame Street* as preschoolers achieve high school grade point averages that are almost 16% higher than those who don't," and the

show also has a positive impact on closing achievement gaps in STEM disciplines.[5] Ultimately, the results are indicative that the combination of education and entertainment on *Sesame Street* has had a positive impact on cognitive development.

But what about the deeper philosophical messages related to community, identity, and self-worth? The goal of helping children develop as individuals within their communities is as much a goal of the writers and producers of *Sesame Street* as establishing fundamental academic skills. According to Jennifer Kotler Clarke, vice president of research and evaluation for Sesame Workshop, "Those of us at Sesame Workshop are continuing . . . to produce content to help children become self-confident, curious, life-long critical thinkers and responsible citizens of their homes and communities no matter their home environment."[6] From a philosophical perspective, it seems that *Sesame Street* is concerned with the empowerment of individuals to define themselves authentically, as well as the interaction of the individual within community. But are these dual goals compatible, or are they necessarily countervailing?

Philosophical considerations of individual identity and a genuine sense of self arise primarily out of Enlightenment traditions and liberal political philosophy that began to place a greater sense of importance on individualism and personal relationships within communities.[7] The Enlightenment (1650–1800) ushered in an age in which thinkers began to express high optimism for the possibility of humanity organizing itself in a manner that would allow individuals to optimally flourish and develop to their fullest potential. Articulating the relationship between the individual and the political system, therefore, became a priority for many philosophers like Thomas Hobbes (1588–1679), John Locke (1632–1704), Baron de Montesquieu (1689–1755), Jean-Jacques Rousseau (1712–1788), Thomas Paine (1737–1809), and many others who were prescribing various models of social, spiritual, and political life. As a result, Enlightenment thinkers emphasized the individual as a means for understanding the proper organization of community, which also resulted in the modern notion of individualistic conceptions of the self.

From these very early roots, there was a clear tension that emerged between the individual and community. At best, community was seen as a necessary evil to protect the inalienable rights all human beings possess by their very nature.[8] At worst, community imposed conventions that corrupted and enslaved the individual.[9] As the discussions focused on the

individual within community evolved, notions of the self emerged as independent and autonomously contained. Rather than being by-products of social and political organization, the self, as an expression of sovereign identity, was central to philosophical discussions about community. Thinkers like Søren Kierkegaard (1813–1855) ascribed a greater sense of autonomy to the individual subject who chooses for herself both who she is and who she wants to be, as well as how she interprets and understands the world. Choice, according to Kierkegaard, is what connects the individual to the world in salient ways. Rather than the important relationship of the self to the world comprising the rules and norms that govern community, the self is connected to existence through the important choices. Our choices, therefore, determine who we are, as the authentic self is a consequence of those decisions and actions. [10]

The concept of individual authenticity was expanded by thinkers like Martin Heidegger (1889–1976) and Jean-Paul Sartre (1905–1980), who embraced the notion that choices were central in determining the individual. Heidegger and Sartre see the self as being defined as both authentic and inauthentic in that the authentic self is an identity the individual freely chooses and accepts responsibility for, whereas the inauthentic is one in which we allow our identity to be chosen for us, thereby abdicating responsibility for our actions. For Heidegger, the human being has an identity that connects her past with how she chooses to project herself into the future. The authentic existence is one in which the individual chooses for herself, free from external imposition and forces of regulation, what she is and who she will be. The inauthentic self is one in which social forces impose a particular set of values not freely selected, and one in which the individual uncritically accepts the values without ever determining those for herself. [11] For Sartre, the authentic self is one in which every action that an individual performs is an expression of her identity. We choose to act in particular ways because that is who we are, and we own the responsibility for our choices. The inauthentic person is the one who assigns blame for her actions on external pressures or social forces operating on her. An inauthentic person accepts no responsibility for her choices because she ultimately feels as though she does not own or control her actions. [12] For both thinkers, then, there is an inherent tension between the collective values of society and the free choices of the individual.

LIFE ON THE STREET

If Heidegger and Sartre are correct, it is would be very difficult to be authentic if we are always bound to others in a community. Other philosophers have argued, however, that being in community helps individuals achieve a greater sense of self through participating in the events that define human existence. Without others in our lives, we would not have an opportunity to experience the instances of joy and grief that defines a human existence.

Aristotle argues in *Politics* that "a social instinct is implanted in all men by nature," meaning that individuals are naturally drawn to community and the formation of social relationships with others.[13] In fact, for Aristotle, ethics and virtue are discovered through interaction and are therefore born from community. However, in order to educate individuals on virtuous behavior and provide for their moral development, the community itself must be properly organized.

For Aristotle, the formation of a properly ordered community allows for the development of *koinonia* (meaning "association" or "a sharing in common"), a type of solidarity that defines a community based on affective friendship. Members develop a deep respect for one another and their capabilities despite their individual differences and unique traits. These bonds develop among the individuals living on Sesame Street, which leads to a type of harmony that Aristotle refers to as "concord"—a feature of friendship in which members of a community "have the same opinions about what is to their interest" when it comes to the larger, core questions and values of the community.[14] As Aristotle suggests about such a community, it need not find common agreement on all things, but ultimately the members' bonds will enable them to share a commitment to the public good of all and the creation of consensus around common values that allow for the flourishing of the individual (what Aristotle would refer to as *eudaimonia*, "the good for man"). In fact, Aristotle goes so far as to suggest that while a person could live a life in isolation, such an existence would not allow that person to be fully human.[15]

In line with Aristotle's philosophical consideration of community, examples of community advancing the individual in *Sesame Street* abound. In the 1988 season finale, the community of Sesame Street gathered to watch the marriage of Luis and Maria. Though marriage involves an interpersonal commitment between two individuals, the importance of a

communal celebration to Maria was made clear when she stood on the rooftop of her building at 6:30 in the morning, asking her friend Linda through sign language how everyone could still be sleeping when she was going to get married. Maria emphasized how meaningful the experience would be when her friends were all gathered to celebrate and witness the special commitment she and Luis were making to one another. Without the community to share that special moment, the event would not have been complete for Maria and Luis. It is through sharing the experience with the community that the event itself takes on a much larger meaning and a more expansive value. A year later, Maria gave birth to her daughter Gabriela (Gabi) in a hospital room filled with people and puppets all there to celebrate the arrival of the newest community member. Quite telling were Maria's first words to Gabi: "Little baby, I want you to meet all our friends." Luis then looked out to the room and said, "Friends, we'd like you to meet our little baby." Big Bird welcomed the baby into the community by telling her, "It is nice to meet you, baby Gabriela. Welcome to Sesame Street."[16]

Just as community is important for making more meaningful those celebratory events in an individual's life, it can also play an important role in helping the individual to heal in times of grief and loss. In 1983, *Sesame Street* lost one of its most beloved cast members, Will Lee, who played Mr. Harold Hooper. As the owner of Hooper's Store, the curmudgeonly but kind Mr. Hooper was beloved by all. Instead of recasting the role following Lee's death, the producers of *Sesame Street* decided to confront his passing directly with the goal of helping children learn to deal with loss. In the episode, the community gathers in memorial, sharing stories of joy and times they spent with Hooper. Big Bird, who becomes the personification of a child's attempts to deal with the sadness and hurt over the loss of a loved one, enters and wants to show Mr. Hooper the drawing he made of him. The members of the community help Big Bird confront the reality of Mr. Hooper's death, and also help him to see past his grief and into the ways in which he was improved through his special relationship with Hooper. Big Bird's drawing of Mr. Hooper still hangs on Sesame Street, an important reminder of the importance of friendship and community in loss and remembrance.

Perhaps the most prevalent example of how community can assist in the development and complete actualization of the individual is in the way that it can sometimes help individuals see through detrimental or

harmful choices that stifle their growth, helping them to achieve their fullest potential. The kind of affective community Aristotle articulates is one that has a concern for the individual for her own sake. At times, the individual may make choices about her life that are harmful. The community that has a deep concern for the individual will ultimately work to help that person see the harmfulness of her choices and help her to work through different choices. Though it may seem as though the community is stifling the individual's authentic choice, if the individual could make a more fully informed choice, she would see that her potential flourishing is being subdued by the detrimental acts in which she is engaged. Once her preferences are redirected, she can actually become more of who she is and wants to be than if she had not had the community there to help her see through her own harmful choices.

An example of the community helping the individual to achieve a fuller, personal flourishing is in the introduction of the Television Monster in 1979, who later became the beloved "Telly." When we first met Telly, his spiraling eyes needed to be permanently affixed to the television. He rushed through Hooper's needing to get "plugged in." Television was an addiction, and it was keeping him from developing other faculties and aspects of himself. When Mr. Hooper and David approach Telly Monster, he does not engage them at all other than to tell them to be quiet because he is "glued" to the television. Later, David and Olivia try to get him to play baseball with them and he won't leave his TV behind, and the only "m" words he can think of are titles of television shows (like *Muppet Show*). However, the community does not give up on trying to get him to engage in a world outside the television. When Telly makes other appearances later, they seem to have been successful in reaching him. He plays his tuba, has a deep friendship with Baby Bear, and is a full member of the community. Had he been left to his own devices, Telly would not have known a world beyond his television set (with the cord that only stretched three blocks). With the help of the community, though, he got to experience a richer, fuller life with greater opportunity at making meaningful choices with his life.

Countless more examples of community helping in the development of the individual appear throughout the many seasons of *Sesame Street*. When there is a fire in Hooper's store and Elmo becomes too frightened to enter the store again, Maria and Alan help him to face and overcome his fears. When Stinky feels like he isn't beautiful before the flower

show, Leela helps him understand how important it is to be himself and how unique he is as an individual. When Prairie Dawn seeks to gain journalistic experience, she is given an opportunity on *Monster News Network* despite not being a monster (and only being seven years old). When Chris finds Leela is homesick for India, he turns Hooper's Store into an Indian getaway for her and presents her with a rakhi bracelet to show her how much he respects and cares for her. An affective community built on principles of respect, pluralism, and harmonious concord helps to advance the individual in ways she could not accomplish absent community. *Sesame Street* reaffirms the importance of community as it relates to the individual in a way that might better help us to understand the positive aspects of community as it relates to the authentic self. Rather than always existing as an adversary, community can sometimes help foster a richer sense of self.

C IS FOR COMMUNITY

Sesame Street provides us with reasons to consider community as an empowering force in helping to advance the individual, helping her unlock her potential in a manner that would not be possible in isolation. Yet, when we consider our own world, the tensions between individual identity formation and the pressures of communal normativity are ever present. The question is: What lessons can we learn from *Sesame Street* that might shed light on the relationship between authenticity and community?

With an emphasis on a respect for pluralistic difference and the importance of each individual,[17] Sesame Street is a community wherein the self is allowed to flourish in an environment that is fostered by the concord of an affective community. The attempt of everyone on "the Street" to support and nourish one another with a care that extends to their authentic core highlights the critical aspects of community articulated by thinkers like Aristotle millennia ago. Carrying that philosophical tradition into the present day, *Sesame Street* shows children that "being yourself" also means seeing a community for what it should be.[18]

Part II

Thinking Like a Muppet:
Epistemology and Logic

7

FINDING FALLACIES FUNNY

How *Sesame Street*'s Playing with Mistakes in
Reasoning Makes Learning Fun

Sheryl Tuttle Ross

In the first *Muppet Movie,* during the scene where Fozzie Bear and Kermit the Frog are singing "Movin' Right Along" while driving across the country to make it big in Hollywood, they see a very large yellow bird and ask him if he wants to join them on their travels. Big Bird responds, "I am on my way to New York City to try to break into Public Television." Big Bird's hopes and dreams were realized by his creator, Jim Henson, who invented a new genre of television programing in the early 1970s—one that insists that audiences are critically engaged with the material. *Sesame Street* broke the mold, as it captivated the attention of its preschool audience and their caregivers alike. The show is much more than simply capturing children's theater on film; it uses filmmaking techniques inherent in the artistry of the moving image and, as such, rewards watching as good television. It is also fun to watch because it uses the humor of fallacies or mistakes in reasoning both to entertain and to educate.

The aim of this chapter is to combine informal logic with the philosophy of humor to demonstrate how a variety of informal fallacies are used rhetorically to elicit laughter at the incongruities on screen as well as a laughter that creates a sense of superiority or mastery of the world. Thus, how we understand what we find funny in the *Sesame Street* franchise will go some way in identifying how fallacies—spoken, written, and

visual—contribute to the educational value of the show. They do so by making the children in the audience feel like experts and by keeping the parents tuned in as they are cued into culling the material for its adult references. In short, *Sesame Street*'s playing with fallacies has made learning fun for generations of adults and their children.

THE GROUNDWORK: LOGIC AND PHILOSOPHY OF HUMOR

The cornerstone of philosophy as a discipline is logic. One might think of it as the basic dance moves that allow a thinker to choreograph ideas into theories and allow the audience purchase into how the thinker puts together answers to philosophical questions big and small. In other words, logic is what turns ideas into arguments and arguments into philosophical theories. The arguments themselves are given names like *conditional argument, causal argument, argument by analogy, inference to the best explanation*, and *dilemmas*. For every argument, there are numbers of ways a thinker may be led astray.

Fallacies are simply mistakes in reasoning, and given that there are some reliable patterns of mistakes thinkers make, there are names given to specific kinds of errors in reasoning. So when someone says, "The side of a river is a good place to store money, because it is a bank," it is a *fallacy of equivocation*, or using the same word with two different meanings in an argument. Another fallacy, a *category mistake*, occurs when things of one sort are presented as if they belonged in kind. So if a disappointed little girl responds to the question, "What did Santa bring you for Christmas?" with the word "upset," she is making a category mistake, as Santa does not bring emotions—he brings toys. *Appeals to authority* are fallacies if the person who is appealed to does not have any special knowledge that should be brought to bear on the situation. The *slippery slope* fallacy or *catastrophizing* fallacies are mistakes about the causal nature or consequences of a situation, predicting the end of the world as we know it. Sometimes when people make these sorts of mistakes it can be a source of amusement or just plain funny. We will identify these fallacies as we discuss particular scenes from *Sesame Street*, and in doing so the examples will help us as we survey the leading theories of humor in order to understand how the human heart and mind

are amused. In true philosophical fashion, the analysis of what we find funny in *Sesame Street* will have the power to revise the prevailing theoretical accounts of humor.

There are different accounts of what makes something funny or humorous, with the main theories being the Superiority Theory, Incongruity Theory, Relief Theory, and Playful Relaxation Theory.[1] While each of these theories has paradigmatic features, they do not represent mutually exclusive options—that is, a particular instance of humor may be explained well by more than one of these theories, and not all instances of humor can be explained by one of the theories alone. However, it is useful to rehearse the major features of each brand.

The Superiority Theory

The Superiority Theory traces its origins to Plato, who is at best ambivalent about the arts, but particularly troubled by art's capacity to represent the world falsely. In addition, laughter was suspect for Plato because it signaled that an emotion has overridden the rational part of the soul, and in Plato's book rationality should always be king. While there is a pleasure in laughing, Plato reasons this pleasure comes at a price of malice toward others and ruins the prospects of a just society.[2] Hobbes likewise believed laughter is an expression of the superiority of oneself over others or at the defects of others. He thought that a great mind need not prove itself superior by comparing itself with the weakest; instead, it should be measured against the strongest or an ideal. Hence humor and its signature laughter have a negative connotation under the Superiority Theory; as such, it does not seem to have much to recommend it for the purposes of children's educational entertainment. In response, we might revise the notion of superiority to involve mere competition and not necessarily malice because competition is necessary to the notion of superiority, whereas malice is not. The Winter Olympic Games clearly involved competition, and the gold medal winners were deemed superior, but good sportsmanship demands that such superiority not involve malice.

There are some *Sesame Street* sketches that seem to traffic in nonmalicious superiority humor. For example, in the episode "Still Life with Cookie," Cookie Monster sees a bowl of fruit that he wants to eat, but Alan explains he is painting it. Alan offers to teach Cookie Monster how to paint. He sets up an easel next to him, helps him think of what to paint

(a cookie from memory), and explains how to make the color brown by mixing red and green paints. One running joke occurs as different neighbors walk past the two painting, Cookie Monster and Alan, with their backs toward each other. We see Cookie Monster holding a paint brush next to a canvas, seeming to scribble all over it; by relying on the *Kuleshov Effect* (which takes place when an audience assumes that two film sequences occurring one after the other in time also represent continuous space), we next see a photorealistic painting of a cookie. Hence, it is easy to assume that it is Cookie Monster's work and that it looks a lot better than Alan's painting. The neighbors passing by always compliment Cookie Monster's painting even though Alan, given the scene setup, is the expert and Cookie Monster the novice. Over the course of the scene we witness an increasingly jealous Alan, who is rebuffed continually when he mistakenly accepts the compliments meant for Cookie Monster. Moreover, Cookie Monster's expert craft is contravened by his eating (and thereby destroying) his masterpieces. There is an element of superiority in the fact that Cookie Monster is ironically a better painter than Alan, but this superiority does not involve a trace of malice. The humor is also aided by a category mistake: when one consumes art, one does not literally eat it. Cookie Monster sings a song about his paintings being good enough to eat, humorously invoking a category mistake.

Further in the scene when Cookie Monster is asked to make a painting with designs, he responds, "Oh, me get it, art for art sake." This mantra of Modernist paintings appeals to the superior knowledge of the parents and other caregivers. At the end of the scene, Cookie Monster has an epiphany: his painting is "way too good to eat," and there is a special feeling one associates with beautiful art. One celebrates Cookie's mastery of his appetites, which makes him superior to his earlier self.

The contention that the Superiority Theory must involve malice is not the only problem with how Plato and Hobbes describe humor. Plato's version presupposes that reason and emotion are wholly separate and incompatible parts of the soul. This is no longer the reigning theory of the mind, as it has been revisited and revised. A Cognitive Theory of the emotions contends that all emotions have some underlining meaning or semantic content that gives rise to the emotion.[3] For example, we are fearful when we think we are in danger or angry when we have been treated unfairly. So if we presuppose a Cognitive Theory of the emotions, and if we reframe the object of superiority in humor, then, instead of the

spectator expressing malice toward the butt of the joke, the spectator is really laughing in recognition that he has mastered the requisite knowledge to find the joke funny. This modification of the Superiority Theory holds more explanatory potential for the humor found in *Sesame Street*. It helps to explain why watching *Sesame Street* is amusing for both children and adults, turning the acquisition of knowledge into a game, and in this game everyone who pays attention can win. The reward is the chuckle or the full belly laugh one gets from decoding the cues on screen.

In a scene called "Celebrity Lullaby," we find that Elmo is having a hard time falling asleep. The comedian Ricky Gervais asks Elmo if he would like to be sung to sleep by a celebrity. The setup of this sketch invokes the fallacy of an appeal to authority, as celebrities are not experts in the field of curing insomnia. Elmo replies, "Sure," but then wonders which famous person he will get to sing him to sleep, hoping it will be Brad Pitt because "Elmo loves Brad Pitt." Ricky responds, "It is me, Ricky Gervais." Elmo asks, "Is Mr. Ricky Gervais a celebrity?" This question is a send-up of Ricky Gervais, an example of the Superiority Theory of humor. Gervais responds defensively, "Of course I am, or else Celebrity Lullabies wouldn't have hired me." Elmo responds that he doesn't care if Gervais "is a celebrity or not." With an air of agreeing to disagree, Gervais begins to sing a song about the letter "N." The sweet sound of the verse changes to a rocking chorus consisting of very loud singing of Na, Na, Na. The incongruity of the verse with the chorus as well as the chorus's being completely at odds with the purpose of a lullaby is funny. Part of that humor is the self-deprecating, faux outrage of Ricky Gervais, and another part depends upon the central insights of the next theory.

The Incongruity Theory

The Incongruity Theory posits that what makes something funny is its ability to disrupt our assumptions about the proper relationship among concepts and ideals. Immanuel Kant, Arthur Schopenhauer, and Søren Kierkegaard are all philosophers who have embraced this view.[4] The underlying idea is that some things go together like peanut butter and jelly, while others simply do not. Human experience is made possible by identifying patterns and learning from those patterns. The Incongruity Theory suggests "the cause of amusement is a discrepancy between our

abstract concepts and our perceptions of things that are instantiations of those concepts."[5] When Bert asks Ernie why he has a banana in his ear, and Ernie responds that he can't hear Bert because he has a banana in his ear, we find it funny because bananas are for mouths and not ears. Again we find humor trading on a category mistake. An example of a visual version of incongruity is in *Elmopalooza*. Jon Stewart, the would-be host of the show, sees the letters *R*, *E*, and *M* move past. Stewart remarks, "Oh, there goes REM, I wonder if U2 are here too." The fallacy of equivocation occurs as the visual refers to the actual letters but the spoken word refers to the names of two popular bands.

The Incongruity Theory offers an important explanation of the power of *Sesame Street*, as educational psychologists describe concept acquisition as one of the main cognitive activities in the first five years of a child's life. One way of doing so is being capable of identifying when a concept is misused, as it entails a refining of the ability to identify when a concept is used correctly.

The Relief Theory

The Relief Theory is compatible with the Incongruity Theory, since laughter simply functions as a release of nervous energy that builds up from the experience of an unnervingly incoherent mental picture of the world. It is also consistent with the Superiority Theory, which suggests one's elevated social status is relevant to finding something funny because the Relief Theory describes the consequences of finding something funny whereas the other theories describe the relationship between the world and the one who laughs. That is, the difference is between what makes something funny and why it is that we laugh when we find something funny. Herbert Spencer and Sigmund Freud are the theorists most frequently associated with this view.[6] For Freud, laughing at jokes expresses pent-up hostility or sexual desire that social forces repress; in a similar account, Spencer maintains that "the excess nervous energy that is relieved by laughter . . . is the energy of emotions that have been found to be inappropriate."[7]

It would be positively strange if it turned out that *Sesame Street*'s humor was so successful because of its potential to relieve aggression or repressed sexual desire, particularly given that the theory of the mind presupposed by Freud and by Spencer no longer holds any currency.

However, we may recast this notion of "relief" as the relief that the way we think and feel is not unique. We all feel anxious and overwhelmed at some time or another. In an existentialist twist, we may think of this as laughing at the absurdity of the human condition, which provides relief.

At the beginning of *Elmopalooza*, Telly Monster commits the slippery slope fallacy and the fallacy of catastrophizing when he worries about Jon Stewart being trapped in the dressing room. Telly Monster worries, "Oh no, if they cannot get out, then there will be no show; if there is no show, then people will be sad; if people are sad, they might not go to work tomorrow; if they do not go to work, the economy will collapse; if the economy collapses, the country will be doomed." We find this funny because we have all been in circumstances when our minds leap to the worst possible outcome. We smile because we recognize ourselves in Telly, and it confirms the relief one experiences when one is among friends and feels securely part of the greater human community. The scene confirms this relief, as it ends with Elmo suggesting that they put on a show themselves "because Elmo wants to fix his mistakes, and because Elmo wants his own trailer." We can laugh at one of the mistaken reasons for Elmo wanting to host the show, and we can laugh with Telly Monster because we are relieved that others sometimes share the catastrophizing dread inherent in the nature of our existential condition. It would be the same sort of relief one feels upon coming home, as our experiencing laughter puts us at ease. The recast Relief Theory shares the same outcome as the next theory; however, the recast Relief Theory posits the unnerving existential condition as its basis for relief, whereas the Playful Relaxation begins with what is useful for a flourishing life— play and relaxation.

The Playful Relaxation Theory

The Playful Relaxation Theory provides an apt contrast to the Relief Theory. Aristotle considered having a good sense of humor to be a virtue, and Aquinas similarly found that there was a sin in both playing too much and playing too little. The idea is that humor is not a contrast to reason, but rather a counterpart to it. Not all humor has qualities to recommend it for general consumption. Aristotle's Doctrine of the Golden Mean, which governs all of the ethical virtues, requires that when we laugh, we must have these appropriate feelings at the right times on the right occasions

toward the right people for the right motive and in the right way to have them in the right measure—that is, somewhere between the extremes, and this is what characterizes goodness.[8] The relational quality of the Golden Mean entails that when we want to figure out whether someone's laughter is a playful laughter, we must identify the relationship between the laughing person and the object of the laughter, assessing the appropriateness with reference to its degree of funniness and the rhetorical situation that gives rise to the laughter.

We may find the situation simply funny, as when Usher sings the ABCs with other Muppets, because it is a playful contrast to his other, more explicit works. Part of the playful relaxation occurs with noticing the wordplay involved in some of the sketches. In an episode of "Super Grover 2.0," a scene begins with the words "At a rodent restaurant in Redhook, one mouse is about to face a cheesy problem." The alliteration of "rodent," "restaurant," and "Redhook" is clever.

The power of this theoretical feature is that one and the same scene can be appropriately funny for different segments of the audience for wholly different reasons. So when the comedian Chris Rock is told not to tell any dirty jokes, and Rock responds that it is too bad because the audience would love his mud jokes, this is funny for the preschool set because the idea of mud jokes sounds funny, whereas for adults who have heard Rock's stand-up routines, the phrase "dirty jokes" means something entirely different, and it's funny because of its latent meaning.

Another example of playful humor occurs in *Elmopalooza* when Prairie Dawn reminds the would-be host Jon Stewart to remember to thank the sponsors. Jon obliges by rehearsing, "Yes, we would like to thank our sponsors 2 and 3." Prairie chastises Jon, saying, "What, you didn't get the memo? 2 and 3 pulled out, but we were lucky to replace them with 6." Jon's witty reply—"Well, if you ask me, '6' is worth more than 2 and 3 put together"—is funny for all in the audience who can decode the wit of the actual numbers and their value as related to the value of numerical sponsorship. It makes a playful jab at the advertising- and consumer-driven realities of mass media. Fallacy of equivocation, where one phrase has two different meanings, is a key part of making this funny.

CONCLUSION

The good-natured humor in *Sesame Street* makes watching the series both fun and educational for children and adults. By rehearsing and revising the four prevailing theories of humor, we are able to better appreciate the educational potential of the show, and we are able to treat *Sesame Street* as an occasion to do philosophy by making the prevailing theories even better. We have Jim Henson to thank for this opportunity because he believed in the power of television as an expression of creativity and as an opportunity to increase learning and language acquisition in the preschool population. By creating a show that appeals to audiences of both children and adults, the thrill of discovery occasioned by the many varieties of humor employed has changed the course for the better of educational television for all who have followed.

8

I SAW MEMORIES OF YOU

Can Dreamfasting Teach Us about Introspection?

Lauren Ashwell

To find out whether you want to watch *The Muppet Show*, or are happy, or believe that there is a monster at the end of this book, I have to observe your behavior and work out what you want, feel, and believe. Maybe I can tell that you want to watch *The Muppet Show* because, after looking up the TV listings, you turn on the television just when it starts. Perhaps, as Kermit explains in his lecture on feelings, I can tell that you're happy because you're smiling.[1] Or maybe I know that you believe there is a monster at the end of this book because you keep warning me that there is. But to know my own mental states I don't—at least usually—seem to require inferences from observations of my own behavior. I don't have to wait to hear myself humming "Mahna Mahna" or wait to hear myself say, "Gah! I've got 'Mahna Mahna' stuck in my head," to figure that out. We can come to know what we are thinking and feeling in a way that feels quite distinct from how we come to know about others' minds. Instead, we find out what we believe, think, and feel through introspection.

While humans have to look to behavior (including verbal behavior) in order to work out what is going on in another person's mind, the Gelflings in Jim Henson's *The Dark Crystal* have a special way of accessing another's mind directly: dreamfasting.[2] On his quest to heal the Dark Crystal, Jen—who thought that he was the last surviving Gelfling after the Garthim wars—meets another Gelfling, Kira. When their hands touch, they accidentally become dreamfasted. Through dreamfasting,

they become aware of each other's memories: how Jen's village was destroyed in the Garthim wars, and how he was subsequently taken in and educated by the urRu; how Kira's mother hid her from the Garthim, and how she came to meet and live with the Podlings. Dreamfasting allows two Gelflings to share memories, without speaking or using any of the other means through which we usually share memories. In many ways, dreamfasting seems a lot like how we find out about our own minds, even though it is a way to find out about another's mind. That is, it seems in some ways quite like introspection.

But in many ways dreamfasting and introspection also seem quite different. Dreamfasting is a second-personal ability—through dreamfasting you can find out about another's mind, not your own—not to mention the fact that it is an ability possessed by purely fictional creatures. Introspection, however, is a very familiar, although very hard to describe, first-personal method for finding out about your own mind, and not others'. As I will explain, it is precisely these similarities and differences that make dreamfasting relevant to the question of how introspection works.

THE DISTINCTIVENESS OF INTROSPECTION

As well as teaching us important things like how to count, spell, share, and cross the street, *Sesame Street* even discusses introspection. Farley, a very philosophical young puppet,[3] sings about the distinctively first-personal nature of introspection in his song, "Figure It Out!":

> I had a friend who lived next door but his family had to move.
> It made me mad, or maybe sad, or maybe just confused,
> So naturally I asked my friend to look inside my head,
> And tell me how I really felt—but he told me this instead:
> He said, "A friend can do a lot of things that no one can do better,
> Like give a friend a friendly hug, or write a friendly letter,
> But the one who knows the things you feel is you and nobody else.
> A friend can't tell you how you feel, you have to tell yourself!
> Figure it out!"[4]

Now, Farley's friend holds an implausibly strong view about our knowledge of other minds (of course a friend can know how you feel—that is why they sometimes just know when you need a friendly hug). However, it does seem like we know our own minds in a way that is distinctively

different from how our friends come to know things about our minds.[5] Perhaps Farley's friend's claim is this: In order to find out about your own mind, you should introspect, as introspection is a better way to find out about your own mind than any other—including asking your mom or your friend. If you can figure it out on your own, then that's the best thing to do.

The idea that introspection is the best way to find out about your own mind is central to most philosophical discussions of introspection, which often start with the assumption that knowledge arrived at by introspection has a particularly special status relative to all other ways of finding out about the mind. Introspection supposedly is, in some sense, the best way to find out about mental states like thoughts, feelings, and desires. Philosophers call this having "privileged access" to our own minds.[6] It is generally accepted that any satisfactory theory of introspection ought to explain how we have privileged access to our own minds.

Examples that are similar to dreamfasting have been used by philosophers to argue against particular models of introspection.[7] The possibility of dreamfasting, and of some other hypothetical ways of knowing another's mind, puts pressure on many of the purported explanations of the privileged nature of introspective knowledge. The problem is that dreamfasting shares with introspection many of the qualities that have been thought to explain the privileged nature of introspection, without dreamfasting appearing to be privileged in the same way. Below I will discuss two versions of this kind of argument. The general structure of this kind of argument is as follows: Given a purported explanation of the privileged nature of introspection, see if you can imagine a second-personal method of finding out about the mind that has the supposedly explanatory feature that is just as (or more) privileged as introspection. If you can, then introspection's possession of that feature cannot be the correct explanation of our privileged access to our own minds.

PRIVILEGE THROUGH DIRECTNESS

Why might introspection be the very best way to find out about your own mental states? Perhaps because other methods of knowing about mental states involve inference from evidence, while introspection is more direct. When I want to know whether you are happy, I look at your behavior and

try to figure out your feelings from that. But there are lots of steps involved in this inference, and lots of places where I might go wrong, even in such a simple example. I might mistake your grimace for a smile. I might notice the smile, but fail to draw the conclusion that you are happy. Smiles are also not perfect evidence of happiness (although they might still generally be good evidence). In contrast, introspection doesn't seem to involve reasoning from evidence. Thus there are fewer steps in introspection for things to go wrong. So perhaps the directness of introspection might explain its privileged nature.

However, there is nothing to prevent a method for knowing someone else's mental states from being similarly direct.[8] In fact, dreamfasting seems to provide just such an example. Jen takes Kira's memories at face value—he doesn't seem to using reasoning to get to the belief that these are her memories. If he is doing any reasoning, it seems only to be inferring from the apparent memories to beliefs about what happened to her in the past. Similarly, when we experience our own memories, the only evidential reasoning we appear to be doing is from the memory experience to the existence of these past events in our lives. So dreamfasting and introspection don't appear to be different in their relative directness—thus directness can't explain the privileged nature of introspection.

One might object that in order to have the right to trust dreamfasting, you need to know something about the external world—you need to know that you're on Thra and not on Earth, and that you're someone with the ability to dreamfast. Perhaps this information, despite appearances, is being used by Jen in coming to believe that these are Kira's memories. But, this objection continues, we don't seem to need any such knowledge of the world in order to trust introspection. If we don't need to know that introspection works in order to generally trust it, but we do need to know that dreamfasting works in order to trust it, then our right to trust in dreamfasting would rest on this information. This makes it look like inference might be involved in having the right to trust dreamfasting—if you need to have good reason to believe that you are dreamfasting, and that dreamfasting is a good way to find out about the memories of others, then the beliefs that you gain from dreamfasting would rely on this information. And with this lack of directness, we get potential gaps where things could go wrong—maybe you think you are dreamfasting but you aren't; maybe you think that dreamfasting is a good way to find out about others' memories but it isn't.

Yet if you are persuaded by the objection that trusting dreamfasting might require this kind of extra information, you should pause for a minute to wonder why introspection doesn't need a similar kind of information in order for us to trust it. We might equally wonder if, although our trust in introspection doesn't *seem* to involve relying on extra information, it might. Introspection does seem to require some kind of intellectual effort, and that effort might be a kind of reasoning. After all, Farley's friend does tell us to "figure it out" through introspection.

Moreover, although it is certainly the case that directness means there are fewer chances for things to go wrong, it isn't entirely clear how that kind of directness would automatically give us privileged knowledge. Suppose Gonzo just "intuits" the answer to a math problem, while Sam takes the time to carefully work out the answer. Gonzo's path to the answer is more direct than Sam's, but this doesn't mean that Gonzo's knowledge is more secure or better—in fact, it seems much worse. So directness—or, at least, directness alone—doesn't explain the kind of privilege that introspective knowledge supposedly has.

PRIVILEGE THROUGH RELIABILITY

Here's another suggestion: introspection gets to have the high degree of privilege because it is incredibly reliable. Once upon a time, it was even thought that introspection was 100 percent reliable. If I believe that I'm thinking about Kermit the Frog, how could I be wrong that I'm thinking about Kermit? Thus, many philosophers claimed that you couldn't make mistakes about your own mind, and some even went as far as saying that you knew everything going on in your mind. But nowadays a claim this strong doesn't seem plausible. The idea that we can fail to know things about our minds, and even make mistakes about our own minds, is all too familiar. Even Muppets make this kind of mistake: at the end of *Muppets: Most Wanted*, some of the Muppets remark that Constantine (The World's Most Dangerous Frog) offered them what they thought they wanted most—however, they admit, they were wrong.[9] You can be confused about whether you *believe* that the Great Gonzo will successfully complete his motorcycle jump, or whether you merely *hope* that he will. And you can be confused, as Farley was, about whether you are mad, or whether you are sad—or maybe both—about your friend moving away.

Once we recognize that introspection isn't 100 percent reliable, however, we see that reliability can't be the explanation for why introspection is a privileged way of finding out about your mental states. There is no reason to think that a process like dreamfasting couldn't be more reliable than introspection. If dreamfasting could be more reliable than introspection, then someone else might have better access to your mental states than you—you would no longer have the best way to access your own mind. Introspective knowledge would no longer be peculiarly special in the way many philosophers assume that it is.

RETHINKING PRIVILEGE

Now, for all I have said, there may be other features that introspection has and dreamfasting does not and that could potentially explain introspection's relative privilege. But note that we can run similar arguments for other putatively explanatory features; for example, privilege isn't explained by naturalness (dreamfasting could be a natural ability, as indeed it appears to be for the Gelflings).[10] So maybe we should take a moment to consider whether we started with a faulty assumption—perhaps we should give up the idea that introspection is privileged relative to all possible ways of coming to know things about a mind. After all, we already know that we aren't perfect in coming to know our own minds; we, like the Muppets, can be confused about what we want or feel,[11] so it seems conceivable that there could be some way—like dreamfasting— through which someone else might know our minds better than we do.

One upshot is that we can't use the quality of access we have to our own minds to draw the line between our own mind and the minds of others. Even if Kira has better access to Jen's memories than he does, they would still be Jen's own memories. Yet it isn't clear in any case that we should have expected a theory of introspection to be able to make the self/other distinction. Another consequence is that we also might have to accept that others, were they to have better access to our own minds than we do, could better inform us of our feelings even when we try to use introspection to figure that out. Maybe in some possible world Farley's friend could look inside his head. If that were the case, introspection might not be as relatively privileged as philosophers assume, but perhaps that's OK.[12]

9

BREAKING DOWN THE WALLS

Experience and *MirrorMask*

Michael J. Muniz

Imagine, if you would, being imprisoned in your own bedroom. All four walls, the floor, and the ceiling are completely sealed. The way out is sealed shut. You're trapped! So what do you do? Perhaps you could turn on the TV and watch a movie. Or you could sit at your computer and write all day long about the mysteries of the universe. Or you could draw like there's no tomorrow. Create an entire world using your imagination. Use every page to cover up your walls and see your creation displayed before your eyes. What if you could travel to your drawn-out imagined world?

This trapped bedroom scenario may not be as unreal as one might think. Consider another type of "trapped" room: the movie theater. In addition to being closed up, it becomes pitch black when the lights turn off. Although you know how you got there, you don't know what's going to happen next. When the sound of the projector behind you is heard and a bright light appears on a screen in front of you, you're experiencing the illumination of the fourth wall—the barrier between our world and the world drawn from someone's imagination. In philosophy, there is a method by which we can understand our moviegoing experience. It's called phenomenology. I know that's a big word, but in short it basically means the study of experience. We experience reality through our own set of lenses (e.g., our senses). We know that certain things are quite possible, and certain things are absolutely not.

The idea of the fourth wall is most often associated with the theater, where stage performers pretend the audience doesn't exist. They create an invisible barrier between themselves and the audience. The fourth wall is broken when performers acknowledge the audience and include them in the performed story. So, this begs the question: Is it possible for movie characters to break the fourth wall and interact with us, the viewers?

THE FOURTH WALL AND *MIRRORMASK*

As the opening credits of *MirrorMask* roll, we see a young girl play with sock puppets. She provides a fictional dialogue between the two puppets about a queen who is overly protective of her daughter, the princess. The princess rebels and they "fight" as the two puppets are roughly pressed toward one another. By the time the opening credits end, we realize that the young girl is in the bedroom of a small trailer. She is interrupted by the knock on the window. It's her mother telling her that she's about to perform on stage. In an instant we are told that our main character is Helena, daughter of Morris and Joanne Campbell, circus managers. The plot of the film is thus set in motion. Rather amazingly, in just a few minutes the general themes and motifs of the entire story are revealed. Given our circumstances and our reality, how are we different from Helena interacting with her own imagination? Helena's role as "puppet master" is a display of certain barriers that exist between our world and our imagined worlds. Haven't we all sat at the edge of our seat in movie theaters, talking to the screen, perhaps to tell the character in peril to "get out" or "don't go upstairs"? Maybe we somehow believe that there's a slight chance that they might hear us . . . or at least we hope they do. But we sit back and realize that our talking to the screen is meaningless because the story is going to play itself out as it was intended to by the filmmakers. The filmmakers are the "puppet masters" who have created an imagined dialogue, an imagined world for our entertainment.

Interestingly enough, the makers of most movies try to incorporate the breaking of the fourth wall by allowing certain characters to look directly at the audience. In reality, it's an actor looking directly into the camera. The issue of whether *MirrorMask* breaks the fourth wall is rather important. Although there are brief moments in the film where certain characters actually look directly at us, thereby breaking down barriers between

fantasy and reality, there are many more moments throughout the film where the idea of barriers is represented. After Helena travels into the world of masks, or Dark Lands, she becomes involved with various characters, particularly Valentine, who guides her through this inferno of the bizarre. Her quest to find the MirrorMask to save the Queen of Light ultimately brings her to the realization that her presence in the real world has been replaced with an Anti-Helena—a rebellious teenage girl who brings mischief and chaos to her family. Quite often throughout the film, there is a window along the path through which Helena can peer into her real world. When she taps on the window, the point of view of the story shifts and we see that Helena is behind glass in one of her many drawings that cover her bedroom wall. As movie watchers, we realize that Helena is inside the world of her own drawings.

IMAGINATION AND STORY

Let's do some more imagining. Imagine going to an aquarium in some major coastal city. You pay your fee, and you enter a maze of exhibits before finally arriving at a dark, cavernous room with a large, thick pane of glass. On the other side of this glass is a world in which a variety of creatures swim nonchalantly by. You gaze at the living creatures and plant life. Are you aware of the fact that only several inches of thick glass separates you from them? Can you ever be a part of their reality?

Going to the movies, to continue the metaphor, is a type of aquarium experience. We gaze upon a screen that displays moving images. Or we stare intently at beautifully drawn worlds and characters. Think of the flying books and other creatures "swimming" through the air in *Mirror-Mask*. It is as if the screen magically became a window. We now become a conscious observer as opposed to an unaware spectator. Yet, when it comes to movies, the same questions arise from the aquarium experience: Are you aware of the fact that you are actually looking at a blank wall when watching a movie? More important, can you ever be a part of that world? If *MirrorMask*, as well as any other movie, is like a circus, then how do filmmakers remove the fourth wall (if they even do)?

Often, when watching movies, particularly those that trigger emotional responses, we tend to suspend our beliefs about our reality for the duration of the story. This suspension is an attempt to escape from our

present reality so that we can enter another. It's like when Helena used to stare at her drawings before she entered them. She represents who we are as movie watchers. We are actually staring at a blank screen with light flashing images before our eyes. But somehow we perceive that we are watching moving images as if a fantastic world lies beyond our reach. Sometimes, when the movie is really good, we desire to reach into it. This desire is called cinematic possession. We become possessed (even if only for a moment) by the realism and attainability of the fictional world.

Some movies even go so far as to provide technological aids to make the reach even more attainable. Imagine watching *MirrorMask* in 3D, or even in an IMAX theater. We would probably feel more like Helena— lost in a fantasy, or in a nightmare. When it comes to cinematic possession, sometimes it is voluntary. Consider the hopeless romantic who enjoys watching a character experience love in typical romantic films. She allows her emotions to be manipulated by the images. But this same cinematic possession can also be involuntary. This usually occurs when a specific emotion is fueling brain activity before walking into the movie theater. As another example, consider a young soldier who is on leave after experiencing combat. He is watching a violent war movie that happens to include a series of high-impact action sequences. The soldier's real-life experience with combat gets triggered in the form of memory. But the involuntary possession happens only when the graphic images change from character to character. The young soldier subconsciously becomes each of the characters for brief moments in story time. For those fleeting moments he has become possessed by the depicted reality because of his connection to similar experiences.

So, when Helena gazes into her drawings from her real world, she is attempting to reach out and enter her fantasy world. Likewise, while she is on her quest with Valentine in the Dark Lands, she gazes back into her real world through various windows. As the plot reaches its climax, we can tell that it has become more obvious for Helena and to us that she wants get back into her real world. However, her goal is unattainable until she acquires the MirrorMask.

BREAKING THE FOURTH WALL

Each time Helena looks through a window from the Dark Lands into her real world, we literally see what she sees. In other words, in what may seem like a complete shattering of the fourth wall, we actually become Helena for a brief moment. However, there is a downfall: we can't actually stay as Helena, nor can we exist in the realm of *MirrorMask*. However exciting or boring your life might be, you can never exist in any fictional world. To go back to the aquarium analogy, that's like diving into the aquarium and swimming with fish *as* a fish. The closest we can ever get is by putting on a dive suit and mask and jumping in. But we're foreigners. We are not *of* that world.

So, was the wall ever broken in *MirrorMask*? Take a look at the following diagrams. Figure 9.1 illustrates our actual experience when watching *MirrorMask* at the theater.

What we've been experiencing throughout the one-hundred-plus minutes of screen time is called projective illusion of cinematic image. [1] So, in a phenomenological sense, according to figure 9.1, we're only watching what the film projects: X marks the spot. The movie actually tricks us

Figure 9.1.

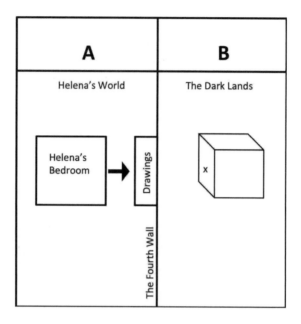

Figure 9.2.

into believing that we're a part of it. In other words, the illusion of *MirrorMask* is such that we believe we're there, or that it is here. So the mystery is now solved. The fourth wall was never broken. It may feel like it's broken, but it never really is. The structure of *MirrorMask*, as designed by its filmmakers, is also its function, which is meant to deceive the audience. Just like when Helena never made it back, her voice is overheard saying that Anti-Helena won. There's a moment of silence. The image changes and Anti-Helena is seen enjoying herself in the bedroom. She throws away all the drawings into a bag and heads outside to burn them. As the fire consumes the drawings, the gateways between worlds, it seems that the story is over and that Anti-Helena actually did win. But, true to form, just like how the audience is deceived, Anti-Helena is herself deceived. Alas, there was one last drawing with a window—the one on the door. Anti-Helena sees true Helena looking through a drawn window on an actual door putting on the MirrorMask. There's a struggle, but in the end, true Helena wakes up in her pajamas outside. The quest to go back home is over. The plot manipulates us into thinking that all is lost. But when we see that it's not, we are relieved.

The best part of *MirrorMask* is that it simulates what would have occurred if the fourth wall had actually been broken. Take a look at figure 9.2, which shows how both Helena's world and the Dark Lands world are structured before the plot is set in motion. As you can see, it looks quite similar to figure 9.1, which depicts our world and the world of *Mirror-Mask*. Helena broke the fourth wall (somehow) when she crossed over into the Dark Lands. The result of this crossover is not what we expected. In fact, after Helena has crossed over, it seems that the world she's in is not so pleasant. It's quite bizarre. It's even horrifying at times, especially when the Queen of Shadows sends her darkness to chase or consume certain characters. In a sense, Helena would have been better off if she had remained in her world (reality as she knows it). Now she must travel back to her reality before Anti-Helena destroys it. But the only way through is with the MirrorMask, as you can see in figure 9.3.

In the end, we are now aware of the power of cinematic possession. Even though at times we tend to enjoy our brief moments while watching a film, ultimately we desire to maintain a relatively stable presence in our reality, just like Helena. For some, this may be the most critical part of

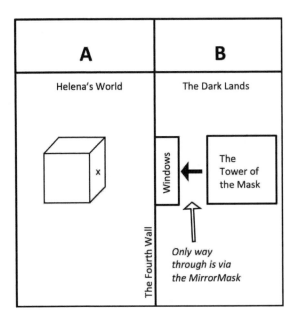

Figure 9.3.

my whole argument, as it deals with our basic understanding of ourselves as beings with free will. Slavoj Žižek, the infamous contemporary Slovenian philosopher, suggests that movies control us in a unique way when he says, "Cinema is the ultimate verbal art. It doesn't give you what to desire. It tells you how to desire."[2] If Žižek is correct, then we should ask ourselves: Do we want to be in a constant state of desire-manipulation? Don't we want to formulate our own desires?

THE MASK BEHIND THE MIRROR: EXPOSING TRUTHS ABOUT THE STORY

Although the fourth wall in *MirrorMask* never actually gets broken, we are tricked into believing that it did. Our puppet masters purposely designed the film to maintain a consistent illusion that deceived us into thinking that the world of *MirrorMask* could be real.

So, back to phenomenology as the method for understanding the experiences mentioned throughout this chapter, if you perceive that everything you watch on the screen is real, then you probably have some sort of slate of experience that is longer than most people's. In other words, what if one day you were being interviewed and you were asked to explain the most bizarre experience you've ever had? If you say that you were transported to a dark world where creatures swam through the air, books were modes of transportation, and you had to find a mask in order to save a dying queen, you'd probably be escorted out of the room in a straitjacket.

The power of story, especially film stories, can make us more aware of our experience in our present reality. The very message of *MirrorMask* is just that. Hence, the way *MirrorMask* was made is its own function. Its purpose is both to entertain and to inform the audience.

10

MUPPETS AND MIMESIS

Plato and Aristotle Take on Jim Henson

S. Evan Kreider

Anyone familiar with Jim Henson's *The Muppet Show* will instantly recognize Statler and Waldorf, the grumpy old hecklers who both literally and figuratively look down on Kermit and the rest of the show's cast. But consider a slight change to the balcony's inhabitants, replacing these two grumpy old men with two grumpy ancient Greeks. Would Plato and Aristotle serve as kinder critics, or would they, too, find Jim Henson's creations worthy of nothing but derision? In this chapter, we will explore the aesthetic theories of both Plato (focusing on his discussion in *Republic* on poetry) and Aristotle (focusing on his discussion in *Poetics* on tragedy) as they might apply to Jim Henson's *The Muppet Show* and *Sesame Street*. In this context, we will see that *The Muppet Show* would fail to capture the praise of either Plato or Aristotle: for Plato, *The Muppet Show* exemplifies everything that Plato despises about poetry, especially the dangers of *mimesis* ("imitation," "representation"), while for Aristotle *The Muppet Show* fails to meet the formalistic criteria of good drama, especially the logical coherence and unity of plot. In contrast, I will argue that *Sesame Street*, while perhaps not without its own flaws, fares much better: for Plato, in that it provides an example of poetry that may serve legitimate educational purposes in less rationally sophisticated audiences, and for Aristotle, in that it provides similar educational value through the proper use of mimesis and *katharsis*.

THE MUPPET SHOW AND PLATO: POETRY, FORMS, AND THE VAUDEVILLE HOOK

The "Vaudeville Hook" is an old gag in which a particularly bad act is yanked off the stage with the aid of a long, wooden hook. This gag features routinely on *The Muppet Show*: lesser talents such as Fozzie Bear and Gonzo suffer its pull on more than one occasion, and even the host of the show, Kermit the Frog, has been snared on occasion. In book ten of *Republic*, Plato argues that poets (which in the relevant cultural context would include those involved in the writing of theater) ought to be banished from the ideal society; one can almost picture Plato standing just off stage, hook in hand, poised to interrupt a production of *Oedipus Rex*. In order to understand why Plato had such a poor opinion of poetry, we must understand a bit about his most famous philosophical idea—the theory of Forms.

Plato believed that the physical, visible world around us was only a lesser part of existence as a whole, and that the highest reality was composed of immaterial Forms. These Forms serve as perfect ideals or exemplars of which material objects in the empirical world are merely imperfect imitations. In book ten of *Republic*, Plato uses the example of a bed: there are many particular beds, but there is only one Form of the Bed, the ideal of the bed to which the craftsman looks, as a sort of blueprint, when making this or that particular bed, making the physical bed a mere imitation of the Form of the Bed. However, it doesn't stop there: according to Plato, the arts are mere imitations of things in the physical world, and thus imitations of imitations, just as a painting of a bed is less real than a physical bed, which in turn is less real than the Form of the Bed. Since real knowledge must be based on real existence, the highest knowledge comes from contemplation of the Forms, while, at the opposite end, contemplation of the arts can only lead us away from true wisdom. [1]

In this context, it is easy to see why Plato would object to *The Muppet Show*. Quite simply, it is an example of a contemporary dramatic art form, a television variety show containing sketches, music, dance, comedy, and so forth. Thus, like any art form, it is simply an imitation of an imitation of reality. Furthermore, it's actually a show about a troupe that puts on a variety show—a show within a show, as it were—thus making it an imitation of an imitation of an imitation of reality! These layers of imitation, each a further degradation of reality, extend not only to the

form of the show but also to the various characters within it. Some of the characters are straightforwardly human, such as Statler and Waldorf. Others are human but barely more than stereotypes, such as the Swedish Chef (who himself imitates the Swedish language through a series of nonsense syllables). Others, such as Kermit the Frog, Miss Piggy, and Fozzie Bear, aren't even human, but rather anthropomorphized animals, removing them even further from reality. Still others, such as Gonzo and Doctor Teeth, are creatures that barely resemble any real-world counterpart, making them about as far removed from reality as anything on the show.

Moreover, Plato objects to the arts not only because they are imitative but also because they encourage imitation in the audience, especially imitation of immoral emotional behavior in those not philosophically mature enough to know better. On a related note, the arts, by imitating human actions rather than simply describing them in a more abstract manner, are particularly good at stirring up our emotions, and our emotions, according to Plato, are often at the root of irrational (and thus morally suspect) behavior. In this regard, Plato's criticisms of the arts still ring familiar today, reminding us of similar complaints by parents' groups that violence in television shows and video games promotes violent behavior in children.[2]

Once again, it's easy to see why Plato would object to *The Muppet Show*, as the show routinely depicts emotional behavior that would be considered immoral in real life. For example, the romantic relationships and inclinations of the cast are far from healthy: Kermit the Frog is engaged in an on-again/off-again, emotionally and physically abusive relationship with the karate-chopping Miss Piggy; Gonzo pursues the affections of a barnyard hen, and not even of the anthropomorphized variety; and Animal's views toward women can only be described as predatory and terrifying. Violent behavior also abounds, with cast members routinely being struck, blown up, and even eaten—not to mention being violently yanked off stage with the Vaudeville Hook.

So for these reasons, both epistemic and ethical, Plato would clearly call for the last curtain to fall on *The Muppet Show*.

THE MUPPET SHOW AND ARISTOTLE:
THE LOGIC OF "MAHNA MAHNA"

Aristotle is far kinder to the arts in general than Plato, but even he would criticize some works of art. In particular, Aristotle believes that good art requires a certain kind of form and logic if it is to serve legitimate artistic purposes. Although Aristotle lacks any unified account of aesthetics, we are fortunate that he gives us a theory of tragedy, which, along with comedy, makes up the two major branches of the dramatic arts. A television variety show is perhaps more comedy than tragedy, but the history of philosophy has generalized from Aristotle's comments about tragedy to other art forms, and we will take that same liberty here. In particular, we'll see that Aristotle would criticize *The Muppet Show* for its lack of form and logic, ultimately rendering the show as illogical and meaningless as "Mahna Mahna."

According to Aristotle, tragedy requires a certain logical unity of plot. In simple terms, there should be only one sequence of actions and events revolving around a small set of characters. In other words, Aristotle believes that multiple plots, subplots, meta-plots and the like are a distraction for the logical sequence of action and consequence that tragedy requires to make its points in the clearest and strongest terms possible. Furthermore, the work should be complete and whole, offering a single story with a clear beginning, middle, and end. In other words, Aristotle would not approve of serialized shows with stories told over multiple episodes.[3]

In that light, Aristotle would clearly disapprove of the form of *The Muppet Show*, since, as a serialized show, it obviously fails to meet his formal criteria. This can cause problems for the audience if they have not seen previous episodes: they will miss the force of running gags (such as the aforementioned Vaudeville Hook) and fail to understand the background to developing relationships between characters (such as that between Miss Piggy and Kermit the Frog). It also fails Aristotle's criteria because each episode contains multiple stories that are as unrelated as it gets (such as a Swedish cooking show that immediately segues into a science fiction tale of Pigs in Space). Finally, it is a show constructed of small stories wrapped in a meta-plot of a band of creatures that run a variety show. On all these counts, *The Muppet Show* is simply far too illogical for Aristotle to bear.

Another of Aristotle's logical requirements is that of action and consequence. In particular, Aristotle is very critical of plays that show bad things happening to people through no particular fault of their own, saying that such events are neither fearful nor pitiful, but simply repulsive. When bad things happen to people, it ought to be from some logical consequence of their character and actions. In particular, we ought only to depict bad things happening to bad people (who simply deserve it) or to good people only from their flaws and mistakes.[4]

Once again, *The Muppet Show* fails by this criterion. Bad things happen to a variety of characters through no fault of their own, but simply for the slapstick comedy effect. For example, Sweetums, an extraordinarily large and monstrous Muppet, routinely swallows smaller Muppets whole. For another example, Muppets (especially the mild-mannered Gonzo) are frequently and randomly blown up in various ways by various other Muppets (especially the explosive-wielding Crazy Harry). As a final and particularly poignant example, a Muppet who beautifully sings the lyrics to Joyce Kilmer's poem "Trees" ("I think that I shall never see; A poem as lovely as a tree") is promptly crushed to death as the nearby tree falls on him.

Finally, Aristotle defines tragedy in terms of its various formal elements, ranking them each from most to least important. At the top of the list are, not surprisingly, plot and character. At the bottom of his list is what Aristotle calls "spectacle." Spectacle is essentially all of the play not simply part of the text: the costumes, the sets, the actors, the props, special effects, and so on. According to Aristotle, since all of the elements of the play necessary to impart the message of the drama are available from the text, the spectacle is simply unnecessary. In Aristotle's view, we can get everything we need from the play simply by reading the text; seeing it performed adds no real content.[5]

Once again, *The Muppet Show* fails to meet Aristotle's standards, in this case because spectacle seems to be one of its most important elements rather than its least important. A variety show is, almost by definition, a show devoted to lambasting the audience with a wide variety of ostentatious entertainments, including song, dance, big sets, fancy costumes, and the like. In the case of *The Muppet Show*, this is exacerbated by the fact that even the special effects are in the hands of special effects—that is, the puppets themselves. Indeed, spectacle is so central to the show that it even features in the lyrics to the opening theme:

> It's time to play the music,
> It's time to light the lights,
> It's time to meet the Muppets on *The Muppet Show* tonight.
> It's time to put on makeup,
> It's time to dress up right,
> It's time to raise the curtain on *The Muppet Show* tonight.

So, despite Aristotle's more generally friendly attitude to the arts, he would agree with Plato's negative opinion of *The Muppet Show*, if for different reasons.

SESAME STREET AND PLATO:
THE GREEK AND THE GROUCH

As we've seen, Plato's views about the arts in general, at least as expressed in book ten of *Republic*, are uniformly negative. However, earlier in the text (in parts of books two and three, specifically), Plato offers a somewhat kinder view, at least with regard to arts that serve a legitimate educational purpose. Although the order of his discussion makes it seem as though he's abandoned this view by book ten, it's at least arguable that there's nothing that particularly commits him to this perspective, and that his own theories about the arts could still allow for some arts to play a legitimate role in society; in fact, this seems quite likely, given that Plato himself chose to communicate his philosophy in a literary form. For our purposes here, we'll set aside his apparently harsher criticisms in book ten of *Republic* and consider his views in books two and three, and, in this context, show that Plato might have looked upon *Sesame Street* in a kinder (shall we say, less grouchy?) manner than he would upon *The Muppet Show*.

Among the many, many topics of *Republic* is Plato's theory of the ideal society. One essential class in this society is the guardian class, essentially the military. Plato spends a great deal of time discussing the education of the guardians: the guardians must develop the right sort of character to fulfill their function of protecting the society, and since this happens primarily through education, it is essential that we choose the right curriculum. According to Plato, we should educate the guardians in large part through the use of poetry—that is, literature and plays—that have the appropriate sort of content, as determined by the wise rulers of

society, who act paternalistically, treating the young guardians as children with impressionable minds that must be molded in the right way. Toward that end, they must censor and edit the classic poems of Homer and the like for content, making sure that they contain only the right sorts of messages, so that the guardians will learn about crucial virtues such as bravery and justice. When they are older, if they demonstrate a disposition for wisdom, they can begin to learn about these things in a more sophisticated and philosophical manner, but as younger people who are not quite ready for such heady things, and who need the guidance of those older and wiser, these poetic myths and stories will do well enough.[6]

With this in mind, one can see how Plato might look more kindly on *Sesame Street* than he did upon *The Muppet Show*. Obviously, *Sesame Street* is a show that serves the purpose of educating children. Some of the education is very basic, such as helping children learn to count: to this day, the author can still sing "Ladybug Picnic" (and, naturally, count to twelve) despite having first heard it back in the 1970s. However, the show does not limit itself to teaching simple academic skills, but also works to instill moral values and character in the audience. For example, Bert and Ernie routinely show the challenges and rewards of friendship, and Big Bird has many informative conversations with the children visiting the street on any given day. Even some of the more unseemly characters teach moral lessons, if only by contrast. For example, Oscar the Grouch shows us not only how to deal with grouchy people in our lives but also how unhappy and isolated such people are because of their grouchiness. Even Cookie Monster, despite appearing to advocate gluttony, is a sort of cautionary tale, showing the absurdity of intemperance; it's also worth noting that, in recent years, Cookie Monster has moved away from being a frenzied eater of treats to acting as an advocate for healthy eating (reminding us as he does that cookies are a "sometimes food").

Admittedly, Plato would still dislike the mimetic form of *Sesame Street*: in his mind, it would certainly be better if such morality tales were taught in a straightforward narrative form rather than through reenactments by fictional characters. Having said that, it still seems that Plato might begrudgingly ("be-grouchingly"?) admit that *Sesame Street* has some value.

SESAME STREET **AND ARISTOTLE: EVERYTHING'S A-OK**

In some ways, Aristotle's *Poetics* is a response to Plato's criticisms of the arts. As is often the case, Aristotle agrees with some of his teacher's basic points, but puts a new (and often more positive) spin on them. In particular, Aristotle agrees with Plato that the dramatic arts are imitative and that they do arouse emotional responses, but he disagrees with Plato that these are bad things. The contrast of the later issue is precisely what would allow Aristotle to look more kindly than Plato on *Sesame Street* or than he himself looked on *The Muppet Show*: while *The Muppet Show* fails to meet the criteria for a quality show, *Sesame Street* manages to earn an "A-OK" stamp of Aristotelian approval.

First, regarding the issue of imitation, Aristotle agrees with Plato that drama is imitative, but he disagrees that this is a bad thing. According to Aristotle, human beings are naturally imitative creatures, and imitation itself is central to learning. We see this, of course, in children, who imitate the sounds their parents make as they learn to speak. Furthermore, all good pedagogy, whether of children or adults, involves a certain amount of imitation. For example, painters and musicians build basic techniques by imitating the works of the master, and even scientists learn experimental methods by imitating the model experiments described in textbooks. Without such imitation, Aristotle believes that learning isn't possible, and not only for the arts and sciences: even moral virtue is developed by imitating the actions of our moral betters (as in the contemporary "What Would Jesus Do?" meme). Thus, contra Plato, imitation makes us better people, both intellectually and morally.[7]

Second, regarding the issue of emotion, Aristotle agrees with Plato that the drama arouses emotional responses, but that this is also a good thing. In particular, Aristotle believes that the purpose of drama is to arouse emotions for the purpose of *katharsis*. This notion has been interpreted differently by different scholars. In the nineteenth and early twentieth centuries, it was interpreted as a "purging" of negative emotions, a kind of "blowing off steam." More recently, some scholars have interpreted it as a "perfecting" of emotional responses by depicting morally appropriate ways in which to emote (and thus linking *katharsis* with imitation). Whether by purging or perfection, drama helps us deal with our emotions in an ethically correct manner, and thus improves us rather than harms us, contra Plato once again.[8]

All this speaks very highly of *Sesame Street* from Aristotle's perspective. Some of the aforementioned examples already speak to learning through imitation. For example, children watching the show learn to count by imitating the Count ("One! One telephone ring!") or singing along with Feist ("One, two, three, four monsters walk across the floor . . . Counting to four!"). They also learn about health by watching "Happy Healthy Monsters" for tips on exercise and diet. In addition, they learn a great deal about emotions and proper behavior by listening to songs and watching short films such as "It's All Right to Cry," "Happy Happy Happiness," and "Sad Flower."

Obviously, a show such as *Sesame Street* is an educational show, and as such, it is also a good one by Aristotle's standards, or an A-OK one, teaching children not only academic basics such as counting but also life skills and values such as health and virtue, so that the children themselves will turn out A-OK:

> Come and play,
> Everything's A-OK,
> Friendly neighbors there,
> That's where we meet.
> Can you tell me how to get,
> How to get to Sesame Street?

CONCLUSIONS AND CRITICS

So how do Plato and Aristotle compare to Statler and Waldorf as critics of Jim Henson? It seems that there is overall agreement when it comes to *The Muppet Show*, though one imagines that neither Plato nor Aristotle would be quite so rude as to heckle in the same way that Statler and Waldorf do. However, Plato and Aristotle would probably look upon *Sesame Street* more kindly, especially for its pedagogical value. Whether they would be able to convince Statler and Waldorf of the same, we can only speculate, but it doesn't seem likely, given the hecklers' cynicism and skepticism: "Why do we always come here? I guess we'll never know," they ask at the beginning of each episode. If not, perhaps there are some empty garbage cans available for habitation next to Oscar the Grouch; one imagines that the three of them would get along just fine.

11

THE BEST SEAT BY THE FIRE

Jim Henson and the Role of Storytelling in Culture

Victoria Hubbell

In the late 1980s, Jim Henson produced his creation *The Storyteller*.[1] To many, the series was a lesser-known brainchild than *Sesame Street* or *The Muppet Show*. Each vignette portrayed an aged man sitting by the fire; together with his talking dog, this storyteller retold classic tales. The stories he told were recognizable myths, folktales, and legends from various time periods and countries. The storyteller told his viewers about the events in the plot as they were performed, whereas Henson's other endeavors did not utilize narration in this formal context.

Each story introduced in *The Storyteller* began in the same manner: The narrator proclaimed, "When people told themselves their past with stories, explained their present with stories, and foretold their future with stories, the best place by the fire was kept for the Storyteller."[2] The audience then met the storyteller and viewed the tale as it was acted out by actors, various monster-like creatures, and a few talking animals.

It's difficult to see the breadth and depth of Henson's simple opening statement at first glance. However, upon reflection, we discover it addresses deep questions about subjects such as destiny and freedom. It makes us examine our ideas about humanity's past, as well as our views on the present and future. In this opening narration, we can find "key expressions of cultural values and frameworks for understanding the world."[3] The important elements we will discuss here are the structure and content of Henson's productions using storytelling and storytellers,

and how these methods transmit Henson's views on valued aspects of life.

PEOPLE TOLD THEMSELVES THEIR PAST WITH STORIES

In order to tell themselves anything, people first needed language. At some long-ago point in history, a group of humans eventually had enough energy to focus on more than survival, and they came to an agreement about what was important to them. That which they valued became the cement in the worldwide phenomenon of the beginning of culture. Researchers across the disciplines acknowledge that the use of language, whether expressive or receptive, oral or written, is always tied to the growth and development of culture.

How does a group transmit its values and thus develop its culture? A simplistic description would answer "through its actions as well as its language." Researchers have studied how people may emulate valid examples presented as teaching for decades, and the literature has substantiated the concept of modeling. One conclusion we have confidence in is that people tend to model their behavior and ideas after sources they deem reliable.[4] Therefore, in many situations we mold and model ourselves after others.

What did Henson do to assure his audience that the episodes contain valuable information and are therefore worthy of following? Although we can speculate on many answers, one of the most obvious is through his use of clarity. The audience is never in doubt about what the intentions of any characters are. They may be selfish (as Miss Piggy often is), but this attribute is never masked. Henson did not deceive or try to trick his audience. In return, we are more likely to trust our own discernments and conclusions about the values presented.

What are some examples of the values contained in the content of the productions? Watch any episode of *Sesame Street* or *The Muppet Show* to see obvious examples of qualities such as tolerance, diversity, patience, and productivity acted out by the characters. We can easily assume that these are values Henson thought were important enough to promote. Now, decades after their inception, *Sesame Street* has been seen in over 100 countries, while *The Muppet Show* has appeared in over 140. Al-

though Henson may have started out promoting cultural ideas and values he found appealing, how many would now argue that his productions have become a part of modern culture itself?

Although all three productions used language and actions to portray values, *The Storyteller* uses a different structure. Here, we see a strict storytelling format, albeit with accompanying actions. The Storyteller follows the same structure as the historical act of composing a tale to be shared with the members of one's group. Its importance lies in our belief that before written language existed, stories were composed, memorized, and verbally repeated again and again. This job was so important that typically one person in the community was the designated storyteller and historian. They were the ones who told people about their pasts through stories. We can study the earliest examples of literature from across the globe and always the basic premise is "This is what happened back when . . ."

Most importantly for this discussion, it was up to storytellers to decide what stories were repeated and passed on. This job played an enormous role in maintaining cohesiveness within the group. By deciding which stories to tell, the storyteller chose which values would be moved forward into the present and which would be likely forgotten. We need only pause for a minute to consider the effect Henson's productions have had on promoting values that strengthened American society throughout the decades.

PEOPLE EXPLAINED THE PRESENT WITH STORIES

Storytelling is interesting in that it cannot be a solitary endeavor. This is true in all societies around the world. The tradition involves members living just south of the Arctic Circle coming together to listen to the tale of the winter when hunters brought in so much game every man, woman, and child grew fat. In many ways, it was the same act in ancient Greece, when people listened to the story of Dawn, who dipped her fingers in rose-colored paint in order to color the sky in preparation for the morning sun. Telling stories took place before Shakespeare sharpened his quill and or even before the Egyptians chiseled their descriptions of the pharaohs into stone.

The process of retelling stories within a community is referred to as the oral tradition in literature and is considered the actual birth of literature, one of the vestiges of cultures around the globe. The event was so often multigenerational and open to both genders that it makes sense that the technique would appeal to Jim Henson, whose productions are loved by males and females, young and old.

Why were stories such an all-encompassing phenomenon? Perhaps the answer is tied to the notion that humans seem to have an inherent need for explanation. We constantly desire to understand lives that more often surprise and perplex us than make sense. In folktales, such as the ones presented by *The Storyteller*, the answers to the "whys" are comfortably obvious: He left his lover because he was bewitched. He was but a poor peasant and so had nothing. Just when she was about to give up, a lion appeared and restored her hope. Here we receive the answer to why some have hope when others give up, why some work hard but are still poor, or why our love may be unrequited.

These stories also lead us to consider explanations of the present that are a bit deeper. Why do we have heartache and suffering, joy and pleasure, rebirth and redemption? Henson's classic tales teach us that humans have lives that travel predictable paths: Everyone has met kings, queens, or simply people who think they are royalty. We have neighbors—some good, some bad. The witches in the world are out to get us. There are quests in our lives that demand our perseverance. We all must confront death.

Apart from considering the content of the stories themselves, it's also necessary to look at the storyteller as an individual. Henson seems to be telling us that we need a reputable guide in our endeavor to find a trustworthy path through our lives. The community storyteller was an almost universal role throughout the world, and one that Henson appears to consider important. Examples of storytellers span the globe and the centuries. They include Scheherazade from ninth-century literature, who kept her killer at bay with nightly stories; the shaman and storyteller Black Elk (1863–1950), who was eventually charged with keeping the tales of his tribe alive through story;[5] and present-day storytellers. In more modern history, the storyteller may not seem so obvious, although the influence remains. For instance, despite a basic distrust in the British government's philosophies, many Serbians note that the British Broadcasting Company (BBC) has "a wonderful presentation that somehow does not leave a

bitter taste. It is so artistic that you follow it with interest and sometimes with awe."[6] If it's true that everyone loves a good story, it is also true that everyone seeks a good storyteller.

PEOPLE USED STORIES TO FORETELL THE FUTURE

Although people have been enamored with the idea of foretelling the future for centuries, most agree this is a difficult and probably impossible endeavor. But what if we looked at predicting the future in another way? What if we believed that certain beliefs, or certain actions and reactions, were a good way to predict favorable versus unfavorable outcomes? What attributes would Jim Henson suggest people try to achieve? Consider a standard set of characters to answer that question: Kermit the Frog, Fozzie Bear, Miss Piggy, the Swedish Chef, Beaker, and Statler and Waldorf. What do they have in common? Well, five perform in *The Muppet Show*, while two prefer to stay in the box seats. Three are animals and four are humans. Five speak intelligibly, one nobody can understand, and one really doesn't speak at all. Upon some reflection, we conclude that they really don't have a great deal in common other than every week they seem to show up in the same place.

Keeping in mind the above cast, diversity seems to be their only unifying factor. Regardless of the story line of the individual episodes, their hesitant leader is the slow-to-anger, quick-to-lend-a-hand, always loyal, and exceedingly patient Kermit. If we are to emulate this leader, we must be tolerant of all the different members of our society. It's important to note that we never see an example of Kermit trying to change any of his fellow participants to fit a preconceived mold. He doesn't demand that others be more froglike. He doesn't ask the Swedish Chef to learn English, nor does he demand that Beaker dye his red hair green.

In attempting to decide what values Henson wants us to favor, we can examine the historical significance of the time in which Jim Henson created *Sesame Street* and later *The Muppet Show*. The United States was then entering a new era on the tail of the tumultuous 1960s. Civil rights movements and television coverage of protests suggested not only that we were a country of different kinds of folk but also that we were a country of people who needed to live together while maintaining our

individual identities. In the initial Muppet shows, we see the birth of this specific concept of tolerance.

Despite their diversity, Kermit's group muddles along and manages to put on a show every week. They may fuss and fume, but they don't desert. They constantly communicate with one another. They keep the dialogue going. They negotiate and compromise. They keep coming back to put together a show. So what's the message here? While Kermit may try to rub off Miss Piggy's rough edges once in a while, he doesn't try to make her into a frog. Kermit never considers throwing his critics in the box seats out of the theater. And he won't stop Fozzie Bear from telling a joke, even though they always flop. It is easy to guess how Henson would answer the question, "How should we treat those who are different from ourselves?" With respect.

When we examine the content of some of the episodes from *The Storyteller*, we see a variation of this same theme. Here we consider the question, "How should we treat those who are considered lesser individuals than others?" In the story of stone soup, presented in "A Short Story," the protagonist befriends a beggar who becomes his only ally and eventually his savior. In "Sapsorrow" (known by many as Cinderella), a myriad of creatures the main character has cared for help her carry out her transformations. In yet another episode relating an early German folktale, a boy is on a quest, and a fish, bird, and wolf he helps along the way later assist him in his hour of need.

These plots present to us a practical reason for giving others a helping hand: Be kind to the little people in your life, and they will be there to help you. Considering the same scenarios in an alternative fashion, we can assume another realm of advice: When others graciously help us, we should repay the favor with loyalty.

In the story "The Luck Child," the events teach us something about our reactions to what we might initially consider unfortunate events. In this story, major disappointments turn out to be the best things that could have happened to a child previously thought to be most unlucky.

Another vignette of *The Storyteller* addresses a deeper question about destiny. Humans have always wondered about death. It is mysterious, yet omnipresent. Is there any other subject every human must face with such little knowledge? Through the telling of an early Russian folktale, we are led into an alternative world where death is tricked. The protagonist attempts to change the natural order of life by capturing death. He suc-

ceeds, and for a time nobody dies. But then, as our wise storyteller points out, people are never released from old age and suffering. They cry out in pain and misery and wish for death to visit them. And so the error is realized, death is released, and people are allowed to die. In this story we are shown that although we may fear and loathe death, its place in the universe should be accepted.

THE BEST PLACE BY THE FIRE WAS KEPT FOR THE STORYTELLER

We have seen that one of the most ancient and basic vestiges of humanity is the story. We say a good story is timeless because despite the age, despite the country, despite the language, we all appreciate a good story. According to language researcher and Okanagan-speaking Jeannette Armstrong, "Language in everyday use requires literature, requires story, and requires writers and storytellers to come together and represent the consciousness of the people."[7] We have seen the truth in this statement, as well as how stories help address the past, present, and future of a people.

Now we can examine whether this requires a storyteller. Why not just present the stories as they are? Why use a storyteller at all? Perhaps the teller is not as important as the story; in the same manner, the writer is not as important as the writing, nor is the artist as important as the art.

Today, little has changed. The storyteller must be appealing to both young and old; the storyteller must be able to speak simply enough for everyone to understand; the storyteller must be clever enough to incorporate multiple meanings (especially necessary to keep the attention of the intelligent and sophisticated in the group).

In both *The Storyteller* and *The Muppet Show*, Henson is careful to keep the storyteller front and center at all times. In both productions, Henson chooses a leader who will help us navigate the events. Throughout the series *The Storyteller*, each story starts with a fascinating character introducing the episode. Although this person does nothing but sit in his chair and talk, we have a hard time taking our eyes off him. Henson's storyteller alternates between handsome and hideous. When he speaks, we note his clear eyes and even smile, while during his next sentence we stare at his strange ears and mottled nose. He sits in a regal chair next to

an awe-inspiring fireplace, although both the chair and his coat appear about to disintegrate from antiquity at any moment.

Henson's storyteller is an artist in his own right. He patiently answers the dog's questions, and comments on the stories, summarizing and concluding lest the audience miss an important point. For example, in one episode he admonishes, "Nothing spreads as fast as gossip," during a story whose main point has nothing to do with the subject of gossip.[8] Henson assumes we need him to help at least some of us understand important features and deductions of the stories. We are given a storyteller we can trust, although Henson could have just as easily presented the stories without a guide.

We can easily speculate what attributes Henson believes such leaders must have if we examine Kermit the Frog. Without meeting Kermit first, we might have said that a frog could never be a role model to emulate. He is small, green, and lacking in physical strength. But it is Kermit's personal attributes that cause him to function as such a good leader for us to follow. He has integrity.

Perhaps the clearest example showing the importance of the storyteller in Henson's eyes is Henson himself. Through his work in all his productions, we meet the master storyteller: Jim Henson. Using skill, intelligence, and an unparalleled ability to judge human nature, he surrounds us with characters to take us down streets and into worlds we would not go by ourselves. He gives us trusted advisors to follow, so that we may learn from our past in order to help us with our present and prepare us for the future. Henson is the master storyteller who clearly deserves the best place by the fire.

Part III

Acting Like a Muppet: Ethics

12

JIM HENSON'S EPICUREAN COMPASS

Navigating the Labyrinth, Road Tripping to Hollywood, and Finding Our Way to Sesame Street

Brooke Covington

What is the greatest good in life?

I don't mean this hypothetically—really, take a moment to think about it. Now, picture it. Whatever you may choose—family, companionship, intelligence, even food—all are driven by pleasure. These things are good because they are pleasurable. And, of course, pleasure is central to happiness (arguably, the greatest good there is in life). Now, before you think of base pleasures like fornication, drunkenness, extravagant luxury, or general debauchery, let me make clear what I mean by pleasure.

Epicurus, an ancient philosopher credited with developing the ancient philosophy Epicureanism, held the belief that everything we do in life is guided by pleasure and the attainment of happiness.[1] Happiness, by Epicurean definition, is the presence of a tranquil soul through sober reasoning and the absence of bodily pain.[2] The greatest good in life is happiness—not as a moment of elation in time, but rather the whole of one's life going well. And the way to obtain such a life is by rationally applying reason and limiting our profligate desires while also developing lasting, positive friendships—all of which are inextricably tied to pleasure.[3]

To be sure, Epicureanism certainly does not equate to a license for self-indulgence or an absence of morality. In fact, Epicureans believe morality and virtues produce pleasure and are thus essential to maintaining happiness.[4] Grounded in ethical hedonism, Epicureanism maintains

that pleasure "is our first and kindred good. It is the starting-point of every choice and of every aversion."[5] In this philosophy, pleasure is the only intrinsic good, meaning everything else in life, even virtue, is practiced not for its own sake, but as facultative to pleasure. Think about it this way—we do not act courageously in the face of danger just for the sake of being courageous; rather, we act courageously to save someone else from danger because of the positive reinforcement we get from doing so. Whether we like to admit it or not, it makes us happy to act virtuously—just as it makes us happy to act ethically, or treat our friends well, or obey the law. According to Epicurus, "It is impossible to live a pleasant life without living wisely and well and justly, and it is impossible to live wisely and well and justly without living pleasantly."[6] Thus, acting virtuously solidifies our position on the path to a happy life by ensuring our mental and physical health. Alternatively, acting in a way that only ensures obtainment of vulgar pleasures will never lead to permanent happiness, since we typically lose our capacity for sober reasoning and serenity when chasing menial pursuits.

As Epicurus asserts, the pleasant life is produced through "sober reasoning, searching out the grounds of every choice and avoidance, and banishing those beliefs through which the greatest disturbances take possession of the soul."[7] And Epicurus isn't alone in this ideology. Jim Henson, an innovative thinker, puppeteer, director, and philosopher in his own right, shares many of the same philosophical beliefs as Epicurus. Throughout his career, Jim Henson—like Epicurus—sought to teach others the importance of moral decision making while also emphasizing the significance of creating meaningful friendships. His many projects attest to the power of friendship, teaching children (and adults) from around the globe that the human capacity for kindness, altruism, and love is unyielding.

In this chapter, we will explore three of Henson's works—the 1986 film *Labyrinth*, the 1979 film *The Muppet Movie*, and finally the revolutionary TV show *Sesame Street*. These works provide the roadmap of Henson's belief system. You will notice that movement, in addition to morality, is a key theme in Henson's works—for, as Sarah and his Muppets demonstrate, it is only through movement that we learn to grow. In the following sections, we will navigate the labyrinth, take a road trip to Hollywood with the Muppets, and walk together down Sesame Street— and Jim Henson's Epicurean compass will lead the way.

FINDING YOURSELF IN THE LABYRINTH

Written and directed by Jim Henson, the 1986 fantasy film *Labyrinth* stars Jennifer Connelly and David Bowie alongside a slew of Henson's more gothic puppets. The opening scene features teenaged Sarah (Jennifer Connelly) reciting lines from her favorite book *The Labyrinth*. Clock chimes interrupt her, indicating that she must return home to babysit her infant brother, Toby. Annoyed that she has to sacrifice her own avocations in order to take care of her brother, Sarah wishes goblins would kidnap Toby. In a flash of lightning, her baby brother vanishes and a barn owl flies into the open window, transforming into Jareth (David Bowie), the Goblin King. He explains to Sarah that he has granted her wish—Toby is being held captive in Jareth's castle in the middle of the labyrinth. To save him, Sarah must choose to enter the labyrinth, find the castle, and save Toby from the Goblin King.

As an allegory for accepting adulthood, *Labyrinth* demonstrates the importance of friendship, sober reasoning, and ethical decision making in a way that is accessible and entertaining to viewers of all ages. Both in literature and in film, the labyrinth trope symbolizes a path to enlightenment, usually featuring a young person who enters the labyrinth as a naive, self-indulgent adolescent only to later reemerge from the labyrinth with a better understanding of the realities of the adult life. This transformation indicates maturation or growth, as in the case with Sarah. As Sarah moves through the labyrinth, she grows into a young adult and learns to accept the moral responsibilities of adulthood.

Regrettably, the path to enlightenment is not an easy one for Sarah—choosing to wish away her brother demonstrates her initial lack of restraint toward her own wants. Epicureans stressed the importance of sober reasoning in modifying our desires so that we are not overcome by greed, envy, jealously, and hate—all of which are emotions that eventually lead to emotional distress and unhappiness. Throughout his life, Epicurus urged his followers to reject pleasures that leave pain in their wake, and even advocated choosing pain over pleasure in instances that will result in greater long-term happiness. [8] Unfortunately, at the beginning of the film, Sarah is unable to see past her own selfish pursuits—it is not until after the Goblin King kidnaps Toby that she realizes she has acted selfishly.

Fortunately, Sarah does enter the labyrinth to save her brother, displaying her capacity to accept potential pain as the cost of long-term pleasure (the happiness that results from rescuing Toby). Nevertheless, Sarah's will to reject selfish desires is constantly tested in the labyrinth. During her journey, she eventually realizes that people are more important than possessions; she understands that her once-prized childhood toys are all "junk"; and she recognizes that the luxuries offered by the careless and frenzied Fire Gang are only temporary and cannot ensure prolonged happiness.

As a staple of Epicureanism, ethical hedonism requires that, under certain circumstances, we must sacrifice our own pursuits for the sake of the people we care for; otherwise, the pain we feel for our distressed friends will disrupt our own happiness.[9] Throughout the film, Sarah's friends regularly risk their own safety to help her find Toby. In doing so, each of these characters are able to maintain mutual trust, support, and amiability toward one another, illustrating the importance of friendship as a mode of ensuring prolonged happiness and safety—another fundamental concept of Epicureanism. In his *Principal Doctrines*, Epicurus decrees, "of all the means which are procured by wisdom to ensure happiness throughout the whole of life, by far the most important is the acquisition of friends."[10] Throughout the movie, Ludo (as a symbol of loyalty), Sir Didymus (as a symbol of bravery), and even Hoggle (as a symbol of self-preservation) help to ensure Sarah's security and maturation in the labyrinth. Without her friends, Sarah would have experienced greater obstacles during her journey, and she would not have emerged from the labyrinth with lasting (though imaginary) friends. And while her fantastical friends may seem like luxuries, at the end of the film Sarah admits, "I don't know why but every now and again in my life, for no reason at all, I need you. All of you," revealing that Hoggle, Ludo, and Sir Didymus are not simply indulgences of the imagination—these friends are needs that ensure tranquility and happiness. Epicurus would agree.

Although friendship is a cornerstone for both Epicurus and Henson, some critics of Epicureanism believe that Epicureans cannot sustain genuinely demanding friendships since hedonism is based on only pursuing one's own desires and not those of others.[11] This is a misrepresentation. Epicureans view friendship as an ethical means of alleviating mental distress and securing mutual support—it is a collaborative effort that ensures personal happiness among all parties.[12] And Henson supported

this ideology. Many of his works echo the idea that friendship is a support system and our ethical or altruistic actions toward our friends help preserve those friendships, which in turn makes us happy. As we will see in the following sections, sacrifice for the sake of preserving friendship is a major theme in many—if not all—of Henson's works.

THE MUPPET MOVIE: LIFESTYLES OF THE RICH AND FAMOUS

Like *Labyrinth*, *The Muppet Movie* operates on Epicurean notions of happiness derived from the pleasures we obtain through camaraderie and moral action. Produced by Jim Henson and released in 1979, *The Muppet Movie* was a blockbuster hit—selling over thirty million tickets, winning a Grammy for Best Album for Children, and nominated for two Academy Awards and a Golden Globe.

Operating as a film within a film, the beginning of *The Muppet Movie* features the Muppets gathered for a screening of their biographical film (ironically) titled *The Muppet Movie*. Kermit calms the crowd, the theater darkens, and the film within the film opens to Kermit singing in the swamp. After learning about a call in Hollywood for performing frogs, Kermit decides to journey across the country to Hollywood to "make millions of people happy" by pursuing his show business dreams. Just before his departure, Kermit encounters Doc Hopper (Charles Durning), who attempts to persuade Kermit to be the spokesperson for his french-fried-frog-legs restaurant franchise, promising Kermit wealth and fame. Kermit quickly rejects Doc Hopper's offer, realizing that any success he would gain as Doc Hopper's spokesperson would come at the expense of betraying his own species and abandoning his morals. Ultimately, Kermit's rejection does not deter Doc Hopper from chasing Kermit and his Muppet friends across the country in an attempt to force Kermit to act in his commercials. Eventually, Kermit defeats Doc Hopper in a western-style standoff thanks to help from his friend Animal. When the Muppets finally arrive in Hollywood, they are given the opportunity to produce their own show as a group—their dream has been recognized and the Muppets can work toward Kermit's original dream of creating a happier, more positive world (and with *The Muppet Movie*, they do just that).

Similar to navigating the labyrinth, the Muppets' journey to Hollywood symbolizes physical as well as emotional and spiritual growth.[13] Both films are based on movement—from adolescence to young adulthood, from inexperience to enlightenment, and from stranger to friend. Kermit, like Sarah, gradually makes friends throughout this journey—each with their own identities and talents. Amid their travels, however, each singular character begins to identify with the group. No longer is it just Kermit the singer, or Miss Piggy the actress, or Fozzie Bear the comedian, or Gonzo the Great—together, they become the Muppets. While developing this communal identity, the Muppets begin to comprehend and appreciate the importance of ethical decision making and the power of friendship—two crucial Epicurean philosophies.

On the surface, *The Muppet Movie* clearly emphasizes the importance of following your dreams—but under the provision that dreams must be grounded in morality and reason. In basic terms, dreams are representations of our most profound desires—some dreams are far-fetched, some are selfish, and some are achievable. As Epicurus contends, it is not enough just to have a dream (or desire or pleasantry); the dream must be just, wise, and purposeful in order for it to lead to a happy life.[14] For Kermit, the true purpose of pursing his Hollywood dream is to make millions of people happy, not just to become rich and famous (made obvious by the fact that Kermit rejects Doc Hopper's offer). In actuality, Kermit has the potential to be just as rich and just as famous working as the spokesperson for Doc Hopper's frog leg restaurants, but, in doing so, Kermit would have to advocate mutilating his fellow species—a distressing idea that directly opposes his moral standing. Because of this, Kermit could never feel any pleasure, much less happiness, as Doc Hopper's spokesperson—regardless of how much wealth or fame he could obtain.

In addition to moral decision making, friendship is of supreme import to Epicureans; Epicurus believed that we should accept pains for the sake of our friends, even at the cost of our own happiness, as long as the result of such action promises greater pleasure in the future (which consequently ensures greater happiness).[15] Like Sarah choosing to enter the labyrinth at the threat of her own safety, the Muppets also choose to act in a way that contradicts their own desires in order to protect the well-being of their friends. For example, Miss Piggy could have done nothing to help save Kermit from Professor Krassman's (Mel Brooks) electronic cerebrectomy device—she was not the focus of the attack and probably would

have been released after Kermit's brainwashing. Fortunately, however, Miss Piggy fights the villains and saves her Kermy. Her decision to act in the face of danger illustrates the significance of friendship and Epicurean sacrifice—Miss Piggy sacrifices her own safety for Kermit, hoping that both she and Kermit will be happier once safe from danger. For an Epicurean, this is one of the major pleasures of having friends—friends will help protect you from bodily harm and mental distress. We *need* friends, and the pleasure that comes from friendship, in order to be happy. Had Miss Piggy left Kermit with Doc Hopper, she would have been safe from bodily harm, but her happiness still would have suffered. Just as Epicurus suggests, Miss Piggy may have contradicted her own desires by fighting to save Kermit, but her heroic actions solidified their mutual trust and confidence in one another as friends, resulting in a lasting friendship and greater happiness for both Kermit and Miss Piggy.

In short, the success of *The Muppet Movie* can be attributed, in large part, to the ethical messages embedded in the film as well as the method of delivery—people love the Muppets. Why? Because of the goodwill and amiability the puppets share with each other. They are friends, first and foremost. Ultimately, Henson was able to educate and inspire the world thanks to the heartwarming appeal of his Muppets—and Epicureanism provided the lens through which Henson produced these creations. Take, for example, another Henson production that starred some of his beloved Muppets: *Sesame Street*.

SESAME STREET: THE COMPASS ROSE

If life is the landscape and Jim Henson provides the Epicurean compass, then *Sesame Street* is the compass rose—it is central to navigating Henson philosophy. Though created in an attempt to educate and prepare preschool-aged children for entering school, *Sesame Street* does not focus solely on letters and numbers or colors and shapes. In fact, one of the major focuses of the show is to help young viewers develop cultural and social literacies. Much of this is accomplished through an Epicurean ideology—the children learn to act appropriately to given situations because of positive reinforcement from their friends on *Sesame Street*. In other words, these lessons teach young viewers to do what makes them feel good, but never if it requires making someone else feel bad. This idea

is the foundation for Epicureanism—Epicurus encouraged followers to act in a way that provides pleasure, but never at the expense of another. And this concept, in addition to the importance of friendship, is integral to *Sesame Street* discussions involving virtues like acceptance, forgiveness, friendship, and kindness. Even today, *Sesame Street* continues to help children navigate complex issues like marriage, pregnancy, and death.

One of the most famous episodes of *Sesame Street* occurred after the death of actor Will Lee, known on *Sesame Street* as Mr. Hooper. The producers of the show were faced with a dilemma—replace Lee without explaining his disappearance to viewers, or create an episode dealing with his death. They chose the latter. In the episode, Big Bird wants to give Mr. Hooper a picture he has drawn of him, but his adult friends explain that Mr. Hooper has died and will not be able to come back. Though Big Bird is saddened by Mr. Hooper's death, he begins to comprehend that he can still cherish his memories of Mr. Hooper. The episode ends with Big Bird surrounded by his friends, demonstrating to viewers that the characters will find happiness again thanks to the support and kindness they share with each other as friends. In Epicureanism, this is the pleasure we are supposed to derive from friendship. There is a reason we do not feel happy when we feel lonely. As humans, we desire other human contact, both primitively for our own protection and survival and also for our own happiness. Friends are not luxuries; as Sarah points out, they are needs.

Overall, *Sesame Street* has impact not only because it is entertaining but also because it is educational. And not just educational in the traditional sense—the Muppets on *Sesame Street* guide children through their formative stages, helping viewers to both learn and grow as individuals. A walk down Sesame Street is a type of movement that coincides with growing up.

At the time of their production, Henson's Muppets were a revolutionary departure from mainstream television. Throughout the decades, it is obvious that the appeal of Henson's creative masterpieces have not only persevered but also grown in popularity (as demonstrated by the continued success of the Henson franchise, in addition to more recent puppet-driven educational television shows for children, such as *Blue's Clues*, *The Wiggles*, *Yo Gabba Gabba!*, and *Pajanimals*, to name a few). And this popularity has given Henson the opportunity to share his timeless Epicurean views with the world. *Sesame Street* still airs today—cultivat-

ing creativity and intelligence in the minds of future generations and creating feelings of nostalgia for past generations.

HENSON GUIDES THE WORLD

There are many naysayers, even disparagers, of Epicureanism. Some say that hedonism of any kind cannot be ethical, and that friendship cannot exist for a hedonist. Others view it as a philosophy grounded in selfishness. I disagree. To be clear, Epicureanism is not tantamount to recommending overindulgence or lack of restraint. In fact, Epicurus regularly scorned profligate pleasures and advocated helping others—as did another, much more contemporary creative thinker: Jim Henson.

Henson's beloved works, which have endured the test of time, speak to our hearts. In a final letter to his children before his death, Henson wrote, "Life is meant to be fun, joyous and fulfilling"[16]—the many creatures from his creative workshop help millions of people find that joy every day. The lessons Henson offers are grounded in some of the greatest pleasures of life: compassion, virtuosity, and friendship. By offering an Epicurean moral framework that can be applied to a variety of ethical issues, Henson prepares us to navigate the maze (or, dare I say, labyrinth) that is life.

13

MY (UN)FAIR LADY

Power, Fairness, and Moral Imagination in *Labyrinth*

Natalie M. Fletcher

When people hear the name Jim Henson, they tend to think of the fuzzy felt faces that made him famous, from the legendary Kermit and Miss Piggy to the lovable cast of *Sesame Street* and *Fraggle Rock*. Yet, according to his family and friends, Henson's experimental projects were actually those closest to his creative and philosophical sensibilities, reflecting his high regard not only for the art of puppetry but also for conceptual wonder and joyful whimsy in an age of seemingly boundless technology.[1] Chief among these projects was his 1986 musical fantasy film *Labyrinth*, the story of an adolescent girl who must navigate an otherworldly maze to rescue her baby brother after he is kidnapped by a goblin king come alive from her favorite fairy tale.

Unfortunately, at the time of *Labyrinth*'s release, critics and audiences were reluctant to join the journey, faulting Henson's story line and star for not living up to the "affectionate anarchy" that made his Muppet brand so uniquely relatable.[2] Few could identify with the lead character of Sarah, played by a young pre-Oscar Jennifer Connelly, labeling her as emotionally wooden and incapable of personal growth.

Granted, puppet-infested fantasy movies set to David Bowie glam rock are not for the faint of heart. But given Henson's personal investment in the film, he took these criticisms with considerable dejection and, sadly, did not live long enough to see *Labyrinth* reach cult classic status, enthralling tons of kid fans (this author included) who, if asked, would

eagerly come to its defense, and not just because of fond memories of staging large-scale scene reenactments with friends in their childhood basements.

Sarah may be the quintessential teenage brat, but we can learn a lot about moral agency from her struggles, especially the mishaps that occur when we are too unimaginative to see the bigger picture. Henson once compared life to a labyrinth, "with all its twists and turns, its straight paths and occasional dead ends,"[3] and it is precisely through this confusing network of choices that Sarah has her first real experiences of power, freedom, and fairness.

A philosopher of childhood in his own right, Henson described *Labyrinth* as "captur[ing] the moment when an adolescent girl realizes she is responsible for her life."[4] As this chapter will show, the fact that Sarah repeatedly finds herself between a rock and a goofy place only further illustrates Henson's keen ability to portray philosophical ideas and coming of age with both nuance and humor.

AN UNFAIR FANTASY

When we first meet Sarah, her fairness radar is far from operating properly. She comes across as a tantrum-prone teen who is too concerned with the whereabouts of her stolen teddy bear to realize how quickly she plays the victim card and refuses to grow up. Though not exactly roughing it in her mansion with all her toys and leisure time, she is indignant at having to interrupt her make-believe games to take care of her baby brother, Toby. "Someone save me, someone take me away from this awful place!" she screams to perfectly timed thunder. Oh, the wild injustice of unexpected raindrops, babysitting duties, and overindulgent parents!

Sarah's childish bedroom further reveals the extent to which she is stuck in fantasy mode. Her book collection points to an obsession with classic fairy tales that glorify innocence, hero worship, and damsels in distress. According to ethicist Martha Nussbaum, while literature is "a crucial preparation for concern in life,"[5] fictional stories become dangerous if they encourage young minds to see the world only in black and white, beyond a shadow of a doubt. The obvious hero/villain dichotomy in many fairy tales risks creating a disgust pathology that causes us to see

anything unfamiliar or foreign as a possible threat or source of malaise—in short, as monstrous.

For Nussbaum, a fear of monsters in childhood can morph into an oversimplified fear of otherness in adulthood: the hero-must-slay-monster mentality can have devastating ramifications on our efforts to think and act reasonably, including "the construction of a 'we' who are without flaw and a 'they' who are dirty, evil, and contaminating."[6] Henson would surely share Nussbaum's concern, given his wholehearted commitment to helping children see past the stereotypical. When critiqued for the frightening expressions of puppets like Cookie Monster, he emphasized the potential for teachable moments: "The child can get to know these monsters and understand that they are not things to be frightened of. It's a scary image, but the child can learn to handle it."[7]

Sarah, however, has yet to learn this lesson about fairly appraising herself and others. Since her ethical scope is very narrow, her feelings of entitlement distort her sense of fairness, preventing her from seeing beyond her self-interested perspective. She assumes there is but one way to view the world: her own. So when Jareth the Goblin King (played by a brazen David Bowie) makes her an offer she can't refuse—freedom from responsibility in exchange for her baby brother—she is initially seduced, unable to imagine a better bargain. What Sarah lacks is moral imagination, or the ability to envision her context from multiple, even incompatible, frames of reference to ensure a broad moral lens with which to approach and assess her lived experience.

Sarah concocts a self-serving narrative of her life situation as an exploited martyr who is "practically a slave" and "suffers in silence" at the hands of a wicked stepmother who forces her to babysit—she considers her circumstances unjust because she cannot compare them to other instances of injustice. Once in the labyrinth, her "It's not fair!" refrain becomes a source of bemusement for Jareth: "You say that so often," he replies at one point. "I wonder what your basis for comparison is." In such cases, if Sarah were more morally imaginative, part of her reasoning process would include asking herself: How else can my situation be perceived? Am I making snap judgments or hasty generalizations? What are the consequences of thinking this way?

Indeed, moral imagination allows us to imagine our way beyond our own context so we can genuinely consider alternative perspectives, and see others and their circumstances as worthy of our moral concern. If a

morally imaginative person has reason to value something, it is likely because she has weighed its moral worth in relation to a host of other possible considerations through careful deliberation. Though she loves her imaginary world, Sarah's own mental landscape at the film's outset is rather arid, and this for three main reasons:

1. Sarah is unaware of her limitations of perspective. She can't see her own conceptual shortcomings, so she does not try to imagine a different set of vantage points to help diversify and problematize her own, especially with respect to fairness. (It's just one night of babysitting—get over it!) In Nussbaum's words, she approaches "each situation prepared to see only those items about which [she] already knows how to deliberate,"[8] making her ethically inflexible.

2. Sarah fails to recognize common experiences between herself and others. She is so caught up in her histrionics that she cannot conceive of similarities between her life and the needs, goals and challenges that others face. (Crying babies are exasperating. Period.) She needs, as Nussbaum emphasizes, to "comprehend the motives and choices of people different from [her], seeing them not as forbiddingly alien and other, but as sharing many problems and possibilities."[9]

3. Sarah does not seem to realize life's complexity. Her black-and-white reading of the world prevents her from imagining the ways in which her own values may conflict with one another and with those of others. Yet, as stressed by Nussbaum, each moral value "generat[es] its own claims . . . in any number of particular situations and actions,"[10] requiring us to be sensitive to the complex role each of them should play. For Sarah, fairness and freedom are in tension with other equally important values like responsibility, and it's only by confronting the labyrinth's obstacles that she eventually learns to transcend her narrow moral scope and expand her imaginative repertoire.

NEVER TAKE THINGS FOR GRANTED

If the labyrinth has a take-home message, it's this: We shouldn't take anything for granted. As Sarah soon discovers, this adage is easier said

than enacted. Philosophically, it can be interpreted as a warning against two things: our proclivity for assumptions and our tendency to lack gratitude. To be sure, we often take things for granted just to get through the day: we assume the sun will rise tomorrow, that cars will stop at red lights, that a new Muppet movie will come out soon (pretty please?).

But taking some things as true without question or failing to appreciate them can be very problematic, revealing another symptom of insufficient moral imagination. In Sarah's case, her reckless actions have resulted in a goblin gang abducting a human toddler and, along with him, any claims to knowledge she may have held.

Upon entering the labyrinth, Sarah's big lesson comes in a little package: a mild-mannered worm intent on having her over for tea. Yet the worm's-eye view is hardly humble, and it is actually a profound source of wisdom. When Sarah's assumptions about the labyrinth layouts keep her from seeing openings in supposed dead ends, he offers this advice: "Well, you ain't looking right. It's full of openings. It's just you ain't seeing them. . . . There's one just across there—it's right in front of ya. . . . Things aren't always what they seem in this place. So you can't take anything for granted."[11]

This kind of perception problem is what interests Mark Johnson in his book *Moral Imagination: Implications of Cognitive Science for Ethics.* According to him, people who lack moral imagination have difficulty framing their circumstances in creative ways, settling for rather restrictive points of view. Imprisoned by limited conceptual framing, Sarah sees others only as possible burdens or pawns, reducing them to caricatures rather than seeing how their outlooks might enrich her own. She assumes that fairies are kind and "supposed to grant wishes," so she is surprised when she is bitten by one. She assumes the false-alarm walls are predicting her doom when they are simply fulfilling their role of intimidating visitors: "I'm just doing my job," one tells her.

Sarah also assumes her logic skills will open doors for her, but the labyrinth's inhabitants, especially Hoggle, aren't convinced. When confronted with a spin on the classic Knights and Knaves logic puzzle that pits truth-tellers against liars, she is a little too smart-alecky for her own good and winds up in a literal downfall. Time and again, the doors of the labyrinth reinforce the importance of not taking things for granted, from the front entrance to the oubliettes to the goblin city fortification protected by a humongous mechanical guard. Still, Sarah only hears what

she wants to hear—her own version of labyrinthitis. Yet, as Johnson notes, "knowing about the precise nature of the particular frames we inherit from our moral tradition and apply to situations is absolutely essential, if we are to be at all aware of the prejudgments we bring to situations."[12]

What our leading lady doesn't yet realize is that the labyrinth punishes arrogance and cowardice alike. Every time Sarah pompously dismisses her experience as easy—"it's a piece of cake!"—she gets herself into trouble, compromising her own safety or that of her companions. Similarly, when she fools herself into thinking she is not accountable for the outcomes of her actions, she gets a reality check that further exposes life's shades of gray. In a strange homage to Henson's beloved Kermit, Sarah's naive judgments give a whole new meaning to the now timeless line, "It's not easy being green."

But based on Johnson's account, if she were more morally imaginative, she could interpret her contexts in new ways, increasing her understanding of fairness and responsibility. She could see that some characters are not out to hurt her but trying to lend a helping hand—or a hundred, in the case of the shaft of talking hands. Depending on her conceptual framing, the brick-keepers rejigging the labyrinth tiles can be interpreted as a horrible affront to fairness or an appropriate reaction to having their home defiled by lipstick. Even the Bog of Eternal Stench can smell sweet to some, as Sir Didymus pungently reminds us. It's all a matter of perspective, and a little humility can go a long way toward removing the blinders impeding moral perception.

BEWARE OF GOBLIN MIND CONTROL

Yet, as Sarah becomes more adept at creative problem solving, her confrontations with Jareth the Goblin King only reconfirm that all is not fair in love and wizardry. She wrestles on the wrong end of Jareth's power play ever since having had the audacity to interrupt his lazy afternoon of crystal-gazing with his horde of baby-snatching goblin minions who laugh and dance on command.

A master manipulator, Jareth represents French philosopher Michel Foucault's worst nightmare when it comes to abuses of power. In his book *Discipline and Punish*, Foucault tracks the historical development

of punishment from physical torture as a public spectacle to the more subtle, but no less damaging, practices of controlling the mind by restraining, confining, or regulating the body. On this view, asserting power becomes less about inflicting pain on others than restricting their freedom and slowly taking hold of their soul, controlling "not only what they do, but also what they are, will be, may be."[13]

In the same power-tripping vein, Jareth runs his labyrinth like a prison, lording it over his underlings in too-tight leggings, as only an androgynous rock star despot could. (No, Jim, the irony is not lost on us.) Sarah's every move is quite literally crystal clear to Jareth thanks to his Panopticon-like surveillance system, which oversees every square inch of his territory through his oscillating show stones. In Foucauldian terms, this close scrutiny places Sarah and the other labyrinth lackeys under the threat of a constant "faceless gaze" that makes them fearfully follow the rules and self-regulate without Jareth having to lift a finger.[14] Beyond space manipulation, Jareth's brand of rough justice also includes time warping, meaning the thirteenth hour may be an unlucky one for our heroine if she doesn't mind the erratic clock.

Jareth's preferred mode of subjugation involves taking Sarah out of her comfort zone just long enough to make her feel eternally indebted to him when he tempts her with an alleged dreamscape, transforming her into what Foucault calls a "docile body."[15] Knowing that grabbing hold of her mind is paramount to ruling her, he sends a fire gang of dancing fiends to distract her from Toby with promises of worry-free fun ("We can show you a good time!") as she tries desperately not to lose her head over their antics ("Hey, her head doesn't come off!").

The masquerade continues when Jareth has the charming idea of drugging his fifteen-year-old captive with a hallucinogenic peach, impairing her judgment so she'll be more readily entranced by his subduing serenade: "I'll be there for you as the world falls down," he sings, spellbinding her. While Henson envisaged the scene as representing a both "attractive and repellent"[16] encounter for Sarah, for Foucault it would epitomize the enduring power struggle between domineering and subjugated bodies. Sarah is the belle of the ball until the bubble bursts: in a Cinderella moment at the stroke of midnight, with her mirror image evoking her new responsible self, she manages to shatter the illusion and finally free her mind.

STAIRWAYS TO AN OPEN MIND

Sarah's emerging moral imagination is best symbolized at the film's climax when she finds herself in a room of topsy-turvy stairways, by far the most alluring real estate in Goblin City. In tribute to graphic artist M. C. Escher's 1953 lithograph *Relativity*, Henson wanted the room to represent a world where perspectives change depending on the fields of gravity: "Nothing tells you what's up or down," he mused. "You can never orient yourself to what you're looking at."[17]

The resulting dizziness makes it harder to discount perspectives as worthy of consideration, breeding the kind of comfort with uncertainty and willingness to contemplate new possibilities that makes morally imaginative reasoning possible. At last, the wise man's words, once as meandering to Sarah as her maze-like adventure, begin to make sense: "The way forward is sometimes the way back—quite often, young lady, it seems like we're not getting anywhere when in fact we are."

In that moment, Sarah takes a big step toward becoming a better sister, but Toby remains just beyond her reach. She realizes the gravity of the situation and tries to defy Jareth by keeping both feet on the ground, while His Highness, the space oddity, floats midway between fantasy and reality. Finally, she takes a leap of faith into the unknown, assuming nothing, and Jareth's kingdom begins to crumble. He makes one final attempt to woo her, but the shallow version of freedom on offer no longer appeals to Sarah, and the liberating words she could never remember come rushing back: "You have no power over me!" she exclaims. In trying to constrain her mind, Jareth winds up setting it free, realizing with a heavy heart that he can no longer live within her.

A now duty-bound Sarah discovers that she has power over her situation simply by virtue of being able to see it differently—the labyrinth becomes a metaphor for envisioning a life of diverse, evolving perspectives. While responsibility certainly epitomizes her transformative journey, her triumph is made possible because she learns to confront her failures of moral imagination. Recognizing how her misguided assumptions derail her, she is less quick to judge the labyrinth's obstacles and creatures prematurely.

Sarah learns to become what Nussbaum calls "an intelligent reader of a person's story,"[18] enlarging the boundaries of the mental landscape that informs her values and choices. She is also better able to read her own

story, understanding that the Junk Lady's rendition of her childhood is actually a knockoff—mere dead weight designed to mislead her. Having faced a few "dangers untold and hardships unnumbered" of her own, she is now ready to tuck away her *Labyrinth* script in a drawer and think twice before ever wishing upon a goblin.

In the end, Sarah starts to see life through the multiplicity of perspectives that Henson so valued and hoped to instill in his young audiences. According to him, teaching children about creative thinking was about showing how "each one can do the same thing differently"[19] and recognizing one another's original contributions. Sarah learns to appreciate those who have contributed to her journey, seeing them as true friends rather than tools for her advancement: "I don't know why but every now and again in my life, for no reason at all, I need you. All of you." Even the villain turns out not so bad—a wise owl dispensing tough life lessons.

For Henson, this sense of openness was imagination's greatest gift. "We can only find peace through greater awareness of our connections," he wrote. "I think it's possible to change the world by reinforcing our interconnectedness, the spirit of one family of man, to the children of the world."[20] Now imagine that.

14

YOU COULDN'T HANDLE REAL LIFE

The Villains of *Labyrinth* and *MirrorMask*

Jennifer Marra

Labyrinth and *MirrorMask*, while decades apart, have a great deal in common: a strong-willed, teenage, female protagonist searching for something in a fantastical world. It is certainly important to Jim Henson to explore the journeys of self-discovery and self-realization in his heroines, but it is also crucial to appreciate the role of his villains. Only by understanding the depth and complexity of his villains can we truly appreciate their contrast with Henson's heroines and their roles in the young women's metamorphoses. In this chapter, I will take a philosophical look at the villains of *Labyrinth* and *MirrorMask*. Who are the villains in these stories? Are they truly as free and powerful as they appear? What role do the villains actually play in the overall theme of these films?

DESIRE FOR FREEDOM

Labyrinth and *MirrorMask* begin the same way: a teenage girl with a vivid imagination wishes her life were different. In both films, her wish comes true. She must go on a journey full of grand obstacles, slimy traitors, and all-powerful villains in order to regain what she had not appreciated in the beginning—the life that she was already living. *Wizard of Oz*–esque, to be sure. But this is Jim Henson. Henson's stories are not only about learning to appreciate what you have but also about taking

responsibility for one's choices and realizing that one's wishes, and the consequences of fulfilling those wishes, have grand implications. Henson takes a common motif and spins it on its head: his heroines must confront the reality of their deepest and darkest desires, made manifest for them in villains, in order to realize that desire itself can be destructive.

The greatest desire our heroines have is for freedom. Sarah wishes the goblins to take Toby away so she can be a normal teenager, and Helena wishes "to be the death of" her mother so she can live a normal life outside of the circus. Jareth grants Sarah's wish, and Anti-Helena and the Queen of Shadows grant Helena's. Sarah must traverse the labyrinth and fight Jareth, and Helena must escape the Shadows to retrieve the charm from Anti-Helena to restore order and awaken the Queen of Light. Our villains, then, are Jareth, the Queen of Shadows, and Anti-Helena. But are they really the bad guys here? They were, after all, simply fulfilling the wishes of the heroines. And they don't wish to harm Sarah or Helena at all; on the contrary, they want nothing more than their affection. I suggest that we concentrate on the sort of freedom these characters have to do as they please, freedom that the heroines so desperately want, in order to give us a better understanding of who our villains are and how they are ultimately defeated.

POWER AND THE VILLAIN

Jareth the Goblin King (in addition to being many viewers' first blush with androgyny and consequently sexual confusion) is a complex villain. He is able to manipulate space and time, he commands a horde of adorably creepy goblins, he can tap into crystal balls and use them for surveillance, he can fit an entire masquerade ball into a peach, and he looks fabulous in a pair of leggings. Jareth seems to be an all-powerful villain bent on turning Toby into a goblin minion and winning the servitude of Sarah. But how does he go about meeting this goal?

It is first important to note that Jareth cannot act to steal away Toby unless Sarah says the words. Once she does, he is bound by the rules of the labyrinth; if Sarah makes it to the center of the labyrinth, he must give up the child. He claims that his love for Sarah is what motivates him to do as she asks, and he is jealous of her friendship with Hoggle. This seems odd for an all-powerful villain. Why couldn't Jareth just take Toby when-

ever he wanted? Why can't he just teleport to a new location every time
Sarah gets close? Why does he have to wait thirteen hours to turn Toby
into a goblin? We know he has the capability to kidnap unnoticed (by
sending his goblin squad), teleport (or turn into an owl), and manipulate
matter (like turning scarves into snakes)—so why doesn't he just do it?
He has the power to control everything, but he doesn't.

The same is true of the Queen of Shadows. The Queen can send
Shadows to destroy the world, she can send armies to retrieve her missing
daughter, and she can persuade Valentine into betrayal with jewels. She
misses her daughter, but will settle for Helena. She knows that the awak-
ening of the Queen of Light will put the world back in order, effectively
ending her takeover. So why doesn't she simply swallow up the Queen of
Light with Shadows and prevent the possibility? And Anti-Helena is even
more powerful than the Queen of Shadows—all she has to do is destroy
Helena's drawings of her world and everything will be extinguished,
including her mother. But she hesitates. Instead of crushing Helena in the
Dreamlands by crumpling up the drawing as she did to all of the others,
she simply relocates the hut that she sees Helena inside. Both villains
have the power to end the struggle between Light and Shadows, Helena
and Anti-Helena, but they don't.

What is it about Henson's villains that leaves them unable or unwill-
ing to use all of the power bestowed upon them? Why can't they simply
snap their fingers and win the day? With all the control they have over
their worlds, why do they suffer, why do they care about the protagonists,
and why don't they break into musical numbers more often? To get clear
on answers to these questions, let's first take a look at the character of our
heroines.

THE STRUGGLE FOR CONTROL

Let's be real: Sarah and Helena are brats. Well, they're teenagers. And as
teenagers, they want things to go their way. They want what they want
when they want it, and they certainly do not want to be told what to do by
their parents. Sarah and Helena are childlike in many ways, slowly
guided into adulthood by parents who want to make the transition as
painless as possible. But the young women are having none of it. Sarah
does not want the responsibility of babysitting Toby because it might

interfere with her plans to act out her play in costumes with her dog. She holds on to ideals of fairness in life and becomes terribly upset when something she deems unjust takes place. Helena wants to be left alone to draw and put on puppet shows, and she absolutely hates the fact that her parents make her work. She doesn't want to juggle in a traveling circus; she wants to stay in one place and have a normal adolescence. Neither character is willing to empathize with the adults in their lives: Sarah knows that her father and stepmother like to go out once in a while, but she doesn't understand why they would want to, especially given how inconvenient it is for her. Helena knows it's her father's dream to run a circus, but she doesn't understand why she has to sacrifice for a dream that is not hers.

The problem for Sarah and Helena is the same: They are frustrated by the fact that they don't have control over their lives. They are being told what to do by people they view as villains—people who, in actuality, aren't so bad. So when Sarah and Helena step into their fantasies, these people are represented by the sorts of all-powerful villains the young women are used to seeing in their stories. Jareth is the man who says he loves Sarah and will give her anything she wants so long as she bows down to him. The Queen of Shadows will grant Helena's every wish and whim so long as she remains the good little girl that she wants her to be. Anti-Helena has all the freedom Helena wants, and she will do whatever it takes to keep it.

But these villains, just as those they mirror in real life, are not actually capable of ruining the lives of Sarah and Helena. Only Sarah and Helena can do that. To make this point more clear, let's take a look at what French philosopher Jean-Paul Sartre says about the nature of freedom.

THE WILL TO CHOOSE

Jean-Paul Sartre describes human beings as "condemned" to be free—that is, in the end every decision we make is fully and completely our responsibility.[1] We are free to choose one option or another, or free not to choose anything at all. Every decision we make is a free choice, and with freedom comes responsibility. We can try to pawn it off on other people, bad advice, or a shoddy horoscope, but at the end of the day we are responsible for our choices. No matter how we try to get out of it, we find

that the buck is always going to stop with us; we choose to listen to other people, bad advice, or shoddy horoscopes, and the choice to do so makes us responsible.[2] This is why, according to Sartre, we feel anguish. At the end of the day, we have no one to blame but ourselves, and we know it. We are responsible for ourselves regardless of whether we want to be, and we can't use anyone else as a scapegoat.

It is this philosophical idea of freedom that is emphasized and reinforced through Henson's villains. Sarah wants to blame her father, her stepmother, and Toby for her disenchantment with ordinary life. Helena blames her mother and father for forcing her to perform in a circus that she doesn't care about. Both young women feel trapped in their own lives and take no responsibility for their own roles. It is only after the pattern of those lives is threatened (by a missing child and a sick mother) that our heroines begin to appreciate what they have. But they can't just get over themselves and accept what has been given to them; they must reclaim their lives *as their own*. To feel ownership over their lives, they must fight for them. And if you're going to fight, you need something or someone to fight against.

Unlike our heroines, these villains have control over their environment. They are in charge, they can command others to do as they say, and they can even defy the laws of the physical world. Jareth can order his goblins to laugh at his stupid jokes, the Queen of Shadows can transform Helena with the eerie makeover robots, and both can tempt our heroines' companions into betrayal. The world itself bows to the whims of our villains, and yet somehow they are still defeated. It hardly makes any sense at all.

But that is because the power to control one's environment is a fantasy, just like the characters themselves. No matter how hard we try, we can't control what happens to us. Life isn't fair. Bad things will happen to us. Babies will cry and mothers will get sick. Lancelot bears will get lost and dads will have to take meetings at the bank. Dogs will get wet and families will fight. Accepting these truths is the first step toward freedom and happiness in many different philosophies, from Christian to ancient Greek to Buddhist.

St. Augustine writes that the only thing that one can control is one's relationship to God. Sin itself begins with inordinate desire—that is, "the love of those things that one can lose against one's will."[3] You take an ethically questionable job for the money, or lie to your spouse to save

your marriage. But money can be taken away from you just like that, due to the crash of the stock market. Your marriage could end in the blink of an eye, even if you did everything right, because your spouse could die. You can't control whether a flood wipes away your house or your company decides to downsize. All you can control, according to Augustine, is whether you keep your eye on the only eternal and unchanging thing out there—God.

The idea of control (or lack thereof) isn't confined to theism. Epictetus, an ancient Greek Stoic, said that you should be clear as to what it is about items and people that you are so attached to, and remind yourself that those things can be taken from you at any moment. "If you are fond of a jug, say to yourself, 'I am fond of a jug!' For then when it is broken you will not be upset."[4] This is true of people as well: "If you kiss your child or your wife, say that you are kissing a human being; for when it dies you will not be upset."[5] Bummer? Absolutely. Harsh? Certainly. And comparing a spouse or child to earthenware? Problematic. But the idea is the same. Human beings die; it's what we do, and nothing we can do can change that. We can't control mortality or anything else. All we can control, for the Stoics, is how we respond to the world around us. We can choose to be upset when something we are fond of is taken from us, or we can choose to understand the inevitability of it.

Buddhist philosophy echoes the same insight: we cannot control what is around us. If we ever want to reach nirvana, the state in which there is no suffering, we must first recognize that all suffering comes from craving things we do not have and clinging to things that we cannot keep.[6] And, just as Augustine and Epictetus recognize, those things include objects, circumstances, and people. Sarah and Helena cannot accept what these philosophers see as crucial to any sort of contentment or happiness. Not only do they think control is possible, but they are also frustrated because they believe there are people standing in the way of them gaining that control and thus fully exercising their freedom.

So Jareth and the Queen of Shadows represent Sarah and Helena's desire to control their environment, which our philosophers tell us is an impossible goal. If we look at what Sartre says of freedom, we can make sense of why our villains fail to win the day. The villains of *Labyrinth* and *MirrorMask* are fueled by the imaginations of our heroines. Jareth is an idea born from a play that Sarah loves and is brought to life by her imagination. The Queen of Shadows is a drawing come to life for Helena.

Anti-Helena is the projected image of what Helena will become if her mother doesn't survive the surgery. But these villains are limited, just like Sarah and Helena and indeed all of us. Sartre says that we are free whether we want to be or not, but understanding one's freedom and responsibility means understanding one's limitations.

Sartre would call this one's context—the sociohistorical and biological situation in which we live. I am free and responsible for all the decisions I make, but I am not free to choose to be born in a different era, or free to fly instead of plummet if I leap off of a building. I am bound by certain rules of nature and limits of my environment, and I have to understand those limits precisely if I am to live in what Sartre calls "good faith." Living in good faith means understanding my freedom (and how I can exercise it) and taking responsibility for it. Failure to do this is what Sartre calls "bad faith."[7] It is bad faith to think that I am bound completely by my context, that I have been forced or determined to make choices by my environment, and to thus take little or no responsibility for those choices. But it is also bad faith to think that I don't have to pay any attention to my context, that I can and should do whatever I want, and that the consequences won't matter. This is the sort of bad faith that Sarah and Helena live in at the beginning of their films.

Sarah and Helena think that they should be free to do whatever they please whenever they want, and that their parents and situations are preventing them from exercising their freedom. This is bad faith. Jareth and the Queen of Shadows, however, can do all sorts of fabulous things but are not free to control everything. And the wonderfully interesting thing about these villains is that they know it. According to Sartre, they are living in good faith; they know their limitations, and they work within their context to get what they want. They can't force Sarah or Helena to do what they want because control over everything and everyone is impossible, just like Augustine, Epictetus, and Buddha insist.

Henson's villains can literally turn the world upside down, but Jareth knows he can't force Sarah to love him, and the Queen knows she can't make Helena her daughter just by giving her a makeover. We empathize with them because, in the end, these villains are just like us. Though they have powers we do not, they are free to exercise their own choices and are bound by their context, just like us, and just like Sarah and Helena. While Jareth and the Queen of Shadows can manipulate their environments in fantastical ways, they still lack absolute control.

But what about Anti-Helena? How does she fit into this scenario? Anti-Helena is what Helena will become if she takes the control she thinks that she needs in order to exercise her freedom. She's not a villain like Jareth or the Queen of Shadows; she's a warning. She controls her environment by destroying remnants of her former self, the drawings, but she doesn't care about the quest to restore balance, and she doesn't care about what happens to the world if she never returns. She is only worried about getting away from her mother and doing whatever she wants; she is Helena from the beginning of the film. She doesn't care about stopping Helena or making her suffer—she only cares about herself. But she, too, can't control everything. She can fight with Helena's dad, eat chips, snog boys, smoke, and everything, but she can't make herself happy. Looking into the mirror and seeing what she will become awakens Helena to the reality of her desires. Freedom itself isn't enough to make you happy; you also have to be willing to let go of the need to control everything. It is this realization that enlightens Sarah and Helena toward the end of the films: they have been free all along, because freedom does not equal absolute control.

CONCLUSION

So what is it that we can learn from an in-depth look at Henson villains? First, those villains only have as much power as we give them, and they are only as monstrous as we make them. Jareth, the Queen of Shadows, and Anti-Helena are what Sarah and Helena made them. We, too, find villains in our lives, people we blame for the ills that befall us, people we think make our lives unfair. But they are only as powerful as we make them. Our imaginations and our refusal to take responsibility for ourselves lead us to create monsters out of people, people just as free and just as responsible as we are. No one, whether hero or villain, can control everything.

More importantly, we learn that our suffering and unhappiness come from the desire to make everything fair, to control the world around us, and to make things go our way. As soon as we realize that this is an impossible goal, the suffering and unhappiness will end. Jareth, the Queen, and Anti-Helena are just like us. They may have more control than we do, but not absolute control. They are free but bound by their

contexts, just like us. The difference, Henson seems to suggest, is that we can transcend beyond the level of the villain. We can, like our heroines, choose to use our freedom to gain stability and peace within ourselves while taking the well-being of others into account. Villains want to use their freedom to manipulate others into serving their own needs in purely self-serving ways. Villains know they are limited but still feel unsatisfied. Heroines will learn their limits and feel complete. Henson's grand revelation is that we are all capable of the heroic, and it is our choice whether we do so.

15

MEEP IS THE WORD

Victims, Victimization, and Buddhist Philosophy
in the Characters of Jim Henson

Dena Hurst

I say "Jim Henson," you say "victimization." Right? Probably not. Words like *Muppet* or the name of your favorite character or movie likely come to mind first. So why link Henson's name to such a topic as victimization? Because, as fans will undoubtedly have realized, Henson's characters and stories are allegorical, all representing more than meets the eye. Themes found in social and political philosophy, including racism, social justice, freedom, rights, and, yes, victimization, are ever present, be they expressed through characters, narratives, or staging. The wonder of his work, however, allows us to explore these issues from many vantage points, and that is the aim of this chapter—to provide a different perspective on what it means to be a victim, one that questions the assumption that victims are somehow different from other people and that victimhood is some undesirable state of existence that must somehow be overcome.

IT ISN'T EASY BEING A VICTIM

Our journey through the world of Jim Henson begins, as any philosophical journey should, with a clarification of the philosophical issue—what a victim is, what it means to be victimized, and the moral status of victims. A victim is one who suffers some kind of ill treatment from another.

Victims generally are seen as underserving of this ill treatment. Criminals are victims of state punishment, for example, but that is because they have been found guilty of committing a crime and thus deserving of their punishment. Victims do not initially seek out their ill treatment, nor do they relish it, and so victims are not martyrs. Victims can, however, vanquish those who harm them or emerge triumphant from victimhood and become heroes.

An animal or child being abused, a woman raped, a civilian killed in a bombing, a person kidnapped and tortured—these are all clearly victims suffering cruelty at the hand of another. We view these victims with empathy or pity. Perhaps we even have a thought of "There but for the grace of God go I," tinged with a bit of guilt at our own good fortune. There might even be feelings of anger over the injustice, a need to release the victim from their plight and do something to prevent it from happening to others. Whatever we feel, we feel *something*. People who suffer through no fault of their own, who are helpless to fight back, evoke emotional reactions.

This is because, whether we realize it or not, we are making assumptions about the moral status of victims and about the rightness or wrongness of the actions perpetrated against them. We intuitively recognize that people ought not to treat others as victims. We place the moral blame on the victimizer, and we view the victim as always morally right. According to the philosopher Immanuel Kant, people who are capable of making moral decisions, who are competent in their cognitive abilities and who can distinguish right from wrong, are considered moral agents.[1] As such, moral agents have attending moral responsibilities to choose right over wrong and to be accountable for the consequences of their moral decisions. Thus, a moral agent who chooses to be a victimizer is consciously doing wrong and is morally responsible for the harm done to the victims. Victims, who do not willingly choose to be victimized, have their freedom taken away by victimizers and thus are not fully moral agents. While the victims know right from wrong, they are unable to choose their actions; their choices are determined by the victimizer. Because victims do not choose to be victimized, they bear no moral responsibility for the harm they suffer.

Complementing the concept of moral agency, we have the concept of being of moral worth. Moral agents have a duty to protect subjects of moral worth. As Kant instructed, "So act that you use humanity, whether

in your own person or in the person of any other, always at the same time as an end, never merely as a means."[2] Subjects of moral worth are those things that have value in and of themselves. For Kant, subjects of moral worth were people, but other philosophers have argued that nature and animals also have intrinsic value and are thus deserving of protection. Peter Singer, for example, is a philosopher who claims that animals have the same moral status as people because they, like people, can feel pain.[3] Ecophilosophers see nature as a subject of moral worth, needing protection, as nature cannot defend against us.[4]

People who are subjects of moral worth may be incapable of being moral agents and thus are deserving of our protection. Some philosophers (Jeremy Bentham and John Locke, for example) view children and people with impaired cognitive abilities as subjects of moral worth and not as moral agents because they lack the cognitive capacity to distinguish right from wrong or understand the moral implications of their actions. Knowledge, including moral knowledge, is learned from experience; thus only fully formed individuals could have the knowledge and experience needed to know right from wrong.[5] In children, this capacity develops over time, with proper instruction and physical maturation; as children grow into adults, they become moral agents. Through the eighteenth century, it was held that women could never be full moral agents; women were viewed as incapable of exercising good judgment, their thinking being clouded by emotions.[6] Any person who does not have the ability to decide right from wrong cannot become a moral agent.

People (aside from the exclusions noted above) generally hold the unique distinction of being both moral agents and subjects of moral worth, as human beings in general are considered to have inherent moral value. For reasons we will explore below, victimizers lose their status as subjects of moral worth by consciously choosing to do wrong, and victims gain unquestioned moral worth simply by being victimized.

But are our moral intuitions correct? To answer this question, we must look more closely at the victimizer and the contexts in which victimization occurs, and here is where Henson's work provides helpful examples. The above claims assume that the victimizer is an evildoer who preys upon the helpless victim, and undeniably there are such situations, particularly when the victim is incapable of being a moral agent (animals, children, and people whose cognitive abilities are impaired). What Jim Henson's work helps us see is that the equal and opposing roles of victi-

mizer and victim are not always so neatly delineated and that the assignment of moral responsibility may not always fall solely on the victimizer. It also helps us to see that this attempt to label victims and victimizers in an effort to assign moral responsibility further victimizes victims rather than offering outlets for healing.

VICTIMS OF FATE: "EITHER SOMEONE GETS EATEN OR SOMETHING BLOWS UP"

The *Muppet Show* vignette "Muppet Labs" found humor in a victimizing relationship. Two characters, Dr. Bunsen Honeydew and his lab assistant Beaker, weekly demonstrated outlandish scientific discoveries. Inevitably, Dr. Honeydew's latest invention would result in some harm to Beaker. For instance, Beaker was electrocuted with an electric nose warmer,[7] attacked by a robotic rabbit,[8] eaten by an automatic wastebasket,[9] and elevated to new heights by atomic elevator shoes.[10] And yet in each episode of "Muppet Labs" Beaker returned to fulfill his lab assistant duties (except for one episode, which we'll discuss shortly).

Beaker is a sympathetic character. The audience can see from his facial expression that he knows what will happen as soon as Dr. Honeydew describes his latest invention, and in some episodes he has to be cajoled into participating. But participate he does, even when he obviously knows it is not in his interest to do so. In this respect, Beaker is not in charge of his own fate and even at times seems bullied by Dr. Honeydew.

This view of victims, however, does not hold in all situations because the victimizer is not always an evil other. Beaker gives us an example of how a person can be a victim of fate in the one episode in which he refuses to go on stage.[11] The scene opens with Dr. Honeydew looking backstage for Beaker, who is hiding in the background under a lampshade. After an unfruitful search, Dr. Honeydew cancels the "Muppet Labs" skit and leaves the scene. The audience is led to believe that Beaker, for once, has been able to escape his role as victim. But just as we think Beaker is in the clear, the janitor comes by and plugs in the lamp, electrocuting Beaker. This one act of rebellion, seemingly an act of liberation, even if temporary, results in the same outcome for Beaker. It is clear from this one short scene that Beaker is unable to escape his fate as perpetual victim.

Victims of fate are often tragic characters in literature, but in life we tend not to accept that there is some force in the universe that has determined that certain individuals will suffer such a fate. Henson reminded us that in a sense we are all victims of fate, at least to a degree. This is a theme depicted in his short film, *Time Piece* (1966), nominated for an Academy Award. The entire premise of the film is a man in constant motion. It begins with the sound of a man's heart beating, fingers drumming, eyes blinking. Then we see the man walking, bicycling, working, running, walking, dancing. Interspersed throughout the clips are images of cars driving, flowers blooming, clocks ticking. This film shows that we are all fated to a life of motion, of the passage of time, until we die. It also reinforces the influence of cultural expectations on the direction of our lives by showing images of the man working, eating, in the company of a female companion, being seduced, a child running happily. We all live within a social and historical context and live a certain kind of life as a result.

VICTIMS OF CIRCUMSTANCE: "THROUGH DANGERS UNTOLD AND HARDSHIPS UNNUMBERED"

Even if we put aside the deterministic overtones of fate, victims of circumstance must be examined as part of our understanding of what a victim is. Being a victim of circumstance implies that the circumstances are beyond the person's control. People are born into war-torn countries and live lives of poverty, violence, and abuse, unable to change their condition. Plane crashes, car crashes, natural disasters, and the like cause harm and death, and the victims often can do little to avoid the consequences or are still harmed or killed even when they attempt to.

Being at the mercy of fate or circumstances beyond one's control reinforces the idea of the victim as helpless, suffering at the whim of fate or due to circumstance—that is, being in the wrong place at the wrong time. Though still subjects of moral worth, it is questionable whether in such cases they are moral agents. The victimizer, though, is not an individual, someone who can be held morally accountable for the victimizing acts. Rather, it is a god or force conspiring against an individual, if the deterministic view is accepted, or a confluence of events beyond the person's control, if the victimization is happenstance. Though in some of

the examples given, other people have a hand in the circumstances lead-
ing to the victimization, we cannot say that there is an intention to victi-
mize, victimizer to victim. In such cases we are left with no one to blame
(except perhaps a vengeful god or failing system) and little to do for the
victim but offer comfort and sympathy.

Henson gives us a glimpse into being victims of fate in the one-hour
television episode "The Cube."[12] In this teleplay, the main character is
trapped in a white cube with no idea of how he got there or why he is
there. Various characters go in and out of the cube and interact with him,
though none give him hints as to what is happening or how he can escape.
As the episode progresses, the characters become odder and more chal-
lenging. Primarily intended as an exploration of the boundaries between
the real and imagined, sanity and insanity, it also illustrates how we can at
times be victims of circumstances, not knowing why we are suffering, but
only knowing that we are. Without understanding the cause of the suffer-
ing, though, it is impossible to know how to end it.

This teleplay also shows how we can at times be victims of our own
making. There is one scene in which the man is told he can leave the cube
and is pointed toward an open door. By this point, though, the man trusts
nothing that he sees and says to his liberator that the open door is a trick:
"The minute I step foot outside this door, two gorillas grab me, dressed in
ballet costumes, drag me back and throw me on the floor and dance
around me singing 'Home Sweet Home.'" That is how the scene unfolds,
and it ends with the liberator praising the man for his ability to predict
how things work in the cube. This scene in the drama is a pivotal point, as
we watch the man shift from reacting to what is happening in his cube to
creating his own reality within the cube.

"The Cube" gives us insight into two extremes of victimization—how
we can become victims through no action of our own, and how we can
become victims of our own making. In "The Cube," the man simply finds
himself in a situation that he cannot control due to circumstances he is not
aware of. His being in the cube just happened, making him a victim of
fate. The more time he spends in the cube, the more he attempts to control
his fate and change his reality by making demands of the various charac-
ters who enter the cube, by attempting to escape, even by contemplating
suicide. By the end of the show, the man is more accepting of his situa-
tion, of the reality of the cube as presented to him. There are times when
we cannot change what happens to us, but we can control our own ac-

tions. Victims may suffer an event beyond their control, but they are lauded for their attempts to regain control, to overcome what has happened, to survive. In "The Cube," surviving means accepting the situation presented.

VICTIMS OF OURSELVES: "I WISH THE GOBLINS WOULD COME AND TAKE YOU AWAY!"

As an alternative to a victim of fate, a person can be both victim and victimizer. We could be complicit in the misfortunes that befall us, and even create the circumstances that lead to our own victimization. In *Labyrinth*, for example, it is Sarah Williams's desire to have baby brother Toby disappear that starts her adventure. She asks the Goblin King to take him away, and that is what he does. Though Sarah is frustrated with her teenage life, and quickly regrets her words, her fanciful wish is what sets in motion a chain of events she then has to rectify. Throughout the course of the movie, Sarah has to fight her way through a maze, at the center of which awaits Toby. The uncertainty, the fear of what lies ahead, and the tension of not knowing whom to trust create the conditions of an oppressive environment for Sarah. She is for a time a victim because initially she sees herself as being at the mercy of the maze. Jareth, the Goblin King, plays on her insecurities, and even plays with time and space, in order to confuse her and make her mission seem impossible. In true hero fashion, though, Sarah emerges victorious.

Attempts to include the victims' actions as factors in victimization have gained ground among libertarian and conservative feminists and political philosophers. As autonomous agents, individuals are capable of making their own decisions, and thus should be responsible for the outcomes of those decisions. Emphasis is placed on the power of the individual. By acknowledging that the victims are individuals who have decision-making authority, the intent is to empower victims to change their circumstances. Claiming that a woman who goes to the hotel room of a famous rock star or sports figure at two in the morning should not be shocked if she is raped is one example. The woman, after all, made the choice to go and should have known what would be expected given the situation she was walking into (see the work of libertarian feminists, such as Camille Paglia and Christina Hoff Sommers).[13] This argument was

also made by many leftist cultural critics following 9/11: the United States should have known its actions in the world make it a target for terrorists, and thus the American people should not be surprised or outraged at the attacks. (Note that these claims in no way suggest that the victims *deserve* what happens—only that they are complicit in the consequences of the victimizing actions.)

This notion of the victims having a hand in their victimization is a bit tricky to parse because holding the victim accountable for being victimized can lead us down the road of "victim blaming," claiming that it is the victim's fault they are victimized. This places an unfair burden on victims, particularly as victims are not always in control of the circumstances leading to their victimization. It is hard to justify animal abuse by saying it is the animal's fault; an animal can hardly speak for itself. Children will not speak out against abusers out of fear, both fear of retaliation from the abuser and fear of being removed from the care of the abuser, the only context with which they are familiar. Rape victims do not "ask for it," and victims of oppression are not to blame because they are the "wrong" color or sexual orientation.

Fear of victim blaming, though, should not prevent a close examination of the role of the victim in the victimizing relationship. In fact, such an examination is imperative because without it we have no framework for exploring victimhood other than the dichotomy of victimizer = bad / victim = good. And if we have learned anything from philosopher Jacques Derrida, it is that binaries should always be questioned in order to reveal the hidden hierarchy contained within, a hierarchy based on the power structure of the culture from which the binary arose.[14] Binaries are inherently limiting, leaving us with a false either/or, and life is seldom so simply reducible. In the relationship between Beaker and Dr. Honeydew, Beaker is a victim of poorly contrived experiments, and yet only once does he actively rebel. There is a caring relationship between the two, despite what happens on stage. Beaker's willingness to continue his role as guinea pig makes him complicit in his own victimization. In "The Cube" and *Time Piece* we are given situations in which there are victims, but the victimizer is life itself. We cannot control what fate befalls us, nor can we stop the passage of time. But within these boundaries we can choose our own actions; in so choosing, we may compound our victimization, becoming victims of ourselves.

FALSE DICHOTOMY: "YOU HAVE NO POWER OVER ME"

The framework of viewing victims as morally right and victimizers as morally wrong leaves us in a position of seeing situations in terms of opposing dualities. The victim/victimizer is an obvious one. Each necessarily exists based on the other. There cannot be victims without some sort of victimizer and there cannot be a victimizer without a victim. This duality does not hold, because not all victims are innocent and not all victimizers are morally wrong—and because one person may play the role of both victim and victimizer.

Further, if the victim is helpless in the face of victimization, then a hero or champion is needed to free the victim, setting up another binary: victim/hero. Even in attempts to empower the victim by bestowing some measure of accountability for the victimizing situation, the victim plays one role or the other. Like Sarah in her journey through the maze, the victim must renounce his or her victim status and proclaim hero status.

This empowerment view of victimization has deep roots in the philosophy of oppression. We have only to look at history to see the number of revolutions staged by the oppressed. Through his exploration of capitalism, philosopher Karl Marx provides a framework for understanding such actions that has continued since its birth 150 years ago. Marx argued that capitalism's failure is built into its inherent division of power between two opposing classes, the proletariat (working) class and the bourgeoisie (capitalist/owner) class. Capitalism functions only as long as the proletariat can be exploited by the bourgeoisie in the production process. Eventually, the proletariat, fed up with its status, will overthrow the bourgeoisie, establishing a new economic order in which there is no hierarchical power and no class divisions. Through revolution, the oppressed and oppressors are both freed from the confines of their power struggle. [15]

For Marx, the system of capitalism corrupts the otherwise good nature of people, and the oppressors suffer a form of dehumanization along with the oppressed. The two are locked together, and neither truly benefits. Freire echoes this sentiment in *Pedagogy of the Oppressed*: "This, then, is the great humanistic and historical task of the oppressed: to liberate themselves and their oppressors as well. The oppressors, who oppress, exploit and rape by virtue of their power, cannot find in this power the strength to liberate either the oppressed or themselves." [16]

These roots, however, are not strictly honored in contemporary theorizing of victims and victimization, as the view of oppression in terms of victim/victimizer (oppressed/oppressor) is not initially presented as a duality of opposites. What the contemporary empowerment view assumes is that the victim must not only overcome victim status but also transform the victimizer and the victimizing situation. Victims cannot simply stop being victimized because they choose to. Like the man in the cube or Sarah in the labyrinth, the victim is trapped in a situation that, though it may have resulted from their own actions, is no longer completely within their control. And the empowerment view does little if victims cannot shift their own consciousness to accept the reality of the situation, much like Beaker, who even in his act of refusing to go on stage is unable to fully transcend his victimhood.

The empowerment view also runs the risk of becoming victim blaming. If the responsibility for liberation lies in the hands of the victim and the victim is unable to make the leap, then it is easy for observers to blame the victim for remaining in the situation. We can watch Beaker put himself in harm's way in each episode, noting his visible reluctance, and wonder why he continues to do this. The same logic is used against victims of domestic violence. Staying with a person who is physically or emotionally abusive seems irrational, but the assumption is that the victim has a real choice. Often this is not the case, either due to the tight control the abuser wields or due to the victim's internalization of the abuse (it's my fault, I deserve it, etc.).

BUDDHA NATURE

Buddhist teachings might provide a way to resolve this dilemma. There are some elements of the empowerment view in Buddhism. If victims do nothing, they only reinforce their helplessness and the power that the victimizer and the situation has over them. Also in keeping with the empowerment view, Buddhism teaches that liberation comes from changing the way one reacts to a situation.[17] However, there is an important distinction between the empowerment view and Buddhist principles, and it is this: Buddhism acknowledges that the person may not be able to change the situation. The empowerment view claims that the change in mind-set from victim to hero will result in new actions that change the

victimizing situation to one of liberation. In Buddhism, the mere act of changing one's reaction changes the person's experience of the situation, but it does not necessarily follow that the situation will change.

Another concept that Buddhism offers is the necessity of suffering. Suffering is one of the truths of life in Buddhist teachings; everyone suffers. In the empowerment model, the assumption is that life is meant to be good, so when something bad happens it must be rectified in order to restore life to its rightful course. And it is up to the victim to do this by somehow taking control of the situation. The victim is expected to adopt the mind-set of a fighter, like Sarah pushing her way through the labyrinth, and overcome the victimizing circumstances and become a hero.

The Buddhist perspective, by showing us that suffering is necessary to our existence, allows us to see victimizing events not as random blows that keep us from the life we think we should have, but rather as part of the life we do have. This does not mean that the victim must be resigned to always being a victim. It means only that the victim must realize the situation for what it is and release what is causing the suffering. The suffering will only increase if the victim focuses on their own plight and gives in to fear, resentment, self-pity, or anger, if they continue to blame others and see the victimizing situation as something external, something thrust upon them. Buddhism instead teaches that the suffering should be accepted; only in realizing that suffering is life can suffering become a catalyst for liberation.

The suffering of the victim can become a catalyst for both the victim and the victimizer, but each must use it for his or her own journey toward enlightenment. The victim cannot redeem the victimizer, nor can the victimizer's regret or sorrow heal the victim. This goes beyond the interdependent dualistic relationship between victim and victimizer or victim and hero, and it goes beyond the transformation of victim to hero (or, in some cases, of victim to victimizer). Buddhism helps us see that the dualistic relationship is actually one of unity, where both victim and victimizer are human beings cast in different roles but part of the same suffering.

What Buddhism offers, then, is the empowerment view without the incumbent obligation to also free the victimizer or change the victimizing situation into one of liberation. It allows victims to focus only on themselves and to reconcile their reaction to the cause of the suffering, whether it is at the hand of another, the result of fate or circumstances outside

their control, or due to their own decisions. Sarah's acceptance of her own power during her travels through the maze is achieved because her perception of the situation changes, thanks to the support of her allies along the way but also thanks to Goblin King Jareth's prodding and challenges.

The man in the cube is unable in the end to change his understanding of his victimization, which is his own thinking, and so he remains trapped in his cube at the end of the teleplay. The man in motion from *Time Piece* reinforces the notion that not all victimizing situations can be changed; suffering is a part of life and death is unavoidable. By understanding the nature of the suffering and the sequence of choices that led to victimizing events, and by accepting that not all situations are within our control, we can let go of blame and judgment and help victims find healing.

16

"WHATEVER"

A Biograffiti of Gonzo the Alleged Magnificent

Christopher Ketcham

So, you were the kid in school they called weirdo. You attracted bullies like flies to Oscar the Grouch's trash can. You came home with torn shirts because the guy in homeroom would yank out the "care instruction" tags from your collar, and you had dark pencil holes in your back from that sadistic creep in second period.

But you got even; you turned to ever more exotic stunts. While others were break dancing, you were out breaking dancing—that thing you did with the supercharged motorized skateboard that went through the neighbor's garage door. After a while your ADHD got the better of you, making you wild-eyed, and soon the bullies didn't want to mess with you anymore because you did stuff that would be banned on *Mythbusters*.[1] And your best friend was called rat fink, and he bears a strong resemblance to Rizzo the Rat, voice and all.[2] Yep, you're a Gonzo. Jim Henson (through Dave Goelz) created the Great Gonzo to help you remember your experience. Hopefully the physical resemblance is not close. Oh . . . sorry, so very sorry. And both of you have the same taste in clothes? Hmmm.

GENEALOGY OF A WEIRDO

You made it through OK, now didn't you? Despite the name calling and tied shoelaces under your desk and the dunking of your hand in warm water at camp while you were sleeping. . . . Your mom only sent you to camp with one pair of sheets! But you survived summer camp and high school and are well on the way to success. Well, I'm not all that convinced you have gotten there yet if you are reading this. Oh, and I see, your kids are kind of weird, too. All right, then, let's look at weird and how weird gets to be weird so at least we can begin to learn what weird is—and do what with it, you ask? Maybe nothing. We'll see.

What about the real Gonzo? Sure, there's a big bird, a bunch of fuzzy stuffed animals, a frog, a pig, and a grouch that lives in a garbage can in the Muppet hood. But Gonzo, well, Gonzo's an enigma. He's like that graffiti that appears one morning on the wall of the abandoned warehouse across the tracks. It's new and different, but what does it mean? You're expecting the local gangbangers and taggers to smear it out and replace it with their own, but they seem to respect it—perhaps even admire it. And it stays where it is even though the rest of the building is tagged many times over. Its weirdness seems to fit in the hood, kind of goes with it (though, like a Salvador Dali mural, it's just plain strange).

To better understand the anatomy of a weirdo, we're going to ask three questions about Gonzo, where he came from, who he is (his identity), and what is a Gonzo. Be prepared for a strange journey.

FROM WHENCE A GONZO?

Like that graffiti, you want to know where Gonzo came from. It depends. It's a bit of a muddle, because like the graffiti even Gonzo's not clear about his origin. One time he said that he was born after his mother died, and then another time he explained in graphic detail how he was created, like all the other Muppets, in a workshop where he becomes from bits of Styrofoam and fuzzy cloth that suddenly—and there you are, a Gonzo is born.[3] Then he found out that he came from planet Oznog, so he's a plaid-blooded Oznogian, in all likelihood without papers or documentation to live in the Muppet hood.[4] But that's not weird—just a fact of existence nowadays. This leaves us wondering: If deep down Gonzo

doesn't know where he comes from, then where does his identity come from? It's time for our second question: "Who is Gonzo?"

I DENTITY; YOU DENTITY; HE, SHE, IT DENTITY; WE YOU THEY DENTITY

So many dentities, so little time.[5] Identity gets complicated for a Muppet. Muppets wear out and are reincarnated, er, remade in the likeness of their former selves. And we are not fooled when Gonzo, dapper as he is, appears in different chili pepper outfits over time. However, unlike Oscar the Grouch, who was once orange and is now green, Gonzo has remained blue through each of his incarnations. But wait, even if Gonzo looks the same, is this the same Gonzo as the dilapidated one on the shelf over there or that one that is now moldering in the landfill? Well, you say, Dave Goelz, Gonzo's Muppeteer, is the same, so Gonzo must be the same. But is Dave the same Dave from the first performance of Gonzo as Dave is today? And when Dave retires, what will Gonzo become—the Great Gonzoni? Preposterous, you say, because the script is the thing, the script and the stage direction! That is what makes the character Gonzo!

In the seemingly endless movie remakes of *A Star Is Born*, aspiring singer Esther, played by Janet Gaynor (1937), Judy Garland (1954), and Barbara Streisand (1976), is always the same. By this logic, everyone who has played Hamlet is playing Hamlet the same way because the script is the script is the script. So why bother doing the play again? Let's just film *Hamlet* with someone, anyone, and declare it finished and done with.

Where's the fun in that? This brings up the question of whether it is the form of Gonzo—blue, clothes hound, sausage proboscis, bulging eyes, something we might call Gonzo's "identity"—that is important or rather his psychological continuity that is the thing. Shakespeare's Hamlet said, "The play's the thing," meaning that he would use his best oratory to elicit a response from his Uncle Claudius: a flinch or a twitch or even a frown, to confirm, at least to Hamlet, that his uncle had committed regicide by killing Hamlet's father, the king.[6] We identify Gonzo by looks; we know him (if anyone can know Gonzo) by deed, the play within the play: his bizarre antics and demonstrations. And there is some continuity in this because, while we know him from his weird capers such

as consuming rubber tires to the tune of "Flight of the Bumblebee," it would be inconceivable, even disturbing, if by the same melody he simply sat eating a bowl of oatmeal at a leisurely pace.[7] We would question whether something untoward had happened to Gonzo. As with Hamlet, with Gonzo the play is the thing for us to know him.

CONTINUITY, DISCONTINUITY, AND DISCONTENTUNITYTUITY

But is that enough? Has Gonzo always been Gonzo? You know what I mean. He hasn't changed, evolved his thinking, his dress, his mannerisms, who his friends are, whom he loves? Preposterous: He has gone from fancying the Pig (Miss Piggy) to chickens. His haute couture has evolved from plaid to chili pepper. He's changed, but is he still Gonzo? Well, are you the same kid who got your fingers superglued to the table in study hall in ninth grade after you nodded off? Of course not.

Can't Gonzo change and still be Gonzo? But how much change can there be for Gonzo to still be Gonzo? Or has there ever been a "Gonzo," or has there only been a continuity of something about Gonzo that has changed over time but you can still identify as being Gonzo? And here's another question for you that comes from this: Are Gonzo's thoughts *today about* the original thoughts he had as a Muppet Baby his identity— or are just the *original* thoughts Gonzo had as a Muppet Baby his identity? Dredge up your own memories. Would it matter if someone had, say, planted them in your mind? Would they seem today any less real, any less yours? These questions lead us to neurosurgery.

HALF A BRAIN

It is possible, of course, to exist with only half a brain, and the slicing of the brain down the middle (the two hemispheres) has been used as a technique to try to treat the severest form of epilepsy.[8] Let me introduce you to the maddest of Muppeteer creators: Dr. Frankenmupp.[9] The world needs more Gonzos, the wicked doctor surmises, so he divides Gonzo's brain in two, removing one half and surgically implanting it in another

Gonzo body that he has stitched together precisely to house this new half-a-brain.[10]

If you reasoned that Gonzo divided is now two Gonzos, in which one does the identity called Gonzo reside—GonzoX or GonzoY? In both? But how can the identity of one now become the identity of two if identity is unique to just one being?

Ten years pass. We know that the theory that GonzoX and GonzoY are now identical cannot now be true because we raised GonzoX in Topeka, Kansas, and GonzoY in Albuquerque, New Mexico. We ask them each to describe where they live. Their answers are different. But is Gonzo gone, leaving behind only GonzoX and GonzoY? Both GonzoX and GonzoY have memories of their life before the split, and they can recall them independently, in exactly the same way.

Therein lies the conundrum for the idea of unique identity. While each of the new half-brained Gonzos at the moment of removal contains the same Gonzo memories, at the moment following division they begin to become different. Their experiences, even if they are exposed to essentially the same conditions, may be slightly different in orientation.

Dr. Frankenmupp didn't stop with surgery. He also used advanced brain-scraping techniques to copy memories from Gonzo into a new Muppet he called Mootant, a bovine-like creature with flippers instead of hoofs (he hadn't given up the surgery thing quite yet).[11] Mootant certainly didn't look like Gonzo, but he could sure remember his every episode, down to the beverages he consumed backstage between takes. Is Mootant Gonzo?

The good doctor went beyond brain scraping. He found that Gonzo's alien DNA could regenerate—could grow back the half a brain that had been surgically removed. The noble doctor administered the appropriate serum to one of one of the Gonzo's half-brained bodies, and voilà! After the suitable period, his brain was whole again. But not quite, for Frankenmupp had engineered a switch between the two halves that he could close or open. Closed, both brain halves would operate independently. When he opened the switch, they would reconnect—all their synapses would be whole again.[12] So he left the brain halves closed to each other for a year, and then pulled the switch. So what would you think the result was? Would it be like you are talking to yourself but another person answering? Pure cacophony? You and your other you welcoming a long lost other to each other, but comparing notes, so how was the trip? But neither

one of "you" had left the brain building, so to speak, and each of "you" had an eye and an ear while both of "you" presumably saw and heard the same things at the same time. But each half of your brain was separated from each other, and maybe each of your brain halves saw or heard the same thing differently. But is it possible that both of your brain halves could still be you while apart, and what is the meaning of the two brains halves when they are reconnected—old you; new you; other, others?

Hang on to your cerebellum, we're not done yet.

STAR DATE 3305670.3

The transporter malfunctions. Captain Gonzo of the Starship *Gizzard II* is both preserved in memory in the transporter and reconstituted at his destination, the frigate *Poulet Rouge*, having emerged wholly intact.[13] The transporter memory then dumps Captain Gonzo fully constituted onto the original transporter. So now there are two identical Captain Gonzos but on different ships, *Gizzard II* and *Poulet Rouge*.[14] Captain Gonzo on the transporter deck of the *Poulet Rouge* orders First Officer Fozzie of the *Gizzard II* to come about and flee at the highest possible warp speed because they are in the greatest danger. Captain Gonzo on the *Gizzard II*, however, says they must wait; the sensors showed no such danger and the other Captain Gonzo must have gotten his brains scrambled in transport. Transporter Officer Beaker me-me-me-me's that no, both captains are the same Captain Gonzo. No brains got scrambled when both were reassembled. "First Officer Fozzie, what are your orders?" asks *Gizzard II*'s pilot, Ensign Kermit.

Yes, Officer Fozzie, what *are* your orders? Who is whom? Both have exactly the same molecules arranged (presumably, as transporters must be incredibly accurate) in the same manner, but who is the captain of the *Gizzard II*? Is there time to deliberate? Must you act now? Of course you must—this is a half-hour show. The most you have time for is a commercial break to think this through (sorry, this is PBS, you don't even have that!). So what is it, Officer Fozzie?

How would you answer? Could you ask each a question that only the real Captain Gonzo would know the answer to? Yeah, both will answer this correctly. But can you accept that the Captain Gonzo on the *Poulet Rouge* has new information that the Captain Gonzo on the *Gizzard II*

could not possibly have? His psychological continuity is the same as the captain on the *Gizzard II*, but his experiences are now different. Is Captain Gonzo on the *Poulet Rouge* now a different Captain Gonzo because his experiences are different? Or do we have two identical Captain Gonzos, each with a different perspective on things? So the decision Officer Fozzie has to make is whether identity is more important than experience. He can remain stuck on the problem of identity and do nothing because he doesn't know what to do, or he can affirm identity but accept that the Captain Gonzo on the *Gizzard II* is the real captain because he sounds like the real captain before he went into the transporter room. Or he can accept that both are the real and true Captain Gonzos, but the Captain Gonzo he needs to listen to is the one who has had the real-time experience of the danger on the *Poulet Rouge*.

OK, we'll assume that a good decision is made by Officer Fozzie. How do we sort it out later, after the crisis has passed? Which Captain Gonzo is in charge? And if one is accepted, is the other destroyed? If we are to destroy the other Captain Gonzo, what are we destroying—Captain Gonzo or someone else? Is destroying a Captain Gonzo murder? Remember, we don't have days to figure this out—as the days pass the differences in experience will begin to show in the two "identical" captains.

So, from all of this funky, chunky, and reconstituted brain stuff, ask yourself two questions: First, do "I" go along when my brain is in two places? Second, do "you" need a body always there to be you (brain-scraped, transporter-stored person), or is there something, a "further fact," that might just be your identity and isn't tied to the body?[15] Tough questions? Very.

BUT SHE NEVER GETS OLD

Many will remember what John Nash (played by Russell Crowe) in the movie *A Beautiful Mind*[16] says as he comes to grips with his imaginary companions: "She never gets old! Marcee can't be real; she never gets old!" Certainly we might want to say the same about the Muppets. See any crow's feet around Big Bird's eyes? Noses grow with age; notice anything different about Gonzo's schnoz? No? Well, then, perhaps we have all been duped by Jim Henson and his followers. How could these

puppets ever be real? They don't change! They always are the same! But are they?

The mad Frankenmupp of our thought experiment cut Gonzo's brain in two and created two similar Gonzos, who have become very different Gonzos over time. One prefers chickens, the other ducks. What are we to make of this?

Let's make it simpler: It's just after the operation, and management wants to use both Gonzos on the show at the same time. There will have to be two Muppeteers: Dave Goelz, Gonzo's regular animator, and another, Evad Zleog.[17] But which Gonzo does Dave get and which one does Evad get? Both Gonzos have started out the same, from the same seed, the brain of the original Gonzo. So does it matter who gets what Gonzo? It shouldn't, right? So both animators perform with their Gonzos from the same exact script. Then something funny happens. Wait a minute, these two mirror images of the other are no longer the same—this Gonzo is different from that Gonzo! What has just occurred? Even though the script for both Gonzos is the same, their animators are different, and even if taught to act in strict Gonzoeze, they both bring different subtleties to the character just like actors who play Hamlet.

Through divided brains, scraped brains, switching brains, transported brains, and whole brains we have explored who is Gonzo (his identity), and we now also have some idea of where Gonzo came from (though this is still up for debate), but the third question remains unanswered: "What is a Gonzo?"

WHATEVERNESS

In *What's a Gonzo?*, the Great Grabanzo says, "You might not know what you are, but you know who you are."[18] We know that the undivided Gonzo has changed and evolved over the years because his Muppeteer, Dave Goelz, isn't the same Dave today as he was in the 1970s. So the question comes up again: Is there something to psychological continuity that allows for change, but only so much change, for Gonzo to be Gonzo? That Gonzo has always done crazy stunts has not changed over time—only the stunts have changed. But is that all there is to Gonzo? Is Gonzo locked into a conception of himself he can never get away from? Does his psychological self push him back toward a central core of Gonzoishness

that he can never escape? Is this continuity, however tenuous, the wag that tails him or the tail that wags him? Ask yourself the same. You have learned new tricks, but you always try to make those new tricks work for you based upon the conception of you that you have of you.

How did Gonzo become a whatever? How did you the weirdo become a philosopher, or John Nash an accidental economist? Certainly, analogous to Nash's theory, there must be some kind of equilibrium inside each of us that pulls us out of what we once were and into what we are and helps us tenuously tiptoe into what we might become in the future. People throw off their addictions, become born again, and change careers, names, spouses, even countries, but after all of this, have they thrown off the continuity of themselves? Even with our exotic brain cleaving, scraping, regenerating, hemisphere-switching thought experiments, what of Gonzo is Gonzo in the resulting Gonzos? And while both half-brained Gonzos go on their merry ways toward either chickens or ducks, is there something inside that says to us "of both, there goes Gonzo"?

But we still haven't answered the question: Why does Gonzo do what he does? In *Muppet Babies* he was raised by a nanny like the other Muppet Babies, including Miss Piggy, Fozzie Bear, Kermit the Frog, Scooter, and Rowlf. But Gonzo was always an outsider.[19] He was called "weirdo" by Miss Piggy and others in *Muppet Babies*. He would not just take plastic blocks and build a unique or pertinacious structure like the others; instead, he imagined the blocks into bugs and animated them accordingly, to the horror of other Muppet babies.[20] Where did that come from—is he just wired differently, or did Dr. Frankenmupp have something to do with his condition?

In *The Great Muppet Caper* his shipping crate is labeled "whatever" when Kermit's is labeled "frog."[21] John Cleese called Gonzo "the ugly, disgusting little blue creature who catches cannonballs."[22] Gonzo's world is always a bit askew from the world of the other Muppets. Yet Gonzo's countenance is not the deadpan of a Peter Sellers or a John Cleese; he is more the wild-eyed mania of a Spike Milligan with the energy of a Robin Williams.[23] While he is out to impress, to be sure, his goal is not to one-up the other Muppets; he appears to want to just do his thing because that is what he does—that is his identity. His mind makes different synaptic connections that produce odd stunts involving bizarre combinations of motorized objects, chickens, and musical instruments, poetry, and/or

singing. He is consistent in his inconsistency, but we are left to wonder from what conception of the world these distorted stunts are derived.

Will he always consume tires to the tune of "Flight of the Bumblebee" or try to catch cannonballs or chase chickens or fly motorcycles? And if we call out to "Whatever," will Gonzo reply? Maybe, but just maybe he will point to that abandoned warehouse wall and say, "I will now run headlong into that graffiti over there, all the while bellowing the soliloquy from *Hamlet*. And just before I hit the wall I will shout, 'To be or not to be!'"[24] But you know he's got it all wrong because that line *begins* the soliloquy rather than ending it. Weirdoes . . . sigh.

Part IV

Being a Muppet: Metaphysics

17

KERMIT'S RAINBOW CONNECTION

The Lovers, the Dreamers, Philosophers, and Me

Kimberly Baltzer-Jaray

Henson's work is nothing purely for kids; it's not plain, rudimentary, or simple: with a community of oddball, lovable, complex characters, it entertains with jokes and slapstick routines while also making effective use of dialogue that is witty and charming, containing larger-than-life ideas that only grown-ups can begin to understand (if they pay attention). The "Rainbow Connection" is no different; it's a deeply, multifaceted, philosophically rich song. A large part of its glorious harmony is due to the fact that a frog puppet sang lyrics filled with grand ideas to an audience that knew more about Play-Doh than Plato. It turns out Kermit was a banjo-playing, log-sitting, sage amphibian (pun totally intended, Wocka Wocka!). A cold-blooded Socrates, if you will.

Although "Rainbow Connection" exemplifies many kinds of philosophy, the three most prevalent traditions woven into its lyrics are metaphysics, epistemology, and existentialism. Metaphysics is an area of philosophy that tries to answer questions about the nature of being and the reality we live in (i.e., what is there and what is it like?), and epistemology is a field concerned with the basis, scope, and nature of human knowledge and the justification for those claims (i.e., what can I know and how can I know it?). These two fields go together like Bunsen and Beaker: you cannot talk about what is out there or what something is like without talking about what and how you know what is or what it is like, and vice versa. In "Rainbow Connection," Kermit is pursuing both metaphysics

and epistemology when asking about the nature of rainbows, and beliefs about them or about wishing on stars. When Kermit sings about his experience of being a frog in the world, among others—all the lovers and the dreamers—he is being an existentialist. Existentialism is a philosophical movement and attitude that emphasizes the uniqueness of individual existence, describing the experience of this life lived in a world with others and how one uses their freedom of thought and action to make choices that all lead to the creation of their essence.

What I hope to achieve here is a greater understanding of how beautifully profound this song truly is and the lessons it teaches us. In the lyrics, Kermit tells us that it's OK to be different, and that we should accept everyone as they are and work together in harmony. He sings of how life can be unfair and tough, but that should not stop you from realizing your dreams or becoming who you want to be. We all have choices to make concerning what we believe and what we must do. Most importantly, Kermit says that one should never fear pursuing a dream, never be discouraged by others who doubt or don't believe in your dream; you should never give up chasing that rainbow connection. Kermit wasn't just a frog puppet; rather, he was our beloved and trusted friend, and this song is not just a catchy opening tune but also a symbol for the philosophical soul Jim Henson possessed. Through Kermit and this song Henson spoke to the lovers, the dreamers, and the one-day philosophers.

AN INQUIRY CONCERNING RAINBOWS

> Why are there so many songs about rainbows
> And what's on the other side?
> Rainbows are visions, but only illusions,
> And rainbows have nothing to hide.
> So we've been told and some choose to believe it,
> I know they're wrong, wait and see.
> Someday we'll find it, the rainbow connection,
> The lovers, the dreamers and me. [1]

The essential questions Kermit asks in the first verse consist of: (1) do we really have knowledge about rainbows or just beliefs, and (2) what, if anything, lies at their end point? These questions reveal a debate between knowledge and belief: Kermit says he knows that those who believe

rainbows are illusions with nothing to hide at their ends are wrong. What is the difference between knowing something and believing in it? The best way to demonstrate the depths of Kermit's philosophical inquiry here is with the famous and highly influential ideas of David Hume and Immanuel Kant (philosophy's seventeenth-century Waldorf and Statler—kind of critical, a bit skeptical, and yet lovable).

Hume[2] begins with some psychology: How does a belief form in us? The mind has two types of content: impressions and ideas. Impressions are the original perceptions; they are the vivid, direct, immediate experience of things around you—the initial experience of things like colors, sounds, tastes, feelings, and so on. Ideas, on the other hand, are copies of these impressions; they are like silly putty pressed into a comic strip—you get a copy of the comic strip that is less bright, less perfect, and a little blurry. Ideas can be simple or complex, meaning they can be single (i.e., gold) or combined with other ideas (i.e., gold ring). The knitting together of ideas into more complex ideas is not only the basis of thought but also the foundation of knowledge. Impressions are stored in the mind for remembering, imagining, reflecting, or symbolizing.

Each idea and impression is separable from any other, and a connection that forms between them happens in the mind. Hume argued that the mind had a natural propensity for combining; it is a natural problem solver. Without our will or intention, the mind connects ideas together in its quest to make sense of the world, to find regularities, patterns, and so on, to assist with the discovery of truth, form the foundation for judgments, and aid in survival. Hume even goes so far as to say that the mind sometimes will smooth over gaps to make a connection. It doesn't like mysteries, uncertainty, or chaos one bit. But sometimes we do consciously make or seek connections, such as the need to see a murder as stemming from a person's motives, situation, or influences. So, sometimes the mind will make a connection by its own principle, and sometimes we actually make the connections ourselves. But we don't just do this randomly and wantonly—experience is the key, since it not only gives us the sense data that forms ideas but also provides instances for connections to occur: when two things happen in close proximity and frequently, like a rooster crowing at sunrise, we naturally and easily connect them together. The three principles of association that Hume described are resemblance (i.e., Camilla looks like a chicken), contiguity (i.e., Kermit is the frog that

has been in every Muppet movie), and causation (i.e., the Swedish Chef fired his musket at pastry dough, making them into donuts).

All human beliefs, even the stuff we call knowledge, are formed as a result of these associations. A belief, for Hume, is an idea followed by a sentiment that compels one to think the association experienced is real and solid: a belief is having an idea that is vivid, lively, and forcible, and it alters the way I feel about what I experience. Beliefs deal largely with probabilities. The higher the probability that one event is linked to another, the stronger my belief and expectation. Conversely, when the probability is low or decreases, so does my belief in the connection of two events or my expectation their connection will occur at all. So, when I experience four hundred days straight of the rooster crowing at sunrise, I come to strongly believe that the rising of the sun makes the rooster crow. This is very different from, say, believing that in the universe there exists a world with creatures just like Gonzo, or that pigs fall in love with frogs, or that every time I buy a lottery ticket I will win the jackpot. One feels more real and likely, while the other feels more like fiction or the work of imagination. But what does this say about knowledge? Knowledge based on relations like those in math and logic, the ones that cannot be refuted by experience, is solid and reliable. But the knowledge that comes from experience of the world is at best probable, sometimes more and sometimes less. We shouldn't despair over this, though, since the information we gather through the senses and connect in the mind is practical and has led to major developments in modern science.

Much like Hume, Kant wanted to understand the boundaries of human knowledge, and how knowledge and belief arise in us. For Kant, the distinction between belief and knowledge is important for matters and judgments that concern truth. Truth, for Kant, is had when there is an agreement with the object: if I judge that "Kermit is green" and he is in fact a green frog, then it is true. We hold things to be true in a few ways. You have opinions, beliefs, and knowledge, and you hold these things for yourself (subjectively) and for everyone (objectively). When you have an opinion, you are consciously holding a judgment that is insufficient both objectively and subjectively. Kant is talking about those opinions that are learned and carried forward without ever having any evidence to support them, both personally experienced and experienced by many others. You see opinions like this often in racism, sexism, and superstitions. For example, you might hear someone say, "A black cat that crosses your path

brings bad luck," and yet they have never experienced bad luck when such an event occurs or even being around a black cat, and maybe don't know of anyone who has. Holding a belief, for Kant, happens when you have subjectively sufficient evidence but insufficient objective evidence or agreement. Beliefs can be highly personal in this way, and rather stubborn. For example, try telling a young kid there isn't a monster under the bed, or Grover that there isn't a monster at the end of his book, when they adamantly believe there is one. You can crawl under there with a flashlight and show them there is nothing there, you can clean everything out so there is no hiding place, you can even have a bright nightlight on, and so on. You can do everything possible to demonstrate that there is no monster, and yet in many cases the child will believe there is one and it's going to eat them. Knowledge is holding a judgment when you have both subjective and objective sufficiency. What you hold is true for you and everyone else, such as judging that the law of gravity operates on Earth, or that nothing rhymes with orange, or that "Kermit is green."

Much like Hume, the source of knowledge for Kant[3] is ultimately our external world. Experience of the outside world provides sensory data for your mind to process, synthesize, categorize, and utilize for judgments. Because you cannot escape from or step outside of the cognitive apparatus you possess, your knowledge is ultimately limited. If you have only five senses, any sensory data that may exist beyond that will not be perceived. What this ultimately means for knowledge is that it isn't truly objective; instead, it is the end result of your cognitive functions and their powers of synthesis. This does not mean that your mind makes up the world, but rather that it plays an important role in constituting the world based on the information it is actively engaged with or passively fed. This is why Kant so famously said you can know the phenomena (not to be confused with "Mahna Mahna" . . . doo doo do do do), that which you mentally process through the senses and synthesize into a cognitive output (i.e., the picture of experience you have), and you can never know *noumena* (the thing-in-itself), that which underlies all phenomena and are considered to be things as they really are, even when no one is looking at them. This implies that while Kermit is green for most of us, it's possible that in "real reality" he is actually a different color.

So, what does this say about metaphysics, epistemology, rainbows, and Kermit? If Kermit were simply talking about real-world rainbows, as in the optical illusions caused by both reflection and refraction of light in

water droplets in the atmosphere that result in a spectrum of light, then both Hume and Kant would tell him the nature of his questions and answers lies in the realm of belief. According to Hume, mental associations, non-rational sentiment, and expectations formed by experience are what form Kermit's knowledge about rainbows; thus it is at best probable. However, Kermit is disagreeing with the idea that rainbows are just illusions with nothing to hide, which is against scientific theory and the opinions of others. Kant would, therefore, argue that Kermit also has belief about rainbows, and not knowledge about them. Kant would also argue that Kermit's knowledge about physical rainbows would be strictly phenomena, not noumena. As to what lies at their end, it's not really possible to answer concretely, since they are optical illusions that lack real connecting end points. We are, once again, back to belief. Kermit believes that rainbows have something to be found at their end points, some kind of good fortune or dream come true, and he is adamant that he will find that rainbow connection. Whether he is talking about rainbows in a real sense or using them as an analogy for chasing one's dreams, he is a firm believer.

EXISTENCE PRECEDES BEING THE LOVER AND THE DREAMER

Who said that every wish would be heard and answered
when wished on the morning star?
Somebody thought of that
and someone believed it,
and look what it's done so far.
What's so amazing that keeps us stargazing?
And what do we think we might see?
Someday we'll find it, the rainbow connection,
the lovers, the dreamers and me. . . .

Have you been half asleep
and have you heard voices?
I've heard them calling my name.
Is this the sweet sound that calls the young sailors?
The voice might be one and the same.
I've heard it too many times to ignore it.

It's something that I'm supposed to be.
Someday we'll find it, the rainbow connection,
the lovers, the dreamers and me.[4]

In these verses we see Kermit questioning and musing about things that relate to life experience: wishes, hopes, dreams, and whether there is such a thing as destiny or are we totally on our own. There is also implied here a sense of how vast the openness of possibility is in life, and how sometimes we seek signs for where to go, what to do, or who to become.

The most fitting philosophers to discuss here are Jean-Paul Sartre and Simone de Beauvoir: an influential, dynamic, socially and politically active, iconic couple whose popularity and pop culture status was nothing philosophy had ever experienced before. One might think you could almost compare them to Kermit and Miss Piggy, but it falls apart: while Sartre did sort of resemble a frog and Beauvoir was a woman of conviction and strength, I highly doubt she went around karate chopping others when frustrated, or obsessing about her looks, or endlessly demanding Sartre's undivided attention.

For existentialists like Sartre and Beauvoir, the answers to questions like these lie within us, not in destiny, the stars, or the universe, and I think Kermit would agree (and does here). In the firmness of his conviction that we will find that rainbow connection, Kermit believes in himself, his capabilities, and finding himself in the journey. In *The Muppet Movie*, he finds himself, follows his dreams, and makes them reality; Kermit self-actualizes existentially.

Existence involves freedom of thought and action; we each possess this freedom and are responsible for all of our actions and choices, and for the person (or frog) we become. Within freedom and responsibility we must also do our best to be authentic: being true to oneself as a free individual while fully acknowledging that who you become is your freedom and your responsibility. This seems implied in Kermit's words about wishing on stars and stargazing: Who ever said that wishing on stars would work? And really, wishing isn't acting and being responsible for yourself—only.

The other thing you must try to avoid is bad faith, a concept of self-deception that arises when you either allow people to have too much influence over your choices or fail to see the influence and presence of others at all in your life. In both cases it is a denial of responsibility that is always necessarily linked with freedom. So, Kermit cannot let Piggy run

his life and make all his decisions, but he also cannot pretend she has no influence at all or isn't affected by his choices. What is required here is finding a balance between yourself and others, so that you and they can be free, everyone is responsible, authenticity can be had, and bad faith avoided as much as possible.

According to existentialists, each one of our lives is a project, a self-made plan for who you will be in the future, and that involves a commitment to activities that help make that plan realized. We each paint our own portrait, so to speak.[5] This project must always be chosen; it must be what you want, and you have the freedom to change it at any time and build fresh roads. In the song, and especially in the movie, Kermit realizes this—he finds the rainbow connection because he had a dream that he developed into a plan, he acted, and he made it a reality. Kermit became what he wanted to be and got where he wanted to go, and even made some great friends along the way.

Beauvoir wrote about the reality of ambiguity. Life consists of an ambiguous mixture of our attempts to transcend the given conditions of the world with our freedom, but the world imposes itself on us in ways we don't choose or control.[6] This ambiguity, this uncertain truth that the world will never reveal its full meaning to us and we can never fully impress our meaning fully on it, is experienced as a failure, and we must not deny or run from it—we must embrace it and engage our freedom in projects that emerge from our spontaneous choices. We must act freely and with our own meaning while knowing that there is uncertainty about the future or if the dream we pursue will be realized. This is the sense of Kermit's words in the final verse of the song, when he speaks of the voice. He wonders if what he hears is his own inner voice directing him or a siren's voice, the voice of fear, doubt, or uncertainty. He answers that he cannot ignore it, and with certainty he knows it's his own and it is what he must follow. Real dangers and chance for failure give full meaning and value to the victories, joy, and wisdom. Kermit's triumph in the movie can only be had if he risked everything to realize his dream, to find that rainbow connection.

ALL OF US UNDER ITS SPELL...

Each verse of "Rainbow Connection" ends with the line "The lovers, the dreamers and me"—the important bit being "ME." It's not "the lovers, the dreamers and Kermit." And the reason for this is simple: just as the lyrics of the song are meant to teach us, the song needs to be sung so that we take those lessons in deeply. When we sing it, we imbibe its message and hold it dear: This song is for me, it's about me, it inspires me, I am a lover and a dreamer in my own life, and in my own way.

With songs like "Rainbow Connection" and their numerous adventures on the screen, Kermit and the Muppets have opened up the world to millions of children for over thirty years. They have no doubt created and inspired countless, fearless dream chasers, and they will continue to do so long into the future. Kermit, for many of us, was our first philosophy teacher, a sage Frogrates (so to speak) with an Academy of zany friends who taught lessons about existence, being in the world with others, the nature of belief, and knowing reality. Kermit's song eloquently ties together ideas from metaphysics, epistemology, and existentialism. We have many beliefs, some are true and some aren't, and the only way we validate our beliefs and gain knowledge is by going out into the world and learning about it firsthand, which means we must make free choices and commit to courses of action and dreams as authentic persons, always being responsible for our actions and avoiding bad faith. In other words, creating dreams utilizes both the belief and the knowledge we possess, and chasing those dreams involves being true to yourself as an individual and as a member of a community.

Through this philosophy, Kermit demonstrated how important it is to always try, give things your best effort, and never shy away from a challenge or a critic, and that both success and failure are beneficial learning experiences. Whether your dreams involve making millions of people happy, performing daredevil feats with a cannon, becoming the funniest comedian, inventing a gorilla detector to save lives, making the perfect spicy sauce that blows your hat off, or singing "Mahna Mahna" your way . . . never give up on a dream, or on yourself.

18

THE PASSION, WILL, AND FREEDOM OF KERMIT, MISS PIGGY, AND ANIMAL

Shaun Leonard

Traditionally, dramatic narratives, particularly in film, revolve around whatever goal the character or characters have for themselves, whatever they will or must accomplish. They meet a series of obstacles that prevent them from achieving their goal until they eventually overcome them and succeed, usually learning something along the way. Occasionally the obstacles or struggle will be internal, a crisis of confidence. Aristotelian thinking might term this type of conflict "man vs. self." When it comes to the most famous of Jim Henson's marionette puppets, we can say that their struggles are even more solipsistic. While it is true that they have their fair share of real-world obstacles and antagonists, all the way from lobster banditos to the aptly named Dominic Badguy, the true conflict in the Muppets' world comes not from the struggle to get what they want, but directly from their wanting. This chapter begins with an examination of Baruch Spinoza's *Ethics* focusing on the restraining of the passions as a story outline for the Muppets, particularly Kermit, Miss Piggy, and Animal.

Baruch Spinoza is one of the most avant-garde philosophers of the early modern period. His philosophy "combines a commitment to a number of Cartesian metaphysical and epistemological principles with elements from ancient Stoicism and medieval Jewish rationalism into a nonetheless highly original system."[1] Spinoza broke from the then traditional and accepted "understanding" of God, man, and the world, contradicting many widespread religious and moral beliefs. He espoused a natu-

ralistic understanding of God and wanted to compose a factual, meta-physical, psychological, and reasonable system of being, constantly working toward the main goal of his work, foregrounded by its title: *Ethica, ordine geometrico demonstrata* (Ethics, demonstrated in geometrical order). More than just another theory of how one might live well, Spinoza intended to demonstrate *the* way in which one could live morally, controlling one's passions and moving as close as possible to perfect virtue and happiness. Somewhat ambitiously, Spinoza attempts to tell us the truth about both God and humankind. A tall order, and thankfully in this chapter we can bypass some of his definitions aimed at demystifying the universe and the laying of many metaphysical foundations and get right to the meat of Spinoza as screenwriter—his concept of the affects and how they work as revolving character arcs.

THE STRENGTH OF THE EMOTIONS

What are the affects? Well, our love and hate, our sadness and joy, jealousy, and so on—these are the affects. Spinoza divides these affects into actions and passions: "When the cause of an event lies in our own nature—our knowledge or adequate ideas—then it is a case of the mind acting. On the other hand, when something happens in us the cause of which lies outside of our nature, then we are being acted upon."[2] Whether we are active or passive, there is some change occurring in our mental or physical capabilities, what Spinoza calls "an increase or decrease in our power of acting" or in our "power to persevere in being."[3] This perseverance is of particular importance to Spinoza throughout the *Ethics*. This striving is also known as *conatus* and is the essence of man "insofar as it is determined to do what promotes his preservation."[4] He states that all beings are naturally imbued with this power or striving: "Each thing, as far as it can by its own power, strives to persevere in its being."[5] An affect is any positive or negative change in this power. Affects that are actions are changes in this power that have their foundation (or "adequate cause") solely in our nature; affects that are passions are those changes in this power that begin or come from outside of us.[6]

Let's provide some Muppet examples. In the 2011 film *The Muppets*, Animal's mantra throughout—in fact, his main story line—is a summation of his internal conflict. In Spinozan terms, he communicates his

battle to restrain his action, to restrain his affect, when he says, "Drum. No Drum."[7]

Miss Piggy's affects center around her conatus, her striving to persevere in her own being. She wants to be a star; she wants to be *the* star. Due to our innate striving to persevere, "we naturally pursue those things that we believe will benefit us by increasing our power of acting and avoid those things that we believe will harm us by decreasing our power of acting."[8] Spinoza catalogs the passions based on how they affect our powers or capacities. When Piggy strives and succeeds, her actions increase her power of striving; this is Spinoza's Joy, the movement or passage to a greater capacity for action: "By Joy . . . I shall understand that passion by which the Mind passes to a greater perfection."[9] Being a passion, joy is always brought about by some external object. For Piggy, this is often the spotlight, singing the lead role rather than the chorus line. But even more frequently, the external object that increases or decreases Piggy's power of acting is Kermit. As the cause of this sadness or joy lies outside of Piggy's nature, these are her passions. She does not seem particularly concerned with restraining them, despite how often they cause her to move to a lessened capacity for action, most often in the second act of an episode or film. At this point in the 2011 film, however, it is interesting to note that she and Amy Adams attempt to divest themselves of external causes by having a "Me Party." The song is not quite Spinozan in fashion, as it deals with self-adoration rather than self-regulation, but the spirit is similar. Piggy has recognized the externality of the cause of her pain. At this point, we should all be asking ourselves the particulars of why we should restrain these affects.

OF MUPPET BONDAGE

Spinoza believes we should moderate and restrain the affects to avoid being indentured to these affects. Spinoza's main problem with joy and sadness is their inconstancy. Spinoza defines joy as "a man's passage from a lesser to a greater perfection."[10] We know from *Ethics* book 2, definition 6 that "reality and perfection I use as synonymous terms." Also, "the more reality belongs to the nature of a thing, the more powers it has, of itself, to exist."[11] Therefore, should we all not strive to increase our joy as a means of increasing our power to exist? If Animal will gain

Joy from banging his drums, why should he restrain himself from the banging of his drums? Spinoza says that we do strive to bang our respective drums and increase our power, but we should not. In book 3 of the *Ethics*, Spinoza admits that "we strive to further the occurrence of whatever we imagine will lead to joy," but he claims that "the man who is subject to affects is under the control, not of himself, but of fortune, in whose power he so greatly is that often, though he sees the better for himself, he is still forced to follow the worse."[12] This is one of many Spinozan ideas that discard humanity's free will, the chief of which will be dealt with at the end of this chapter. Spinoza warns us of this human flaw because while some affects can increase our virtue, others can decrease it. If we are subject to the affects, then we are not in control of our own capacity to persevere in our own being and we are at the mercy of random chance or fortune to determine our efficacious power. In Spinoza's view, we can only have true security in our virtue, in our very essence, when we "act . . . in accordance with the dictates of reason on the basis of seeking what is useful to one's self."[13] This utilitarian restraint is represented best by the ringleader of the Muppets. Kermit the Frog, above all else, represents Spinoza's dictum that we should strive to be free from the passions.

One could argue that Kermit's attempts to disentangle himself from Miss Piggy's more forceful passions is Kermit trying to remove himself from his external cause of joy and sadness. "It's Not Easy Bein' Green" is an attempt by Kermit to accept himself. In fact, as the emcee of *The Muppet Show*, he frequently took it upon himself to try to restrain or satisfy the passions of the other Muppets, often in that order. Take the 1976 Juliet Prowse episode of *The Muppet Show*. Instead of sending Fozzie onstage to tell a joke, in a pinch or because of a disaster, Kermit redirects him into a scene in which he is supposed to dance. In the same episode, when Kermit talks about his childhood (or, in this case, tadpolehood) to Juliet Prowse, he says that he wanted to be a dancer. This is clearly an attempt by the host of a show to interact with its guest star, and in many ways it shows a level of restraint and self-abnegation of which no other Muppet is apparently capable. In fact, of the core group, he is the Muppet who is most comfortable with solitude, be it leaving behind his swamp home or living as a recluse in a derelict mansion.

A true examination of Spinoza's moral system of restraint is its success or failure within a test group. For our purposes, we can take the

Muppets as our sample. If Kermit succeeds in restraining his passions, then all he is left with are internal objects, internal Kermit, his core character traits. These traits are that he is a performer and that he brings people together, that he organizes and manages his friends for the benefit of the show, which, though it is for himself, is also for his audience. He fails even when he follows Spinoza's roadmap to perfection. When he only focuses on his internal self, he is left with characteristics built around other people, other Muppets. In this he is not alone. Miss Piggy, at her core, wants the attention of others. Fozzie wants to make people laugh, Walter wants to be a member of a group, and Statler and Waldorf need people to heckle. If Spinoza is writing the screenplay, then the characters, in striving to increase their joy, defying Spinoza, *and* in the restraint of the passions and agreeing with Spinoza, are trapped, to our unending enjoyment, in a story cycle that demonstrates Spinoza's *Ethics*, regardless of whether the Muppets agree with his ideas. Perhaps the Muppets are more suited, then, to television, where eternal recurrence is encouraged, than to film, where a final answer, a last lesson, is sought and taught.

There is a distinct difference in the narrative styles of television and film, stemming from the fact that television is continuous storytelling. Spinoza's philosophy of restraining the passions was aimed at human beings, whose lives do not take place over ninety minutes or in the course of an Aristotelian day. In short, television is suited to the exploration of a question or a series of questions. Character struggles recur. Films, however, as singular units of entertainment, must provide the beginning, middle, and end of a story. Films are statements. Films are answers. Miss Piggy and Kermit's relationship is in a constant state of flux in the television shows, but most Muppet films end with definitive statements, a reuniting or reconciliation. In the 2011 film, Kermit admits that he needs Miss Piggy. Walter also joins the Muppets. He has decided he is a Muppet as much as Gary has decided he is a man. In a television format, these conclusions eliminate potential story lines for future episodes, so such final resolutions are rare before a series finale. A human life is a constant struggle, a constant striving to persevere in one's own being, with no decisive success or failure. In fact, Spinoza believes human ability to be limited, in many ways removing the very possibility of success and tacitly accepting failure.

The preface to book 5 of *Ethics*, "Of the Power of the Understanding, or of Human Freedom," begins with Spinoza's account of what he will go on to say in this section of the book, that he will be "showing how far the reason can control the affects." This implicit acceptance that reason cannot fully conquer the emotions is followed by an explicit statement "that we do not possess absolute dominion over them."[14] This is another way in which we can see how the Muppets' stories follow Spinoza's guidelines. Usually depicted as underdogs, the odds are against the Muppets. They are not expected to succeed, and often do not, particularly on television. Yet they still try their best to overcome circumstances that will never truly be in their control.

Spinoza is not a pessimist. Were he here, he might argue (perhaps pompously) that he is a realist trying to explain the underlying workings of the universe in a way people can understand, so that they can better themselves and learn how to be more virtuous and content. Think of him as a seventeenth-century Hoots the Owl, trying to explain to Cookie Monster that his favorite snack is a "sometimes food." However, Spinoza's philosophy is one that reduces human power and free will to somewhat unacceptable parameters. The concepts of free will and servitude are significant in book 4, "Of Human Bondage," because Spinoza uses this book of the *Ethics* to logically argue that one cannot ever be completely free from the passions, but one can learn to "moderate and restrain" them and be guided by reason so that a man (or a Muppet) can be *more* free and can be "endowed with power to act according to the laws of his own nature." This nature is still a manifestation of God, the underlying substance, and as such the extent of our freedom can only be to exercise our faculties of reason to restrain our affects and avoid the pain that comes from "excessive love for something that is liable to many variations and that we can never fully possess."[15] Spinoza's theories of God and free will are inextricably linked, by mathematics of all things, and will be discussed here with regard to their impact on the lives of Muppets and others not composed entirely of felt (or, to be more precise, antron fleece).

NO FREEDOM FOR US

Spinoza goes against the Judeo-Christian idea of God as the seven-day intentional creator of the world and instead states that everything exists because everything necessarily and causally comes from the divine nature.[16] Spinoza believes that from God, the substance underlying all things, "all things have necessarily flowed forth in an infinite number of ways, or always flow from the same necessity; in the same way as from the nature of a triangle it follows from eternity and for eternity, that its three interior angles are equal to two right angles."[17] God could not have but created the world, and it could not have but been created. In fact, he writes, "Things could have been produced by God in no other way, and in no other order than they have been produced."[18] Here we can see that Spinoza strips God of free choice. The world can only be the way that it is because "nothing in the universe is contingent, but all things are conditioned to exist and operate in a particular manner by the necessity of the divine nature."[19] Swiftly and mathematically, Spinoza has robbed humankind of free will. In fact, he does so twice over. Not only are all our actions a necessary consequence of the creation of all things, reverberating infinitely from the genesis of the world to the present like some sort of divine domino effect, but they are also frequently the result of causes more immediately external to ourselves. Steven Nadler put it best when he said that "the actual behaviour of a body in motion is a function not only of the universal laws of motion, but also of the other bodies in motion and rest surrounding it and with which it comes into contact."[20]

NO FREEDOM FOR THEM

The Muppets are essentially a variety show theater troupe. Each segment of the show is linked inextricably to the segments before and after, and, as is common with the Muppets, even these planned acts are impacted by other Muppets behaving badly. However, the Muppets, from Spinozan theory and from the way in which their characters are constructed and written, can only behave the way they do. The Muppets have little agency after creation, even Kermit, whose core character involves him corralling the others and getting them to participate. Do the Muppets have free will? Or are their actions predetermined by their creation by their god, Jim

Henson, who in turn could *only* have created them the way they are, much as God could *only* create Jim Henson the way He did? The Muppets do not grow and change. If one of them tried, they would quickly be dragged back into the fold of the troupe, back into their role within the group. This is not hypothetical, for the montage wherein Kermit and company get the group back together in the 2011 film plays out this exact scenario multiple times. These actions are motivated by the constraints of the plot, yes, but this plot is motivated by the existence of an audience. Character behaviors are expected by the viewers and rewarded by the writers and performers. Media is created to be consumed. Without an audience, there would be no television or film, so in this way the audience creates the media—the audience is God. The only free will that the Muppets have exists in the liminal space between episodes and between films. Kermit and Miss Piggy will be happy together at the end of the film, and will be fighting when the next begins. Statler and Waldorf may decide to be kinder to the other Muppets at the end of a show, and will be meaner than ever throughout the next one. For us, there are no liminal spaces. Life just keeps going. Spinoza's ideas about freedom are so controversial because of his mathematical approach and the certainty with which he denies human free will and claims human inability. He does not anthropomorphize God as an intentional, fatherly creator; Spinoza states that God simply *is*.

In the end, Spinoza and Henson were not that different. Both were radical and original, and they created things that would change everything that came after them. Spinoza's theory of a slow and impossible struggle to achieve perfection would work as well for television as Joseph Campbell's monomyth does for film. Henson's Muppets are all striving to not only persevere in their being but also show the audience that perseverance *and* that being through comedy and musical theater. I would like to believe that we have more than simply "adequate" free will, not simply because it robs us all of accomplishment and spontaneity, but also because implies a pointlessness and lack of ability to fully change and improve, and all of these things disagree with what we were told as children, by our teachers, our friends, and our Muppets, who are some combination of both.

19

"LIFE'S LIKE A MOVIE"

Performativity and Realness with the Muppets

Christopher M. Culp

As Nicky, the scheming younger brother of Lady Holiday, is being handcuffed and taken to jail, Miss Piggy exclaims, "You! It was you! Kermit was right! You're a phony. You're a phony! Yes, you are! And you know what, you can't even sing! Your voice was dubbed!" This moment, in *The Great Muppet Caper*,[1] reveals a curious paradox within the Muppets' performance style and place in culture. Miss Piggy admonishes Nicky (played by Charles Grodin) for his evil-doing, particularly in how she suspects his flirtatious advances toward her were fake or artificial. For those unfamiliar with the movie, Nicky Holiday is Kermit's competition for Miss Piggy's love in the film, culminating in a Busby Berkeley–esque fantasy musical number (complete with synchronized swimming) in Piggy's head with Nicky and Kermit singing for her affections. As Kermit and Nicky sing for her love, it is highly apparent that a professional tenor's voice has replaced Nicky's, giving the song an extra dose of ridiculousness and dreamlike quality. Piggy's insult is funny because she is complaining about Nicky's artificiality within her dream, a place we might not consider real. It is especially funny considering that Miss Piggy is a Muppet—a puppet with personality whose aspects are all, one could say, dubbed onto each other.[2]

As a group, the Muppets have continually tried to make it big. As a performance troupe, the Muppets have always had the desire to perform by living the vaudeville/variety show life (*The Muppet Show*[3]), breaking

into Hollywood (*The Muppet Movie*[4]), and getting into journalism and high fashion (*The Great Muppet Caper*), not to mention hitting Broadway (*The Muppets Take Manhattan*[5]). Ostensibly, they have made it—yet each film reiterates their struggle to be considered legitimate actors. The Muppets are more than that, however—they are real personalities within celebrity culture.

How can the Muppets seem real in these contexts? Moreover, what do I mean when I say that they seem real? This is coextensive with their existence as celebrities in our world. They are independent (or perhaps codependent) upon their puppeteers; yet they have outlived the originators. They are cultural markers of production and nostalgia, with a presence in almost every form of mass media from music to YouTube. Furthermore, they are more "real" than many of their celebrity counterparts. In relation to the fully formed characters of Kermit, Piggy, Fozzie, and Gonzo, the guests on *The Muppet Show* end up playing caricatures of themselves that seem blatantly shallow and artificial.

This chapter is meant to confront the issues of reality within the Muppets as a way to summarize two contemporary terms in philosophical discourse: performativity and simulacrum. Both refer to a postmodernism epistemology and moment within history where the common notions of reality, like the sciences or logic, are increasingly approached with skepticism. Sometimes defined as the problem of the twentieth (and now twenty-first) century, locating the real in daily life has become increasingly problematic and challenging. Epitomized by Kant's Copernican Revolution, philosophers began questioning our knowledge of the real or the existence of an independently existing reality through phenomenology, existentialism, and philosophy of language. Each of these, and many more, question the "given" nature of reality and have greatly shaped the field of contemporary philosophy and the shape of current intellectual discourse. And yet I can describe the Muppets as "real" celebrities and still make sense—making them an interesting case study in contemporary realness.

PERFORMATIVITY: CELEBRITY AND
THE ART OF THE CAMEO

The Muppets' aesthetic depends heavily on the use of the cameo; by having a guest actor come in and play a small or bit part, often for humorous effect. Every film and television show employs the use of cameos—from the celebrity guests each week on *The Muppet Show* to the recent films. In one respect, cameos attract new viewers because a celebrity's fan base might tune in to that episode. Aesthetically, however, cameos have a profound effect on the way in which we watch the show.

Cameos are a great example of what theorist Judith Butler calls *performativity*. A commonly misunderstood term, Butler is not talking about the art of performance that an actor or musician might employ in the performance of a monologue or musical work. Instead, Judith Butler's use of the term investigates the ontological description of reality in the sense that she wants to describe the world as it is. Butler's first major theorization of the term occurred in *Gender Trouble*,[6] bringing a combination of Hegel and Simone de Beauvoir's philosophies to the American Academy in order to analyze and critique dominant understanding of gender and sex in our society. While her analysis focuses on gender and sex, Butler and others have expanded the theory as a conceptual framework of understanding all identities including care, class, human, and (now) Muppet.

Performativity suggests that identity is always already being performed in everyday actions and movements, regardless of your intention. Identity, as such, is always a verb—an act of doing rather than an essentialist identity. Based on de Beauvoir's comment that "one is not born, but rather becomes, a woman," Butler asserts that all identities are performing and, in the act of performing, are constantly becoming. So, to say that one is a woman or man is to say that one *acts as* a woman or man. These performances are unstable, however, because Butler is resisting essentialist and stable categories of gender. Woman and Man are identities with no original definition—there is no original Woman or Man that is the solid definition of those genders. But because we are constantly performing gender, these categories do not need to be solid—they can flow with the ways in which human beings change internally and externally, as well as their relationship to an outside world. In this way, cameo is not merely a recognition of an actor as character—if so, then all acting

would be considered a series of cameos. Instead, a cameo performance includes the activity of performing two identities, the character and the celebrity persona, to an audience familiar with the actor's stage persona.

The phrase *always already* is important in describing Butler's sense of performance. Her borrowing from Hegel *always already* indicates an endless continuation. As opposed to actors, who may start and stop a performance on stage, the performance of our identities as subjects (or subjectivity) is always already in motion from the day we are born. (Although Butler often refers to drag performances as interesting cases of subverting and critiquing gender, these performances are still of the momentary and intentional actor's sense of performance, and not the ontological and foundational sense.)

Using Butler's theory, we can define cameos in a more philosophically useful way to explain why they are so affective in movies and television. In cameos, celebrities are *always already* performing their celebrity. For example, Charles Grodin in *The Great Muppet Caper* is *always already* performing his celebrity persona as Charles Grodin while, as an actor, performing the role of Nicky Holiday. He does this by being recognizable as Grodin throughout the film, frequently nodding to the camera with a wink or smile (as if we are in on the joke that he is acting a role) and performing in a melodramatic or campy way. His character is basically a stereotypical Hollywood villain without the curly moustache; he even has the diabolical laugh of a villain. This provides a curious comparison between the Muppets and their celebrity guests. As cameos, roles such as Nicky Holiday are seen as an actor playing a character first, and then, secondly, a character in a film. Because of this, they seem artificial and performative.

The Muppets are positioned in the opposite way. Beginning with *The Muppet Show*, all Muppet movies and shows have included a break in the fourth wall. Breaking the fourth wall is a technique of breaking out of the established narrative, often directly addressing the audience and the "real" world outside of the film or television episode. An example of this is in *The Muppet Movie*, when Kermit and Fozzie come upon the Electric Mayhem for the first time. Instead of explaining their story to the band, Kermit remarks, "Fozzie, you can't tell them the whole story. You'll bore the audience." Acknowledging the audience thus shows that Kermit and Fozzie are aware they are in a movie—that they are acting out roles that are very much like them, but not exactly them. *The Muppet Show*'s back-

stage exposure is a special representation of this fourth wall—it shows the background and the technology and labor behind producing the performance onstage. The Muppets interrupt their acting performances by acknowledging that they are performing—by breaking the fourth wall. Cameos, however, only transcend the fourth wall if we, the audience, recognize the celebrity.

The Muppets, then, achieve a sort of realness and authenticity in two ways via performativity. Compared to their celebrity guests, they seem more real as actors when they break the fourth wall and show their "actor" selves in addition to their character's roles. The second way is in the creation of the fourth wall space. By addressing the audience, the Muppets give themselves life outside of the film, fleshing out their identities by providing a dividing line between their self and their acting career—Kermit is both a frog and an actor, Miss Piggy is a pig and an actor, and we constantly see that shift between those identities while the cameos work to hide that switch.

SIMULACRUM: WHEN COPIES BECOME REAL

By placing different levels of performance in reference to each other, some seem more authentic than others. This is a fairly common technique in theater and especially puppetry as a way of playing with notions of reality and the real for dramatic or humorous effect. This alone would not imbue the Muppets with such a weight or gravity that would extend over decades of entertainment. Yet the Muppets have a persistence that needs further explanation. To do this, I would like to investigate another term that can help expand Judith Butler's ideas about performativity: Jean Baudrillard's notion of *simulacrum*.[7]

A simulacrum is an image that closely resembles something, such as a duplicate or carbon copy of a thing. A common example of this is the map: a map is a simulation of a specific geographic and topographic structure. Mapmakers try to depict each detail they want in the creation of a useful, comprehensive map. Once the map becomes more and more detailed, however, it begins to become indistinguishable from the original landscape and can, in fact, be seen as a replacement of reality in human experience. It would be as if, instead of standing on the street, you opted to "stand" on the street using the street view in Google Maps. Your

experience of that street corner becomes a relation to a reality that begins to subsume other perceptions. This is not to say that you begin to live life only through Google Maps, but the idea highlights the relationship we have with such technology in treating it as virtual reality on a daily, if not hourly, basis.

Baudrillard describes simulacrum coming out of a four-step historical process. In the first step, humankind recognized the extreme power of the sign as a representational device. We acknowledge that creating a language between us can offer great amounts of communication, and those who have mastery over language can have mastery over those objects as well. This sort of alludes to a basic language—where words are direct reflections of objects. The second step in this process is the disassociation of language from its objects (realizing that *cat* as a word does not tell me everything about the cat on my lap but merely gives me a hint of the creature's characteristics). Third in this process is the destabilization of the dominant reality—in our case, Butler's destabilization of gender (or, rather, acknowledgment of its destabilization) challenges the reality of male and female as gender categories. Instead, as Butler puts it, we are engaged in performativity of genders that have no origin. Lastly, the fourth step is *simulacrum*, where the simulation one is engaged in has no relation to reality and, furthermore, does not need a relationship to anything other than itself.

Whether or not you agree with his loose description of the understanding of *simulacrum*, Baudrillard's approach is easily demonstrated with the Muppets themselves. Many of the main cast are puppets based on real animals—for example, a frog, a pig, a bear. Their personalities subsequently develop via performativity and interaction with a culture that shapes our expectations of them. The best example of this is Miss Piggy, the diva pig. As an audience, we are supposed to accept that Piggy is a beautiful, glamorous diva—a common joke throughout the franchise. The Muppets then form their own destabilization of reality—that is, they make celebrity guests feel awkward. They also turn, self-reflexively, to the technology that creates them by emphasizing movie production, moments of breaking the fourth wall, and even sometimes revealing their puppet ancestry.

This begs the question of whether the Muppets are simulacrum in Baudrillard's sense and, because of that, hold some kind of representational power over our own conception of the real. That is a topic outside

of this book chapter, but I want to focus for a moment on the character who pushes the limits that exist within the boundaries of the Muppets themselves: Gonzo the Great. Gonzo, self-identified as a *whatever*, does not fit with the core Muppet group because he seems to be lacking a representational origin. While the Muppets commonly are creative creatures, new forms and formulations of what a body can be, Gonzo struggles with his displacement and wishes to find his roots, his family. He performs the outsider status, both in his wild performance art and in his moments of sadness and reflection. He does this in comparison to the other Muppets—his interactions are framed by being the "whatever" in a room of pigs, frogs, chickens, and bears. His identity is much more complex than those of his friends.

This complication manifests itself in two major ways. For one, Gonzo does not look like anything. His nose, often described as a "beak," and general body do not have a correlation with any sort of real creature in our world. Yet he is humanized and part of the core group. Second, his performances place him outside of the vaudeville style. When we first meet Gonzo in *The Muppet Movie*, he explains, "Well, I want to go to Bombay, India, and become a movie star." His path is different from those of the rest of the Muppets only in that it is harder to create a character—to create Gonzo—without representational background and history. When Fozzie tells Gonzo that there are better ways to become a movie star, Gonzo's reply is "Sure, if you want to do it the *easy* way." I pick this moment because it emphasizes that Gonzo's path to reality and identity is more wrapped up in the ways of simulacrum and layer upon layer of representation than some of the more direct and obvious creations (e.g., pig, puppet, diva, Miss Piggy).

CONCLUSION: "GOING TO GO BACK THERE SOMEDAY"

John Hodgman, in his comedy almanac *The Areas of My Expertise*, describes *The Muppet Movie* like this:

> This was a movie about puppets who go to Hollywood to become stars. As they travel, they frequently consult the script of the movie in order to know what to do next. When they reach Hollywood, they begin making a movie about the movie the viewer has just been watching. The puppets build plywood simulacra of props that, earlier in the

film, were presented as real. Then the roof of the soundstage smashes in and a powerful rainbow shines down and obliterates everything, including a plywood imitation of the fake rainbow that had appeared in the first scene. The frog and bear and pig simulations panic as the fake/real and real/fake worlds nearly destroy each other. The puppets then look directly into the camera and instruct the viewer that "life's like a movie: write your own ending."[8]

This humorous description, eerily descriptive of the entire Muppet project and aesthetic I have been describing, pinpoints the complex relationship that the Muppets have to various levels of performative, simulation, and virtual realities. As layer upon layer of performance, reality, script, and improvisation converge onscreen for our entertainment, one thing has remained consistent: the Muppets are performance and resist performance at the same time.

In conclusion, the Muppets' journey through reality and illusion continues. In 1989, the Muppets began their journey to the Walt Disney Company, eventually becoming the property of Disney. In that time, the Muppets saw a fading away and then a recent resurgence with *The Muppets*[9]—another film about becoming stars, though this time having to confront nostalgia along the way. In the meantime, something ineffable has changed about the Muppets. In working through nostalgia, as characters and as commodity for audiences, the Muppets have a past integrated into their story that imbues a different kind of reality—a more traditional, linear model. These converge in the ending of *The Muppets* as Kermit admits failure in a moving speech, just as masses of people wait outside to shower them with praise and fame once again.

Baudrillard comments that "Disneyland is presented as imaginary in order to make us believe that the rest is real, when in fact all of Los Angeles and the America surrounding it are no longer real, both of the order of the hyperreal and of simulation."[10] Disneyland is perhaps unique in creating a physical space of imagination for us to participate and engage. Instead of being spectators, we can meet Mary Poppins and Cinderella. Baudrillard's suspicion is that, in creating a world of the imagination, Disney is a distraction and dishonest. It is not dishonest about its own creations, but instead situates the world outside of Disneyland and Disney World as real. As I hope to have shown, the Muppets have never been able to hold up that divide. Their reality is ours; our world is as ridiculous as theirs is to us. As fake and real combat for attention, the

postmodern world of signs and significations is overwhelming human experience.

Perhaps the long-standing fame of the Muppets lies in their ability to frame reality, to create the frames that separate fake and real, and allow us the momentary release of traversing those fields of experience. This journey is tied up best with Gonzo's journey as a *whatever* creature. He is without home, without identity, and always lies on the outskirts of the weird and surreal (even for the Muppets). But in his construction, he also expresses a sincere wish to find reality, testing the limits of his body and mind through daredevil stunts and risky performance art. When Gonzo sings in *The Muppet Movie*, "I'm going to go back there someday," his sincerity cuts through layer upon layer, unmasking the ways in which performativity and simulacrum have formed the human condition in the twentieth and twenty-first centuries.

20

TRAVELING MATT'S ADVENTURES IN OUTER SPACE

Fraggle Rock and Post-Structuralism

Ryan Cox

Traveling Matt, the brave Fraggle explorer, gets a lot of things wrong. Because the conical shape of the cone reminds him of a hat, he assumes that he is supposed to place an ice cream cone, ice cream end down, on his head. Elevators, to Matt, resemble teleportation devices. He sees the world differently from the people around him and as a result recontextualizes his experiences so that they can be communicated to Gobo and the other Fraggles. However, the viewer is able to see Matt in these situations and recognize the familiar world. Ice cream, elevators, balloons, dogs, boats, and subways are, if not a part of the viewer's everyday life, things they understand contextually. They mean things and are governed by conventions that the viewer recognizes and has been conditioned to conform with. Traveling Matt, however, presents these things as new. They are made new and strange and, as a side effect, opened to possibility. Traveling Matt's adventures in Outer Space—along with the show's geography, the absurd politics of the Gorgs, and the centrality of play to the Fraggles' lives—reveals the show's reliance on post-structuralist philosophy and the free play of the signifier. *Fraggle Rock* uses deconstruction and linguistic play in order to accomplish its narrative, political, and pedagogical goals; it uses post-structuralism to open the viewer to possibility and fun.

Traveling Matt's adventures with ice cream cones and his confusion about elevators reflect a fundamental problem of symbolic systems: there are no intrinsic links between objects and their meanings. Context is everything and, as Jacques Derrida suggests, "there are only contexts without any center or absolute anchorage."[1] Put simply, context does not exist and language is a field of play where similarity and difference collapse, leading to a constant blurring of meaning and substitution.[2] Play is important; it both describes the uncertainty and possibility of the free play of the signifier and serves as the core of a Fraggle's experience: Fraggles are primarily occupied with the serious work of "yo-yoing, cheerleading, tumbling, roller skating, waving flags, jumping up and down . . . singing songs and making music."[3] Fraggle life is about play and possibility, a play and possibility influenced by and inherited from post-structuralist approaches to language, and this is coded into the show.

MAPS BETWEEN MAPS

Spatially, the show is organized around four settings: the eponymous Fraggle Rock, where the Fraggles and the Doozers live; the Kingdom of the Gorgs; the Workshop of Doc and his dog Sprocket; and Outer Space, a simulacrum of the real world, where Traveling Matt explores and catalogs the behavior of the Silly People. The workshop is technically part of Outer Space, where a rupture, a hole in the wall, provides access to Fraggle Rock, just as an opening on the other side of Fraggle Rock allows for access to the Kingdom of the Gorgs.

The show's pitch book states that "Fraggle Rock is a small space, existing just beyond everyday reality," and while "Fraggle Rock does not exist in our world . . . you can get there from here."[4] This establishes Fraggle Rock firmly in the tradition of children's literature where the magical land or space is accessible through a portal—Narnia is reached when the Pevensie children pass through the wardrobe and Alice arrives in Wonderland after she goes down the rabbit hole. Traditionally, the passage through this portal has served to remove the rules and governance of the child protagonist's parents and, therefore, offers the possibility of danger and adventure. Passing from one world to the next is a single action; the story does not take place in this passing. This is where Fraggle Rock diverges from this trope because Fraggle Rock is not the

magical world—it's the portal. On one side lies the human world of Outer Space, where the mail comes regularly and Doc lives with his dog Sprocket, and on the other is the Kingdom of the Gorgs, populated by giant monsters, talking compost heaps, and the ruined vestiges of mythical kingdoms. These are both blue-sky worlds possessing light and space. They run parallel to each other. These two realms may have different cultural markers affixed to them—Doc the inventor representing progress and science, and the monarchical and agrarian Gorgs evoking the idealized pastoral past and magic—but, given the established tropes, they are two sides of the same coin. The caves of Fraggle Rock should be the portal through which readers/viewers and their stand-ins navigate between these two spaces, and not a space itself. The hole in the wall of Doc's shop and the cave mouth to the Kingdom of the Gorgs are peripheral to these worlds and can only access the other by descending into the dark labyrinthine space of Fraggle Rock. Discursively, this structural relationship means that Fraggle Rock resembles the space within the wardrobe or in the rabbit hole, a space that conveys metaphorically the distance between the two lands at either end but is not necessarily a real space itself.

The show, however, frustrates this reading by setting the main action in this space. Most of what happens does so in this in-between space, and the main characters who live in this in-between space are the only ones who can travel with relative impunity between the two ends. As the location where these two worlds touch, overlap, it becomes simultaneously a site of rupture and suture where the perceived differences between the workshop and the Gorgs collapse and deconstruct themselves. It also becomes a site of possibility, of potential, a generative space due to its uncertainty. As Barthes suggests, it is at the seam where culture occurs and recurs. [5]

While the borders of Fraggle Rock are clearly defined, the space within is open to constant exploration and expansion. New caves, chambers, and inhabitants can be introduced as the needs of an individual episode might dictate. Fraggle Rock as a place needs to be malleable in order for *Fraggle Rock* the television show to introduce new characters and situations for the show's protagonists to interact with. This, in part, transforms what might otherwise be a claustrophobic and limited/limiting space into a place with truly unlimited possibility. The edges of Fraggle Rock that do not touch upon either Outer Space or the Kingdom of Gorgs are, then,

unreachable. This means that the Fraggles cannot be defined or restricted by this space. The Fraggles may face the threat of repression and disciplining from without, as both Sprocket and the Gorgs represent physical threats to the Fraggles' well-being and the many unexplored corners of the cave system hide a variety of threats; however, this is balanced by the sense of community at the center of Fraggle life and the diversity of experience that the undefined and decentered space could potentially provide for both the reader/viewer and the Fraggles themselves. Within the shapeless boundaries of Fraggle Rock there is the opportunity to meet a sea monster or enter the land of the lotus eaters (which the Fraggles call the Caves of Boredom) or simply to constantly explore, which carries with it the continual possibility of the new. Since nothing in Fraggle Rock is necessarily spatially fixed or limited by geography, the world is constantly open to exploration and discovery. The fact that Cantus and the Minstrels indicate that in their wanderings through Fraggle Rock they are continually encountering new communities of Fraggles punctuates this openness by introducing the idea that there are an untold number of other communities in this space existing in parallel.[6] Fraggle Rock has coded into its geography open possibility and the potential to tell and experience any story that is necessary or desired. This spatial, structural configuration means that Fraggle Rock is a text of possibilities.

There is a certain amount of irony in the fact that a cave is an open and undefined space full of possibilities. Caves are enclosed spaces that stand in binary opposition to the openness of the land and sky above, and this enclosure (at least going back to Plato's Allegory of the Cave) has long been figured as an imprisonment and a fetter. The irony is magnified when we again consider the fact that discursively Fraggle Rock resembles the portal between worlds, a vehicle for transiting between to realms of possible experience but not a place of experience itself. But this makes sense if it is read through the lens of post-structuralism. As a place, it represents a failure of a binary structure to hold. Space and enclosure, up and down, limitation and possibility all collapse in Fraggle Rock, since the baggage all of these signifiers carry with them must be called into question when exposed to the decentered and in-between space that the Fraggles inhabit.

PUPPETS, POLITICS, AND POST-STRUCTURALISM

The second significance of Fraggle Rock's spatial in-between-ness is that it allows for the contamination and critique of the two spaces that it transverses. The ability of the Fraggles—and this is an ability that seems to be limited almost exclusively to Fraggles—to move throughout the three spaces forces or invites a contrast between the three. This is acutely apparent when the Fraggles travel to the Kingdom of the Gorgs. The Kingdom of the Gorgs is everything that Fraggle Rock is not: it is above-ground with open skies; it is sparsely populated, with the only obvious inhabitants being the Gorgs themselves, the Trash Heap and her attendants, and a few birds; it has an agrarian economy in contrast with the industrialization of the Doozers; and it has centralized authority, with Pa Gorg as titular king. The Gorgs are also, particularly when compared to the Fraggles, quite big. These differences set the Gorgs up, to some extent, as natural antagonists for the Fraggles, and, indeed, Junior Gorg's desire to catch and thump any Fraggles he can get his hands on bears this out. These fundamental structural differences between the Fraggles and the Gorgs renders the Gorgs' garden, a key source of food for the Fraggles, a dangerous place and functions as a key device for introducing action into the show.

Beyond this, the contrasts between the two places introduce a subtle critique of the ideologies operating in the Kingdom of the Gorgs. The Fraggles live a communal life, with no obvious centralized authority. There are Fraggles whose opinions carry more weight, but this stems largely from experience and knowledge (this is certainly true in the case of the World's Oldest Fraggle and the Storyteller, both of whom owe their respect to their knowledge rather than an exercise of power). The Fraggles—a species dedicated to carefree fun, music, art, and adventure—live side by side with the Doozers—a crew of small construction workers that find pleasure in work and are continually building. The Fraggles eat the Doozers' structures, Doozer towers made of Doozer sticks, thus finding easy sustenance and preventing these structures from overwhelming Fraggle Rock. This relationship is symbiotic, as the Doozers view the continual destruction of their labors as an opportunity to continue construction and rebuilding. In the episode "Boober Rock," when Boober Fraggle smashes a Doozer bridge, a Doozer exclaims, "Hooray! Now we can rebuild it!" while a second calls to double the

work crew.[7] This is presented throughout the show as a necessary balance that is mutually beneficial to both parties. Implicit in this arrangement and the way Fraggle society works as a whole is an openness to possibility. The Fraggles are socially and politically adaptable—Wembley even once volunteered himself as a potential subject to Gorg rule[8]—in a way that is consistent with their undefined living space. What remains consistent is a focus on the community that also allows for the individual to pursue personal interests and fulfillment. The key feature is a lack of coercion and overt control.

The Gorgs, however, value the trappings of authority. Throughout the show there are only three Gorgs, Pa, Ma, and Junior, and they live as subsistence farmers because "[a]fter all, they've got to eat."[9] Still, despite the lack of subjects and infrastructure, the Gorgs cling to the illusions of their power, claiming rulership over the universe. Pa Gorg wears the crown as the King of the Universe and Ma Gorg is the Queen, which leaves Junior to function as heir apparent, the court, the royal guard, and the kingdom's lone subject. Monarchy, at least as portrayed by the Gorgs, comes off as rather ridiculous—the kind of thing that is attractive to bumbling clowns like Junior and his family, and certainly, as evidenced by the decline in the royal station, something that is very outmoded. Implicit here, particularly when contrasted with the Fraggles, is that power is derived from the people and the common good, and that authoritarian models are not desirable. The Gorgs, clinging as they do to the trappings of power, the performance of power in the absence of any real ability to exercise it, can be read as a deconstruction of centralized, authoritarian structures.

AFFIRMING PLAY

The ability of *Fraggle Rock* to critique and contrast the other realms that make up the show's spatial universe through infiltration and contamination is most significantly realized in Outer Space. Outer Space is the human realm and is to be assumed to be a representation of the world inhabited by the show's viewers and authors. It is, then, filled with things that are immediately recognizable—when Traveling Matt descends into the subway, he is riding the same line in Toronto from the same station that I did when I took my first subway ride—and governed by familiar

rules. Outer Space is the known, mundane world, seemingly divorced from the free play and possibility of Fraggle Rock or the ridiculousness of the Kingdom of the Gorgs. For the viewer, in Outer Space there is no possibility of meeting sea monsters or receiving advice from a wise Trash Heap named Marjorie; it is the space where rules and restrictions are inculcated into the human subject. Fraggle Rock upsets the dichotomy between the mundane and fantastic by providing a denaturing lens. In almost every episode, Gobo receives a postcard from his uncle, Traveling Matt. Traveling Matt is an explorer who once discovered the entrance to the Kingdom of the Gorgs and has since been exploring Outer Space. Through these postcards Matt communicates his observations about Outer Space and its inhabitants, the Silly Creatures. Since Matt is always already outside the norms of Outer Space—Matt as a Fraggle is both physically and culturally other in human society—he experiences everything he encounters through a new lens. This means that Matt does not necessarily recognize the differences between a human and a dog other than one is hairier than the other, and does not understand the conventions that govern the viewer's relationship as a subject with the rest of the world. He is totally open to new experiences and processes them through the context as he understands it, but also through his life experience as a Fraggle and an explorer.

Traveling Matt is a quintessentially post-structuralist figure, exploring a world that resists naturalized coherence. The way he sees the world exposes that world to deconstruction and play. The elevator becomes a teleporter, the subway a moving cave, the ice cream cone a hat because, when taken without context, their meaning is lost. The failure of these objects to reflect an inherent meaning is not negative or traumatic. Instead, it frees Matt and the other Fraggles to play with or reorder the world. For the television show, this has the practical effect of providing endless narrative possibility along with sight gags and other jokes. It also allows *Fraggle Rock* to rather subtly lead the young viewer to favor community over authority—an important political and pedagogical message. For the viewer, the effect of *Fraggle Rock*'s use of post-structuralist thought is more profound. If Traveling Matt can recognize the resonances of a hat in an ice cream cone, then it stands to reason that the viewer could also recognize these resonances. In fact, the jokes in the Traveling Matt segments are structurally dependent on the ability of the viewer to identify both where Matt diverges from convention and why he is able to

make the intuitive leaps that he does. The show models the free play of the signifier and the language games that derive from the arbitrary nature of the sign. It also demonstrates how this opens the world up to possibility and experimentation. Through the introduction of a Fraggle into what is understood as the real and orderly world, the show reveals Outer Space to be more and more like Fraggle Rock. Outer Space becomes new, undefined, and open to possibility.

21

ONTOLOGY AND SUPERPOSITION

Where the Muppets Meet and Do Not
Meet Schrödinger's Cat

Rhona Trauvitch[1]

Much of the charm and longevity of the Muppets is born of how readily the audience can connect to and identify with them. Despite the reality that pigs and frogs do not typically talk, let alone date, Miss Piggy and Kermit's relationship seems familiar. Undeterred by the general impossibility of the Muppets, their fans relate to them as they would to friends. Doubtless, one of the reasons for this is that throughout their six decades of existence these outrageous creatures have portrayed very real and human characteristics and problems. Aside from their forms (and the fact that they are puppets), they are as fallible, compassionate, imperfect, and vulnerable as you and I.

If we peek through the magnifying glass of philosophy, we can detect yet another ingredient of the Muppets' believability and relatability. It turns out that a large part of the Muppets' magic is accomplished by means of their ontological ambiguity. Ontology, which is concerned with the nature of being and existence, is a branch of metaphysics explored by philosophers who seek to understand reality. Ontological considerations come to bear when we attempt to determine to what extent a character exists: whether the character is fictional or nonfictional, and how fictional, with relation to other fictional or nonfictional beings.

The nature of the Muppets' being—their ontological status—is blurry because, while they are fictional characters, they are often depicted as

occupying the same ontological stratum as nonfictional beings. Rather than remain as fictional characters in a fictional setting, they continuously cross the ontological boundary and show up in nonfiction. Sometimes the Muppets appear in real-world events such as the Academy Awards or a late-night talk show (where the setting is nonfictional), and other times they appear in films, dramas, and sitcoms (where the setting is fictional). Instances of the former included Miss Piggy's guest cohosting on the 52nd Academy Awards alongside Johnny Carson[2] and Kermit's appearance on *The Ellen Show*,[3] and instances of the latter include Kermit's appearance on *Mr. Magorium's Wonder Emporium*, Kermit's and Miss Piggy's appearances on *30 Rock*, and Big Bird's appearance on *The West Wing*.[4] When Miss Piggy appears alongside Carson at the Academy Awards, she is presumably as nonfictional as Carson. On the other hand, when Kermit shops at the Emporium, he is presumably as fictional as Mr. Magorium.

Are the Muppets fictional, nonfictional, or both, simultaneously? Because of all of their ostensibly ontologically paradoxical appearances, the Muppets seem to exist in a state that is ambiguous until the context of a given appearance of theirs is taken into account. Without this context, our idea of the Muppets' fictionality—or lack thereof—is jumbled. Only in observing the context of a given appearance can we determine the Muppets' ontological state.

This phenomenon wherein observation resolves ambiguity is not unlike that which occurs in another field altogether—quantum mechanics. We shall see how the ideas of quantum superposition and the collapse of the wave-function can help us understand the situation of the Muppets. Indeed, it is important to examine their situation—even though doing so may expose the magic—so as to better understand our relationship to the Muppets, as well as their cultural impact. Much of the Muppets' appeal is a consequence of their ontological ambiguity, because the Muppets' proclivity to take on nonfictional hues magnifies their relatability. That they can so easily and imperceptibly cross the border between fiction and reality serves to amplify their nonfictionality—their humanity.

Thus, following a brief overview of the notion of fictionality, we will inspect two scales at which the Muppets' ontological ambiguity operates. In the micro scale of contextualization, we will investigate degrees of fictionality among the Muppets themselves. In the macro scale of contextualization, we will note how the Muppets' ontological status is deter-

mined in terms of how they are placed alongside nonfictional beings. In both scales we will see that the ambiguity serves to render the Muppets more relatable to their audience.

OF FICTIONALITY

What is meant by "fictional entity," and in which ways can one speak of the *existence* of such an entity? The numerous connotations of "fiction" include dream, hallucination, falsity, impossibility, nonexistence, and social—rather than objective—construction. The connotation I wish to focus on is that of fabulation. That is, "fiction" will be treated as that which has been purposefully fabulated as part of a narrative.

Fictional objects exist in that we interact with them, can speak of them, and are affected by them. Much has been written about the problem of the existence of fictional objects, as well as the nature of their existence. While it is not the purpose of the present argument to review or revisit such works, we can gain an interesting and useful point of departure from theories arrived at by the consideration of fictional characters.

What are some of the characteristics of fictional characters, despite or even because of their fictionality? J. J. A. Mooij writes of fictional objects,

> It is nearly universally accepted that fictional entities (whatever they are) can be described, i.e., that correct statements can be made about them; other statements about them, of course, can be incorrect. The current standard view is that such statements are true or false according as they are conformable to, or incompatible with, something authoritatively said or implied in the relevant fictional text.[5]

For example, it is correct to say of Miss Piggy that she is a diva-like character who sometimes practices karate, and it is incorrect to say of Miss Piggy that she does not have an on-again, off-again relationship with Kermit. The correct description is compatible with the way in which the Muppets' creators imagined Miss Piggy, while the incorrect description is incompatible with the fiction. Therefore, while Miss Piggy is indeed fictional, there are correct descriptions and incorrect descriptions of her, given what was "authoritatively said or implied in the relevant fictional text."

Additionally, Mooij points out the nature of the existence of fictional objects: "Fictive objects do exist if, and only if, they have been *made* to exist, i.e. if, and only if, they have been created. . . . What would be necessary for real existence of a fictive entity would be some kind of substance or significance, or some kind of further articulation. That is, it should be anchored in the world that is already there."[6] Miss Piggy has been created and made to exist, and she is articulated every time she makes any kind of appearance. This is differentiated from a purely conceptual entity that has not been articulated and "anchored in the world that is already there."

ONTOLOGICAL AMBIGUITY, MICRO SCALE: *N*-TIER FICTIONALITY

On the micro scale of ontological ambiguity, we encounter the notion of degrees of fictionality in the relationship between Big Bird and Mr. Snuffleupagus. Michael Davis discusses the origin of Snuffy, writing that the show's producer, Dulcy Singer, and writer, Tony Geiss, "agreed that the character was always envisioned as Big Bird's imaginary friend, a fine idea while it lasted."[7] David Borgenicht explains why this did not last:

> It was 1985, and the writers had just about run out of ways for Snuffy to be "just missed" by the *Sesame Street* adults. Moreover, researchers had become worried about the message this was sending to children— that they might not be believed by the adults around them if they told them something unusual. . . .
>
> At that time, increasing numbers of stories about child molestation and abuse were being told in the media. The *Sesame Street* educators worried that if children saw that the grown-ups didn't believe what Big Bird said (even though it was true), they would be afraid to talk to adults about dramatic or disturbing things that happened to them— afraid that adults wouldn't believe them, either.
>
> So the writers and researchers decided that it was time to have Snuffy "become real" and be seen by the adult cast.[8]

Before Snuffy became real—that is, between 1971 and 1985—he was Big Bird's imaginary friend. Snuffy's status as an imaginary friend of Big Bird, who is himself a fictional character, complicates Snuffy's fictional-

ity. As a fictional character fabulated by a fictional character, Snuffy is a doubly fictional character—one who is twice removed from reality.[9] But does that make him *more* fictional than Big Bird? Is he somehow less real, and can we even consider fictionality in terms of degree?

Of course, it is true that Singer and Geiss fabulated both Big Bird and Snuffy. However, as part of their fabulation, they stipulated otherwise. Within the frame of reference of *Sesame Street*, the fabulation/creation/authorship of Snuffy is attributed to a fictional character—Big Bird. Once we enter the frame of reference of *Sesame Street*, the original fabulators, Singer and Geiss, disappear. This stipulation must hold for the narrative structure (wherein Snuffy is Big Bird's imaginary friend) to keep from collapsing. According to this stipulation, the act of fabulating a character into existence has been repeated—but this time by a fictional being. The second-tier fictional—Snuffy—is *more fictional* than the first-tier fictional—Big Bird—precisely because the act of fabulation is attributed to a fictional being, Big Bird. The repetition of the act has further diluted the "realness" of the new character—the second-tier fictional.[10]

The notion of attribution is the essential point when we consider how the second-tier fictional affects the status of the first-tier fictional. This is because the one attributed with fabulation is also by extension attributed with a theory of mind and creative capabilities. Only a being with a mind and an imagination can fabulate. This makes the fictional character, who is attributed with fabulating another fictional character, more like the author—and thereby more "real-like." While every fictional character can conceivably fabulate, once a second-tier fictional enters the picture the first-tier fictional is presented as one who has actually (and not only conceivably) fabulated.

Since Big Bird is presented as someone with a theory of mind and creative capabilities, it is possible to conceive of him—and therefore all other creatures on his ontological stratum (the other Muppets)—as occupying the same ontological stratum as his fabulators (Singer and Geiss), who occupy the same ontological stratum as his audience. The audience can more closely relate to the Muppets now that the latter are presented as being on the same ontological stratum—now that they are more "real."

ONTOLOGICAL AMBIGUITY, MACRO SCALE:
MUPPETS IN AND OUT OF FICTION

The ontological status of Snuffy with relation to Big Bird is not the only unusual ontological characteristic of the Muppets. Also confusing is that the Muppets appear in nonfiction as readily as they appear in fiction. As mentioned earlier, Miss Piggy has presented at the Academy Awards, and Kermit visited Ellen DeGeneres on *The Ellen Show*. Meanwhile, Kermit appeared in *Mr. Magorium's Wonder Emporium*, as did Big Bird in *The West Wing*. There are multitudes of examples of the Muppets' dual role. To wit: *The Great Muppet Caper* (1981) is a work of fiction, and in it the Muppets are fictional characters. The same applies to *The Muppets Take Manhattan* (1984), *Muppets from Space* (1999), and *Kermit's Swamp Years* (2002), among others. On the other hand, when the Muppets join Jimmy Fallon on his final show as the host of *Late Night with Jimmy Fallon* (2014), they must be perceived, as far as the audience is concerned, as occupying the same ontological stratum as Fallon—that is, the stratum of nonfiction. Otherwise, we are faced with the absurd situation of a nonfictional entity communicating with a fictional entity (across an ontological divide). In order to make ontological sense of this situation, the viewer will likely ferry the Muppets onto the ontological stratum on which Fallon exists, rather than the other way around, because the context—the entire show of *Late Night* and its participants—is one of nonfiction. [11]

The implications of the ontological ambiguity on the micro scale are the same as those on the macro scale: that the Muppets can so seamlessly occupy the ontological stratum of the audience—to be as real as the audience—makes it easier for the audience to relate to and identify with the Muppets.

A CAT COMES TO THE RESCUE

This notion of an entity that can occupy more than one stratum at a time brings to mind a certain scientist's speculative cat. In 1935, Erwin Schrödinger published an account of his thought experiment, which conveys the notion of quantum superposition: a phenomenon whereby two particles can be in two supposedly incompatible states at once.

The thought experiment posits a box, which consists of a radioactive atom, a detecting apparatus, a container of poison, and a cat. There is a 50 percent chance that the radioactive material will decay, which will lead to the detector's recording of a particle. According to the setup in the box, if the detector records a particle, the poison will be released and the cat will die.[12] When we open the box, there is a 50 percent chance that we will find the cat dead, and a 50 percent chance that we will find the cat alive. The perplexity lies in the notion that until we open the box and observe its contents, the cat exists in a superposition: he is both dead and alive.

Why did Schrödinger devise this thought experiment, and in what context? In *In Search of Schrödinger's Cat*, John Gribbin notes that "Schrödinger thought up the example [of the cat] to establish that there is a flaw in the strict Copenhagen interpretation, since obviously the cat cannot be both alive and dead at the same time."[13] In *Explaining the Universe*, John M. Charap describes the rationale for this thought experiment as follows: "Even though the rules of quantum mechanics were first formulated for systems on an atomic scale, there is no reason why they should not also be applied to macroscopic systems too. Indeed, they must be so applied if we are to accept that quantum mechanics is of general and universal validity."[14] The macroscopic system is that of the box and its contents.

Charap explains the controversy engendered by Schrödinger's thought experiment when he writes,

> It is hard enough to imagine the state of the atom after an hour as being described by a wave-function which, until the act of measurement, is a superposition of two components, each with the same amplitude, one of which describes an undecayed atom while the other describes an atom which had decayed. But can we contemplate a wave-function describing such a superposition of dead cat and live cat? Are we really prepared to accept that until we open the box and "perform the measurement," there is some sort of superposition of dead cat and live cat inside the box, each occurring with equal amplitude after an hour? . . . How are we to think of ourselves as quantum systems?[15]

Indeed, the idea that the cat is both dead and alive simultaneously is counterintuitive, and difficult to wrap one's brain around. While the aforementioned questions have been discussed for decades, for our purposes it is enough to note that on the quantum level, the superposition of

an entity is a fact. Schrödinger's cat is a speculative example of such a superposition on a classical level.

Schrödinger's cat is both dead and alive until someone opens the box and observes him. At the point of observation, the wave-function—to use the language of quantum mechanics—collapses, and the cat takes on one state: the cat is then either dead or alive. Observation also leads to the collapse of the wave-function in the case of the Muppets. The ontological status of the Muppets can be determined and set only when the audience/ observer takes into account the context in which the Muppets are present- ed, and until that point the Muppets are in at least two intuitively incom- patible ontological states at once. I write "at least two" because there is also the aforementioned notion of degrees of fictionality, as demonstrated by the case of Snuffy. A second-tier fictional character poses the ques- tion: Fictional with relation to whom? If Snuffy were to fabulate an imaginary friend, Snuffy would be nonfictional with relation to this third- tier fictional character, fictional with relation to the first-tier fictional character (Big Bird), and doubly fictional with relation to the audience.

The idea of fictionality as relative foregrounds the notion of context, and context allows us to determine the Muppets' ontological status. To apply this to our macro examples: In watching *Muppets from Space* and establishing the context of the Muppets within it, the viewer is effectively collapsing the wave-function, and the Muppets, at this moment of meas- urement, take on the quality of being fictional. When viewing/observing this episode of *Late Night* and establishing the context of the Muppets within it, the viewer is effectively collapsing the wave-function, and the Muppets, at this moment of measurement, take on the quality of being nonfictional.

What Schrödinger's cat and the Muppets share is the quality of super- position: cat and Muppets occupy more than one state simultaneously. The cat is both dead and alive, and the Muppets are both fictional and nonfictional (and, in the case of Snuffy, doubly fictional).

OTHER DUALITIES

In "'Starring Kermit the Frog as Bob Cratchit': Muppets as Actors," Ginger Stelle points to a different existential co-occurrence in the Mup-

pets. She holds that "the Muppets exist simultaneously as characters and performers."[16] Stelle notes,

> The Muppet movies represent the greatest display of this phenomenon as the films ask audiences to accept the Muppets on the same terms as human actors . . . when Brad Pitt appears in a movie, audiences see him as the character he plays. The Muppet movies ostensibly ask audiences to see the Muppets as their on-screen characters rather than as their off-screen personae. However, the Muppets bring their characters with them . . . the Muppets "play" themselves.[17]

This duality of character and performer is thus another duality that asks the audience to accept certain tenets—for instance, the Muppets exist as entities with lives and histories that are separate from the characters they play in the films in which they star. This places the Muppets on the same ontological stratum as the human actors alongside whom they perform. Stelle argues that *The Muppet Christmas Carol* (1992) "presents the most illuminating insights into the ability of the Muppets to become actors."[18] Kermit does not play "himself"; rather, he plays Bob Cratchit, just as a human actor would play Bob Cratchit in other adaptations of Charles Dickens's novella. But Stelle points out that "at the same time, however, the Muppet-as-actor duality makes itself felt," and she offers Gonzo—who plays Dickens—as an example: "Several of Gonzo's characteristic traits appear throughout the film. . . . He enjoys flying into the past attached to Scrooge with a grappling hook, something The Great Gonzo would enjoy. He also retains his love of chickens."[19]

Recently, MSNBC anchor Rachel Maddow appeared as herself in the fictional Netflix series, *House of Cards*,[20] and in 2012 astrophysicist Neil deGrasse Tyson appeared as himself in a Superman comic.[21] The difference, however, between these examples and instances wherein the Muppets appear as themselves in any medium is that the Muppets originate in fiction, whereas Maddow and Tyson do not. The case of Muppets who take the role of actors who play characters in movies is different from the case of Muppets who appear in movies "as themselves." Examples of the latter include the aforementioned appearances of Big Bird on an episode of *The West Wing* and Kermit in *Mr. Magorium's Wonder Emporium*. Either iteration—Muppet as actor or Muppet as him/herself—establishes the Muppet as nonfictional, since in both functions he or she emulates the situation of a nonfictional person who both acts in a movie as a character

and appears in a cameo role—as him/herself. Thus, the duality Stelle describes is one ensconced within one half of the duality presented in our argument. That is, the character/actor duality is contained within the non-fiction half of the fiction/nonfiction duality.

CAT AND MUPPETS

The more we can identify with a character, the more we can empathize with the character's joys and sorrows. The Muppets' ontological ambiguity has the effect of diluting their fictionality and bringing them closer to our nonfictional selves. Discerning the nuances of the Muppets' ontological situation therefore allows us to better appreciate our decades-long connection to them.

It is both fascinating and fortunate that we can understand the Muppets' ambiguous ontological classification by turning to another field entirely. Physics clarifies the situation of the Muppets because quantum superposition is analogous to the Muppets' occupation of several ontological strata simultaneously. Quantum mechanics provides us with the language that allows us to conceptualize the unusual ontological niche of the Muppets.

And what of an introduction of cat and Muppet? It is only when we open the box and observe its contents and also establish the context of a given Muppet appearance that we will be able to determine which state of cat meets which state of Muppet.

22

THE METAPHYSICS OF MUPPETATIONALITY

Lauren Ashwell

"Dad, what is a Muppet?" asks Lisa Simpson. "Well, it's not quite a mop, and it's not quite a puppet, but man . . ." Homer begins to laugh, distracted by thoughts of Muppets. "Hehehehehehe . . . so to answer your question, I don't know."[1] Although Homer does not provide us with an analysis of what it is to be a Muppet, his response belies a tacit understanding. As I will argue, Muppets are tied to absurdity, and so to laughter.[2]

We can all name paradigm Muppets: Kermit, Miss Piggy, Gonzo, Fozzie, Animal, and so on. But a mere list of Muppets was not what Lisa was asking for—having watched the Muppets on television, she had that information. She was looking for something deeper than just a catalog of Muppets; she wanted to know what Muppets *are*. What makes these things Muppets rather than non-Muppets?

There are benefits to an exploration of Muppethood beyond simply being able to answer questions like Lisa's. A metaphysical understanding of the nature of Muppets helps us ask other questions about the Muppets in a deeper sort of way. Without a general understanding of what a Muppet is, we can only consider questions about particular Muppets, or about defined groups of existing Muppets—although, of course, these questions can also be incredibly interesting. And, perhaps also through investigating what it is to be a Muppet, we will also understand ourselves better—and maybe see why the Muppets have held our attention for so long.[3]

THE MEANING OF *MUPPET*:
HOW DO WE ASK METAPHYSICAL QUESTIONS?

From his very early work, Jim Henson used the word *Muppet* to refer to his puppet creations. *Muppet* appeared in print in 1955 within an advertisement for *Afternoon*, a show on WRC-TV channel 4.[4] Henson's appearances with his puppets on shows such as *Saturday Night Live* were billed as including performances by "The Muppets" or "Jim Henson's Muppets." This led to *The Muppet Show* and numerous Muppet movies. Shows such as *Sesame Street* and *Fraggle Rock* have, at times, been promoted as featuring "Jim Henson's Muppets." If we consider all these uses of the word *Muppet*, it seems plausible that, to be a Muppet, one must at least be a puppet character—although I use "puppet character" broadly to cover characters that are brought to life by actors in puppet suits, and also creations that are puppeted from afar by technology.

Yet, of course, not all puppets are Muppets. I sometimes perform with puppets; sadly, I have never had the privilege of working with a Muppet. Futhermore, not all puppets created by Jim Henson's companies are Muppets. UrSkeks are not Muppets, nor are Gelflings.[5] So what marks the line between Muppet and non-Muppet? I will argue for a dispositional account of Muppetationality: Muppets are those Jim Henson creations that are disposed toward absurdity.

Now, you might think that questions about what makes something a Muppet can be answered with a dictionary, or maybe with Wikipedia (or, more appropriately, the Muppet Wiki). However, dictionary definitions and Wikipedia entries aren't generally in the business of giving metaphysical definitions. They may tell you lots of fun and interesting things about the Muppets, and perhaps be helpful in working toward a metaphysical definition, but they themselves don't usually try to address Lisa's question: What *is* a Muppet?

To see how dictionary definitions fall short of answering metaphysical questions, suppose you want to know the metaphysical nature of cookies. Now, you could start with a dictionary definition:

> cook·ie *noun* \\'ku̇-kē\\: a sweet baked food that is usually small, flat, and round and is made from flour and sugar.

This definition tells us that if it isn't sweet and it isn't baked, then it isn't a cookie. But it fails to define the nature of cookies. While it correctly

entails that light bulbs, cilantro, and Beef Bourguignon are not cookies, it does not give us enough information to correctly identify all and only the cookies; it does not separate the cakes from the cookies. It tells us that cookies are usually small and flat (while cakes generally are not), but cookies can be large, and there are mounded cookies.

Moreover, even if our definition did give us enough to correctly identify all and only the cookies, this still might not be enough to give us insight into the nature of cookies. For here is a condition that all and only cookies meet: being such that Cookie Monster is in fact obsessed with them.[6] While he might sometimes eat other things, Cookie Monster only obsesses over cookies, and if it is a cookie, well, that's good enough for him. But knowing this, even though it gives us a way to identify all and only cookies (put it in front of Cookie Monster and see if he yells out, "Cookie!"), this doesn't give us any deep understanding into the nature of cookies—this condition tells us more about Cookie Monster than it does about cookies themselves.[7] After all, cookies aren't cookies merely because Cookie Monster is obsessed with them.

Definitions of *Muppet* fare no better in answering metaphysical questions. The definition given for *Muppet* (prior to Disney's purchase of the brand in 2004) was as follows:

> Muppets \'mu-pets\ 1: a trademark of The Jim Henson Company for a fanciful troupe of famous puppet characters created and performed exclusively by, and/or for goods and services coming exclusively from, the characters at The Jim Henson Company [var—Muppet; The Muppets]; 2: none[8]

For merchandising copyright, this definition serves its purpose—for copyright, all we need to know is that if it isn't a Jim Henson Company puppet character, then it isn't a Muppet, and you had better not call it a Muppet. But, as with the cookie definition, this definition doesn't draw a clear line between Muppets and non-Muppets. While it tells us that only puppet characters from the Jim Henson Company are Muppets, it doesn't tell us which of those characters are Muppets (all of them? some of them?).[9]

Moreover, the definition also includes features that are merely accidental to Muppets, and so have no place in a metaphysical definition. It is possible that the Muppets could have, in some alternate (very far-off) universe, failed to be famous, without this being a threat to their Muppet-

hood. If such a situation is conceivable, then being famous is not part of the nature of being a Muppet.[10] Muppets aren't Muppets because they are famous.

In asking in a metaphysical tone of voice what a Muppet is, we are asking what makes something a Muppet. Why is this a Muppet, rather than a non-Muppet? So, in our investigation, we will be looking for the following kind of explanation: Muppets are Muppets *because* . . .

A MUPPET BY ANY OTHER NAME

Now, you might think that even without Wikipedia and dictionaries, this is a straightforward question to answer. *Muppet* was a term introduced by Jim Henson, so the Muppets are Muppets because Henson (and others involved in creating the Muppets) called them *Muppets*.

If things are Muppets simply because they are called Muppets, being a Muppet is a response-dependent property.[11] Response-dependent properties are properties that things have in virtue of people's responses to those things. If the property of being funny is response dependent, then things are funny because they make us laugh. If Fozzie Bear tells a joke and we don't laugh (or at least smile) at the joke, it just isn't funny.[12]

So perhaps:

> *Response-Dependent Muppetism:* Something x is a Muppet because x has been called "Muppet" by appropriate Muppet authorities.

Of course, to really understand Response-Dependent Muppetism, we have to know who the appropriate Muppet authorities are—presumably this included Jim Henson when he was alive, and perhaps other various people within the Jim Henson Company.[13] I can call whatever I like a Muppet without changing the Muppety facts, because I am not an appropriate Muppet authority. But if Response-Dependent Muppetism is true, then the Muppet authorities can just call anything a Muppet, and it will be so. Yet this seems wrong—my coffee table could not be a Muppet, even if Jim Henson himself were to have called it that.

This suggests that we need further restrictions on what could be a Muppet. As we noted earlier, it is plausible that Muppets are puppet characters. So perhaps:

Partially Response-Dependent Muppetism: Something x is a Muppet because x is a puppet character and x is called "Muppet" by appropriate Muppet authorities.

This accommodates the intuition that my coffee table could not have been a Muppet,[14] no matter what Jim Henson said about it.

However, we should think carefully about response dependence before we hastily adopt such a view. Contrast being funny—which is plausibly response dependent—with the property of being a bear. While of course the word *bear* was introduced by people, and so in some sense what the word applies to is up to us, once the word has been introduced, our responses don't determine what is and isn't a bear—that's a matter of biology. It is very easy to confuse the explanation: *Muppets are Muppets because . . .* with *Muppets are CALLED "Muppets" because . . .* (compare: *bears are bears because . . .* and *bears are CALLED "bears" because . . .*). It's obviously true that the word *Muppet* applies to the Muppets because Henson decided to introduce the word. If he hadn't, they wouldn't be called that. But this fact about language doesn't straightforwardly mean that if he hadn't called them *Muppets*, they wouldn't *be* Muppets. Similarly, bears would still be bears even if we hadn't called them that.

Note also that even terms for invented kinds of things aren't automatically response dependent. The people at Apple can't go and call just any product that they create an iPhone, even though they invented the word. A room-sized computer with no Internet or phone access simply couldn't be an iPhone, even if it were created by Apple, and even if it were dubbed *iPhone* by appropriate Apple authorities. Even for introduced terms, the term comes to be associated with certain salient conditions that become essential to that kind of thing. The property of being an iPhone isn't a response-dependent property, even though the word had to be introduced by someone; instead, it involves a whole lot of characteristics, like being made by Apple, having a touch screen, having Internet and phone capabilities, and fitting in a pocket. I can imagine Apple coming out with a product very much like an iPhone, calling it an iCommunicator, and someone quite rightly saying, "Oh, that's just an iPhone by another, much less catchy, name."

AM I A MAN, OR A MUPPET?

There is a further problem with response-dependent views. When Walter asks, "Am I a man, or a Muppet?" he is not earnestly inquiring about whether he is a puppet that some Muppet authorities happen to call a Muppet.[15] The crisis of identity that he is going through at that point is not going to be answered by calling up the appropriate Muppet authorities. When he exclaims, "I'm a Muppet!" he doesn't say this because he's thought carefully about naming practices.

Now, of course, Walter's question about his nature occurs in the fictional world of the movie. We, however, aren't asking a question about what is true in a fictional world, but rather about what a Muppet is, out here in the real world. Obviously, not everything true in a fiction is true in reality—for example, it is true in *The Muppet Movie* that Kermit once lived in a swamp.[16] A character in a movie might intelligibly ask "Am I an actor?" of herself; this may be an open question within the movie even though we know that, outside of the fiction, she is most certainly an actor. In watching a fictional presentation, we suspend judgment about certain things that we know to be true, and Muppet movies are certainly no exception to this truth!

Yet even within the fictional world of a movie, the word *actor* still means the same thing as in the real world. Even though the words might apply to different things in the fiction than in the real world (someone might be an actor outside of the movie, but not within the fiction), most terms used within fictional presentations retain their real-world meaning. It is reasonable to accept that *Muppet* means at least roughly the same thing inside and outside of the fictions.

So while the Muppets would not have been called *Muppets* without Jim Henson introducing that term, Muppets are not Muppets simply because Jim called them *Muppets*. The nature of Muppets is something deeper than a response dependence suggests. Being a Muppet must be the kind of thing that could be important to a young Muppet like Walter—something that could be vital to one's identity. Moreover, Uncle Traveling Matt would not have said that being a Muppet requires imagination if Partially Response-Dependent Muppetism were true—what imagination is needed if a Muppet is a Muppet simply because it is a puppet character that some Muppet authority happens to call a Muppet?[17] The importance of knowing whether you are a Muppet, and also the need for imagination

to be a Muppet, suggests that being a Muppet must essentially involve something about one's character.

DISPOSITIONAL MUPPETISM

Character traits are dispositional—they involve something like a tendency to behave in a particular way.[18] A paradigm case of dispositionality is fragility—fragile things tend to break when under physical stress. Dispositional properties have long been thought to be associated with conditional statements; it is generally true that fragile things would break if they were under physical stress.[19] To be disposed toward a particular behavior, you don't have to behave in that way all the time—fragile glasses are fragile even when they aren't breaking.

So it is plausible that Muppets are Muppets because of how they are disposed to behave. But what particular behavioral disposition is involved? There is a certain use of the word *Muppet*, once common in parts of the Commonwealth, where people are called "Muppets" because they are absurd, perhaps a bit awkward, and often run into ridiculous problems—in other words, they are disposed to act an awful lot like Muppets do. When Walter and Gary both sing, "If I'm a man, that makes me a Muppet of a man," they are using the term in this metaphorical sense.[20] It is this disposition toward absurdity that makes what is otherwise a mere puppet character into a Muppet.

Thus, what it means to be a Muppet is the following:

Dispositional Muppetism: Something x is a Muppet because x is a puppet character created by appropriate Muppet creators and a central feature of that character involves the disposition to engage in Muppetry, where Muppetry is the property of acting absurdly or getting oneself into absurd situations.

This conception of what it is to be a Muppet recognizes the importance that the puppet character is created by appropriate Muppet creators, who will presumably be appropriate because they have been deemed to be so by appropriate Muppet authorities. Yet this view is substantively different from Partially Response-Dependent Muppetism, as it entails that even if Henson himself were to have called Gelflings or UrSkeks "Muppets," they still would not be. Those characters simply are not disposed toward

Muppetry. Furthermore, characters can be Muppets even if they were never clearly called "Muppets." Sir Didymus, the Labyrinth goblins, the Fireys, and Fizzgig are quite clearly Muppets, even if they were never called that.[21]

This analysis is not without its challenges, but they can be adequately met. One objection is that the following principle seems quite intuitively plausible: *If X is a Muppet baby, then X is a Muppet.*[22] Skeeter, for example, was a Muppet baby, but it is not clear that she was ever a puppet character[23]—and even if she was, it is still conceivable that there could be Muppet babies that were never puppets. However, the characters in the cartoon *Muppet Babies* are Muppet-like characters, but they are not Muppets.[24] It is plausible that the only baby Muppets are the ones introduced as puppets in *The Muppets Take Manhattan*. If we assent to the principle that *If X is a Muppet baby, then X is a Muppet*, we are speaking loosely, and perhaps making a similar sort of mistake as we would if we thought that piggy-banks are pigs (or banks).

My analysis may also seem to require us to accept a slight difference in meaning within the fictional worlds of the Muppets and outside of the fictions. One might object that within the fiction, it is not true that there are any Muppet creators, so it cannot be true in the fiction that Muppets are Muppets in part because they were created by appropriate Muppet authorities.[25] However, this is not the case—Muppets do make references to themselves as puppets,[26] and they are sometimes quite aware that they are puppets who were created—for example, in *The Muppets Celebrate Jim Henson*, Scooter asks Gonzo, "Do you mean Jim Henson was responsible for us?"[27]

One might also object that the bits of felt and furry cloth that Muppets are constructed out of are not disposed to act in any particular ways, let alone act absurdly. And those bits of cloth could have been used to bring to life characters that did not act in absurd manners. But this is no objection to my account, for Kermit and other Muppets are not simply pieces of cloth. There is one and only one Kermit (the character), even if there have been many Kermit-puppets over the years. Muppets are puppet characters, and, as characters, they have character traits, and thus dispositions to act in particular ways. While they do require a puppeteer to manifest their disposition to engage in Muppetry, this does not count against their having this disposition.[28]

There are, of course, differences in how each Muppet manifests his or her disposition to engage in Muppetry. Some Muppets are self-consciously absurd, like Crazy Harry. Some simply manage to often get themselves into absurd situations. Others would most certainly deny that they are disposed toward absurdity—I cannot imagine Sam the Eagle admitting this. His absurdity, however, lies in taking himself and everything else so seriously. [29] Yet even he would think that those who favored a response-dependent account of Muppetationality over a dispositional account are a bunch of weirdoes. [30]

NOTES

I. MUPPETS, MONSTERS, AND MISFITS

1. Bruno Bettelheim, *The Uses of Enchantment: The Meaning and Importance of Fairy Tales* (New York: Vintage, 2010).

2. Jean-Luc Nancy, *The Inoperative Community* (Minneapolis: University of Minnesota Press, 1991).

3. Jean-Luc Nancy, *Being Singular Plural* (Stanford, CA: Stanford University Press, 2000).

4. *Sesame Street*, season 10, episode 1204 (December 21, 1978, PBS).

5. Caroline Stanley, "Watch Jim Henson's Original Pitch for 'The Muppet Show,'" *Flavorwire*, April 6, 2012, http://flavorwire.com/277308/watch-jim-hensons-original-pitch-for-the-muppet-show.

6. *Pluralism* can be used to refer to a diversity of identities and values at the social level or at the level of institutions. Philosophers like John Stuart Mill and Isaiah Berlin believe that a diversity of viewpoints in society is inescapable, and that the competition between these viewpoints has a positive effect on society. At the level of government, James Madison famously writes in the *Federalist Papers* that government must be designed to accommodate the diversity of competing interests in society. Robert Dahl is a more recent political theorist, who argues that an essential characteristic of democracy is about sharing power among a diversity of people and groups.

7. *Sarasota Herald-Tribune*, November 27, 1977, 9.

8. *Bear in the Big Blue House*, season 4, episode 18 (October 6, 2003, Disney Channel).

9. Iris Marion Young, *Justice and the Politics of Difference* (Princeton, NJ: Princeton University Press, 1990), 48.

10. Young further explains, "An objective account of social relations and social problems, and an objective judgment of what policies and actions would address those problems, instead are accounts and judgments people construct for themselves from a critical, reflective, and persuasive interaction among their diverse experiences and opinion." *Inclusion and Democracy* (Oxford: Oxford University Press, 2000), 114.

11. This sketch can be viewed on YouTube at https://www.youtube.com/watch?v=KwEYuaV6cpc (posted February 24, 2013).

2. MISS PIGGY'S FEMINISM

1. Sarah Pacella, "Top 8 Reasons Why Miss Piggy Is the Ideal Role Model," *Thought Catalog*, April 3, 2014, accessed June 2, 2014, http://thoughtcatalog.com/sara-pacella/2014/04/top-8-reasons-why-miss-piggy-is-the-ideal-role-model/.

2. Masala Skeptic, "Listen to the Pig," *Skepchick*, December 14, 2011, accessed April 30, 2014, http://skepchick.org/2011/12/listen-to-the-pig/.

3. Alison M. Jaggar, *Feminist Politics and Human Nature*, Philosophy and Society series (Totowa, NJ: Rowman & Allanheld, 1983).

4. Kathleen Kennedy, "It's Time to Get Together for Some Sex and Violence on the Muppet Show," in *Kermit Culture: Critical Perspectives on Jim Henson's Muppets*, ed. Jennifer C. Garlen and Anissa M. Graham (Jefferson, NC: McFarland, 2009), 142.

5. Jim Lewis and Louise Gikow, *Miss Piggy's Rules: Swine-Tested Secrets for Catching Mr. Right, Keeping Him and Throwing Him Back When You've Had Enough* (Philadelphia: Running Press, 1997).

6. Jo Breeze, "Feminism Friday: What Makes a Feminist Icon?" *Rarely Wears Lipstick* (blog), April 12, 2013, accessed April 30, 2014, www.rarelywearslipstick.com/2013/04/feminism-friday-feminist-icons/.

7. Andrea Houston, "Miss Piggy—Muppet, Diva and Gay Icon—Does a Press Conference in Toronto," *Toronto Life*, March 19, 2014, accessed May 1, 2014, www.torontolife.com/informer/toronto-culture/2014/03/19/miss-piggy-press-conference-toronto/.

8. C. Cooper, "Fat Studies: Mapping the Field," *Sociology Compass* 4 (2010): 1020–34. doi: 10.1111/j.1751-9020.2010.00336.x.

9. Angela Stukator, "It's Not Over Until the Fat Lady Sings: Comedy, the Carnivalesque, and Body Politics," in *Bodies out of Bounds: Fatness and Transgression*, ed. Jana Evans Braziel and Kathleen LeBesco (Berkeley: University of California Press, 2001), 197.

10. Ibid., 204.

11. Sandra Bartky, "Foucault, Femininity and the Modernization of Patriarchal Power," in *Feminism and Foucault: Paths of Resistance*, ed. Lee Quinby and Irene Diamond (Boston: Northeastern University Press, 1988).

12. Denise Jolly, "Why I Posed Naked in Brooklyn," *Huffington Post*, May 30, 2014, accessed June 2, 2014, www.huffingtonpost.com/denise-jolly/be-beautiful-pose-naked-in-brooklyn_b_5374106.html.

13. Maryanne Fisher and Anthony Cox, "The Uniquely Strong but Feminine Miss Piggy," in *Kermit Culture: Critical Perspectives on Jim Henson's Muppets*, ed. Jennifer C. Garlen and Anissa M. Graham (Jefferson, NC: McFarland, 2009).

14. Ibid., 176.

15. Ibid., 185–86.

16. Jami Philbrick, "IAR Interview: Kermit the Frog and Miss Piggy Talk 'The Muppets,'" *I Am Rogue*, November 21, 2011, www.iamrogue.com/news/interviews/item/5302-iar-interview-kermit-the-frog-and-miss-piggy-talk-the-muppets.html.

17. Katha Pollitt, "Hers: The Smurfette Principle," *New York Times*, April 7, 1991, accessed May 1, 2014, www.nytimes.com/1991/04/07/magazine/hers-the-smurfette-principle.html.

18. Anita Sarkeesian, "Tropes vs. Women: #3 The Smurfette Principle," *Feminist Frequency*, April 21, 2011, accessed May 1, 2014, www.feministfrequency.com/2011/04/tropes-vs-women-3-the-smurfette-principle/.

3. KERMIT AND LEADERSHIP

1. Philosophical and political anarchism can include a range of views, but generally the term denotes skepticism of political authority and a rejection of hierarchical power structures. Many anarchists believe society can be organized in ways that do not require the use of force, formal law, or traditional government. Furthermore, they suggest that these familiar institutions of the state are the tools by which the privileged exploit, coerce, and dominate others. Famous philosophical anarchists include William Godwin (*An Enquiry Concerning Political Justice*, 1793), Max Stirner (*The Ego and Its Own*, 1844), Leo Tolstoy (*The Kingdom of God Is within You*, 1894), and Emma Goldman (*Anarchism and Other Essays*, 1910). Similarly, the term *liberalism* describes a diverse set of views, though it can be understood as referring to a tradition of thought that values individual freedoms and liberties but, unlike anarchism, considers some form of state (complete with a system of law, hierarchy, and enforcement) essential to the protection of these liberties. Liberals therefore believe in at least the possibility of legitimate political authority and in the necessity of government. While liberals share the anarchist worry that hierarchical political power can

threaten individuals' freedom and become oppressive, they believe that the ideal liberal state (for example, a democratic state with political institutions that are governed by a code of equal rights and a commitment to equality) will be able to contain this threat. Famous liberal political philosophers include Thomas Hobbes (*Leviathan*, 1651), John Stuart Mill (*On Liberty*, 1859) and John Rawls (*A Theory of Justice*, 1971).

2. In *The Great Muppet Caper*, Kermit tries to get the group to join him in the attempt to catch the thieves "red-handed." After warning them that it may be dangerous, nearly every member backs out, offering a variety of made-up excuses. It is Fozzie who gives the inspirational speech, complete with mocking emotional soundtrack, that regains the group support. See "Piggy's Fantasy," *The Great Muppet Caper*, produced by David Lazer, Frank Oz, Bruce Sharman, and Martin Starger, directed by Jim Henson, 94 min. (1981, Burbank, CA: Walt Disney Home Entertainment, 2005), DVD.

3. Though only because his dad owns the theater.

4. Various goals driving the plots of *The Muppet Movie* (1979), the *Muppet Show* (1976–1981), and *The Great Muppet Caper* (1981).

5. In his biography of Jim Henson, Brian Jay Jones notes that Henson was a fan of the comic *Pogo* because of its ability to voice opinions or commentary on serious issues while remaining entertaining. He writes, "What it taught Jim Henson is that, done right, you can have it both ways. You can entertain younger audiences while still playing to adult viewers. . . . When done right, it's possible to be silly and subversive at the same time." Brian Jones, *Jim Henson: The Biography* (London: Virgin Books, 2013), 29.

6. "So Much for Hollywood," *The Muppet Movie*, produced by Jim Henson, David Lazar, Lew Grade, and Martin Starger, directed by James Frawley, 97 min. (1979, Burbank, CA: Buena Vista Home Entertainment, 2005), DVD.

7. "Man-to-Frog Showdown," *The Muppet Movie*.

8. While there is mention throughout the movie that Kermit and the others are traveling to Hollywood so that they can become "rich and famous," I think this characterization of their aims is intended more for a laugh than as a genuine description. Importantly, Kermit and the others never worry that by including more and more Muppets along the way they will cut into the "profits" to be made. The attitude is always "the more, the merrier," a motto that jars with any selfish interpretation of the Muppets' aims.

9. "You Can't Take No for an Answer," *The Muppets Take Manhattan*, produced by David Lazer, directed by Frank Oz, 94 min. (1984, Culver City, CA: Columbia TriStar Home Video, 2001), DVD.

4. GO AND FIND YOUR SONGS

1. Duncan Kenworthy, producer, "Origins," *Fraggle Rock*, season 1 bonus disc interview (Santa Monica, CA: Lionsgate, 2008), DVD.

2. Kenworthy, "Origins."

3. *Down at Fraggle Rock: Behind the Scenes*, produced by Jim Henson, Diana Birkenfield, David Gumpel, and Ritamarie Peruggi, TV movie, *Fraggle Rock*, season 1 bonus disc, 49 min. (1987, Santa Monica, CA: Lionsgate, 2008), DVD.

4. "The Minstrels," *Fraggle Rock*, season 1, episode 18, directed by Jim Henson (1983, Santa Monica, CA: Lionsgate, 2008), DVD.

5. Jocelyn Stevenson, cowriter, "Origins," *Fraggle Rock*, season 1 bonus disc interview.

6. Rod Stryker, *The Four Desires* (New York: Delacorte Press, 2011), 20.

7. The Bhagavad-Gita, likely composed between 400 and 300 BCE, belongs to the sixth book of the vast Mahabharata epic; the title means "Song of the Lord." Arjuna, deeply distressed by the thought of his kin on both sides of the war dying in battle, is overcome with doubt and resolves not to fight. He halts the armies just as the battle is about to begin and turns to Krishna—his charioteer—for counsel. Krishna guides Arjuna out of his paralysis by elaborating on key elements of yogic philosophy.

8. Georg Feuerstein, *The Bhagavad-Gita: A New Translation* (Boston: Shambhala, 2011), 199.

9. *Down at Fraggle Rock: Behind the Scenes*.

10. "The Thirty-Minute Work Week," *Fraggle Rock*, season 1, episode 5, directed by Norman Campbell (1983, Santa Monica, CA: Lionsgate, 2008), DVD.

11. "The Great Radish Famine," *Fraggle Rock*, season 1, episode 19, directed by George Bloomfield (1983, Santa Monica, CA: Lionsgate, 2008), DVD.

12. Stryker, *The Four Desires*, 50.

13. "I Want to Be You," *Fraggle Rock*, season 1, episode 7, directed by Perry Rosemond (1983, Santa Monica, CA: Lionsgate, 2008), DVD.

14. "All Work and All Play," *Fraggle Rock*, season 2, episode 32, directed by Jim Henson (1984, Santa Monica, CA: Lionsgate, 2008), DVD.

15. Feuerstein, *The Bhagavad-Gita*, 129.

16. Swami Adiswarananda, *The Four Yogas* (Woodstock, VT: SkyLight Paths, 2006), 11.

17. Feuerstein, *The Bhagavad-Gita*, 109.

18. Feuerstein, *The Bhagavad-Gita*, 107.

19. "Beginnings," *Fraggle Rock*, season 1, episode 1, directed by Jim Henson (1983, Santa Monica, CA: Lionsgate. 2008), DVD.

20. "The Doozer Contest," *Fraggle Rock*, season 2, episode 36, directed by George Bloomfield (1984, Santa Monica, CA: Lionsgate, 2008), DVD.

21. Jerry Juhl, writer, "Origins," *Fraggle Rock*, season 1 bonus disc interview.

22. "The Minstrels."

23. "The Honk of Honks," *Fraggle Rock*, season 4, episode 95, directed by Richard Hunt (1987, Santa Monica, CA: Lionsgate, 2008), DVD.

24. We could, for fun, liken the Honk of Honks to the mantra OM, which is typically chanted at the beginning and end of yoga-asana practice and meditation. In yogic philosophy, OM is considered the original, divine vibration of all-encompassing consciousness—without which there could be no song.

5. OVERCONSUMPTION AND ENVIRONMENTALISM IN *LABYRINTH*

1. *The Dark Crystal*, directed by Jim Henson and Frank Oz (1982, Culver City, CA: Columbia TriStar Home Video, 1999), DVD.

2. Jeff Moss (music) and Sarah Compton (lyrics), "We Are All Earthlings" (New York: Sesame Street, Inc., 1990).

3. "Bein' Green," Muppet Wiki, accessed May 25, 2014, http://muppet. wikia.com/wiki/Bein%27_Green.

4. Joe Raposo (music and lyrics), "Bein' Green" (New York: Sesame Street, Inc., 1970).

5. Ibid.

6. "Bein' Green," Muppet Wiki.

7. *Arthur*, directed by Steve Gordon (1981, Burbank, CA: Warner Home Video, 1997), DVD; Ralph Beliveau and Randolph Lewis, "Alex Cox," *Senses of Cinema* 48 (2008), accessed March 20, 2012, www.sensesofcinema.com/2008/great-directors/alex-cox/; Giuliana Bruno, "Ramble City: Postmodernism and *Blade Runner*," *October* 41 (1987): 64; *The Toy*, directed by Richard Donner (1982, Culver City, CA: Columbia TriStar Home Entertainment, 2004), DVD.

8. Kim Humphery, *Excess: Anti-Consumerism in the West* (Cambridge: Polity, 2010), 22.

9. Ibid., 23.

10. Douglas B. Holt, "An Interview with Juliet Schor," *Journal of Consumer Culture* 5, no. 1 (2005): 8.

11. Ibid.

12. Ibid.

13. *Labyrinth*, directed by Jim Henson (1986, Culver City, CA: Columbia TriStar Home Video, 1999), DVD.

14. Ibid.

15. Aric Rindfleisch, James E. Burroughs, and Nancy Wong, "The Safety of Objects: Materialism, Existential Insecurity, and Brand Connection," *Journal of Consumer Research* 36, no. 1 (2009): 4.

16. *Labyrinth.*

17. Ibid.

18. Ibid.

19. Ibid.

20. Ibid.

21. Ibid.

22. Ibid.

23. Sarah Moore, "Global Garbage: Waster, Trash, Trading, and Local Garbage Politics," in *Global Political Ecology*, ed. Richard Peet, Paul Robbins, and Michael Watts (London: Routledge, 2011), 141; Gustavo Crocker, "Squatting on Garbage Dumps: Beyond the Self-Help Housing Debate: A Case Study of a Guatemala City Garbage Dump," master's thesis, University of Cincinnati, 1992, 102; Jo Beall, "Thoughts on Poverty from a South Asian Rubbish Dump: Gender, Inequality and Household Waste," *IDS Bulletin* 28, no. 3 (1997): 73.

24. Holt, "An Interview with Juliet Schor," 6.

25. Ibid.

26. Humphery, *Excess*, 5.

27. Moore, "Global Garbage," 135.

28. Robert D. Bullard, *Dumping in Dixie: Race, Class, and Environmental Quality* (Boulder, CO: Westview Press, 2000), 37–38, 42–43.

29. Moore, "Global Garbage," 135.

30. "Revamp Dumps, Forget Slumdog," *Indian Express*, last modified February 11, 2010, http://archive.indianexpress.com/story-print/578267/; *Slumdog Millionaire*, directed by Danny Boyle and Loveleen Tandan (Beverly Hills, CA: 20th Century Fox Home Entertainment, 2009), DVD.

31. *Labyrinth.*

32. Michel de Certeau, *The Practice of Everyday Life*, trans. Steven Rendall (Berkeley: University of California Press, 1984), 117.

6. WHO ARE THE PEOPLE IN YOUR NEIGHBORHOOD?

1. See Amartya Sen, *Identity and Violence: The Illusion of Destiny* (New York: Norton, 2006), and Michel Foucault, *Discipline and Punish: The Birth of the Prison*, trans. Alan Sheridan (New York: Pantheon Books, 1977).

2. "Mississippi Agency Votes for a TV Ban on '*Sesame Street*,'" *New York Times*, May 3, 1970, 54.

3. For more on the research into the educational impacts of *Sesame Street* on the growth and development of children, see Shalom M. Fisch and Rosemarie T. Truglio, eds., *G Is for Growing: Thirty Years of Research on Children and "Sesame Street"* (New York: Routledge, 2000).

4. "Literacy and Numeracy," Sesame Workshop, accessed July 15, 2014, www.sesameworkshop.org/what-we-do/our-results/literacy-numeracy/.

5. Ibid.

6. Jennifer Kotler Clarke, "*Sesame Street*, School Readiness and Summertime," *Huffington Post*, July 16, 2014, accessed August 8, 2014, www. huffingtonpost.com/dr-jennifer-kotler-clarke/sesame-street-school-read_b_5592520.html.

7. There is some scholarly debate regarding the idea that conceptions of the individual in relation to religious and political communities primarily arose out of Enlightenment thinking. For instance, Colin Morris, professor of medieval history, argued that modern notions of individualism and personal identity could be traced back to the twelfth century. However, from a philosophical perspective, the Enlightenment was the beginning point of a flood of important works focused on individualism and rights. See Colin Morris, *The Discovery of the Individual: 1050–1200* (New York: Harper Torchbooks, 1972).

8. See John Locke, *The Second Treatise of Government* (New York: Barnes & Noble, 2004).

9. See Jean-Jacques Rousseau, *The Social Contract*, trans. Christopher Betts (Oxford/New York: Oxford University Press, 1994).

10. Søren Kierkegaard, *Concluding Unscientific Postscript*, trans. David F. Swenson and Walter Lowrie (Princeton, NJ: Princeton University Press, 1971); and Søren Kierkegaard, *Fear and Trembling*, trans. Howard V. Hong and Edna H. Hong (Princeton, NJ: Princeton University Press, 1983).

11. Martin Heidegger, *Being and Time*, trans. John Macquarrie and Edward Robinson (London: Blackwell, 1962).

12. Jean-Paul Sartre, "Existentialism Is a Humanism," trans. Philip Maret, in *Existentialism from Dostoevsky to Sartre*, ed. Walter Kaufmann (New York: New American Library, 1956).

13. Aristotle, *Politics*, 1253a29–31.

14. Aristotle, *Nicomachean Ethics*, 1167a26–28.

15. For Aristotle, things are defined functionally. An eye's function is to see. A thing that looks like an eye but cannot see is an eye in name only (e.g., a glass eye). By extension, a human who is solitary is a human in name only (homonymously), not a genuine human being. To be human is to be a rational, social animal.

16. A similar celebration of community was demonstrated in season 37 when Gina adopted baby Marco during her visit to Guatemala.

17. For an extended discussion of the kind of community that cultivates pluralism while also fostering connectedness, see the first chapter in this collection, Timothy M. Dale's "Muppets, Monsters, and Misfits."

18. I would like to thank Bill Schneider for his comments and insights on early drafts of this chapter, as well as his enduring tutelage and friendship. A special thanks to Connor, Keira, and Gavin for helping Daddy with his research.

7. FINDING FALLACIES FUNNY

1. John Morreall, *Comic Relief: A Comprehensive Philosophy of Humor* (Chichester, UK: Wiley-Blackwell, 2009), 1–26.

2. Ibid., 4–8.

3. Ronald de Sousa, *The Rationality of Emotions* (Cambridge, MA: MIT Press, 1987).

4. Morreall, *Comic Relief*, 10.

5. Ibid., 10–15.

6. Ibid., 15–23.

7. Ibid., 17.

8. Aristotle, *Nichomachean Ethics*, Book I.

8. I SAW MEMORIES OF YOU

1. *Sesame Street*, season 1, episode 66, directed by Neil Smith, written by Jon Stone, Jeffrey Moss, Bruce Hart, Carol Hart, and Ray Sipherd (February 9, 1970, PBS).

2. "The Gelflings shared with Aughra their gift of *Dreamfasting*, to share one's mind directly with another." Brian Froud et al., *The Dark Crystal: Creation Myths*, vol. 1 (Los Angeles: Archaia, 2011), chap. 2.

3. In other *Sesame Street* episodes, Farley also investigates identity ("Me," season 7, episode 724), the relativity of taste ("Wonderful/Yucchy," season 2, episode 242), the difference between types of mental states ("My Mind," season 2, episode 246), and the difference between numerical and qualitative identity ("Toy Box," season 9, episode 1091).

4. From Pamela Brandt and Helen B. Hooke, "Figure It Out!" in *Sesame Street*, season 23, episode 2970, directed by Lisa Simon (March 20, 1992, PBS), performed by Jerry Nelson.

5. There might also be occasions when our friends can inform us reliably about how we feel. Imagine Bert yelling, "I'm not angry!" and Ernie calmly

answering, "Oh, I think you are, Bert." In this case, it is plausible that Bert, in the midst of his anger, fails to introspect.

6. Exactly what this epistemic privilege consists in is a very murky matter. See William Alston, "Varieties of Privileged Access," *American Philosophical Quarterly* 8 (1971): 223–41, for a discussion of some of the different kinds of epistemic privilege that have been attributed to introspection.

7. For discussion of similar examples, see Brie Gertler, "The Mechanics of Self-Knowledge," *Philosophical Topics* 28 (2002): 125–46, especially 128–35; and Richard Moran, *Authority and Estrangement: An Essay on Self-Knowledge* (Princeton, NJ: Princeton University Press, 2001), especially 33–35.

8. John Heil argues that directness cannot be the grounds for introspection's privileged nature in his article "Privileged Access," *Mind* 97 (1988): 238–51, especially 238–41.

9. A possible response is that this is not a case of introspection going awry—we can make mistakes about introspection's subject matter without it being a failure of introspection. Similarly, we can make mistakes about the color of objects right in front of us without it being a failure of perception—it may be that we just don't have our eyes open. The problem with this response is that when we make mistakes about our own mental states, we can very easily think that we are introspecting, and if that's what's going on, our right to trust introspection still seems to be lessened.

10. John Heil, "Privileged Access," and Brie Gertler, "Mechanics of Introspection," also consider another possible type of explanation: perhaps introspection is privileged because the very mental state that is being introspected is part of the introspective belief that you are in that particular mental state. It is beyond the scope of this chapter to evaluate this kind of "inclusion" theory of introspection, except to note that such a theory needs to be able to explain failures of introspection as well, like the case of the Muppets in *Muppets: Most Wanted*.

11. Eric Schwitzgebel, in a series of papers, gives further examples of introspection's actual fallibility. See, for example, "The Unreliability of Naïve Introspection," *Philosophical Review* 117 (2008): 245–73.

12. Thank you to Ginger Hoffman and the editors of this volume for very helpful comments on earlier drafts of this chapter.

9. BREAKING DOWN THE WALLS

1. There are three other kinds of illusions: (1) the reproductive illusion, which is like having two mirrors facing each other and seeing the reflection infinitely repeat itself; (2) the Müller-Lyer illusion, which affects our depth perception; and (3) the trompe l'oeil illusion, also known as the eggbox illusion,

which affects our ability to decipher the direction, or position, of an image. For information on illusions (especially cinematic illusion), see Richard Allen, *Projecting Illusion: Film Spectatorship and the Impression of Reality* (Cambridge: Cambridge University Press, 1995).

2. Slavoj Žižek, *The Pervert's Guide to Cinema: Parts 1, 2, 3*, directed by Sophie Fiennes (San Francisco, CA: Lone Star, 2006), DVD. This is a fun documentary that discusses the film-viewing experience.

10. MUPPETS AND MIMESIS

1. Plato, *Republic*, 596b ff.
2. Ibid., 392c ff., 602a ff.
3. Aristotle, *Poetics*, 50b21 ff., 51a17 ff.
4. Ibid., 52a22 ff., 53b1 ff.
5. Ibid., 49b20 ff.
6. Plato, *Republic*, 376d ff., 398c. ff.
7. Aristotle, *Poetics*, 48a1 ff., 48b4 ff.
8. Ibid., 49b20 ff.

11. THE BEST SEAT BY THE FIRE

1. Originally produced as a television miniseries, the show first aired at the end of 1987. *The Storyteller* was written and created by Jim Henson, and it starred John Hurt as the storyteller, with Brian Henson as operator and voice for the dog. Season 1 had a total of nine episodes, although an additional one was shown in the United Kingdom in 1990 and not the United States. Season 2 featured a spin-off telling Greek myths in a different format.

2. *The Storyteller*, produced by TVS Television and Henson Associates (1987–1988, Culver City, CA: Columbia TriStar Home Entertainment, 2003), DVD.

3. Joseph J. Foy, "Introduction," in *Homer Simpson Ponders Politics: Popular Culture as Political Theory*, ed. Joseph Foy and Timothy Dale (Lexington: University of Kentucky Press, 2013), 1.

4. Thomas Good and Jere Brophy, *Looking in Classrooms* (Boston: Addison Wesley, 1993).

5. Black Elk recounted his memories in his book about the Oglala Lakota tribe. At the age of thirteen, he fought in the Battle of the Little Big Horn and later survived the 1890 Wounded Knee Massacre. Using his son as his translator,

Black Elk specifically stated the importance of his role in the lives of his people, both individuals and the collective whole.

6. Kamenko Bulic, "The Aesthetic Alchemy of Sounding Impartial: Why Serbs Still Listen to 'The BBC Conspiracy,'" *Journalism: Theory, Practice and Criticism* 11, no. 6 (2013): 10.

7. Jeannette Armstrong, "Keynote Address: The Aesthetic Qualities of Aboriginal Writing," *Studies in Canadian Literature* 31, no. 1 (2006): 20–30.

8. Refers to an early Russian folktale. "The Soldier and Death," *The Story-teller.*

12. JIM HENSON'S EPICUREAN COMPASS

1. Epicurus, *Letter to Menoeceus*, trans. Robert Drew Hicks, accessed January 3, 2014, http://classics.mit.edu/Epicurus/menoec.html, par 5.

2. Ibid., par. 5.

3. Epicurus, *Principal Doctrines*, trans. Robert Drew Hicks, accessed January 3, 2014, http://classics.mit.edu/Epicurus/princdoc.html, princ. 20, 28.

4. Epicurus, *Letter to Menoeceus*, par. 6.

5. Ibid., par. 5.

6. Epicurus, *Principal Doctrines*, princ. 5.

7. Epicurus, *Letter to Menoeceus*, par. 6.

8. Raphael Woolf, "Pleasure and Desire," in *The Cambridge Companion to Epicureanism*, ed. James Warren (New York: Cambridge University Press, 2011), 165.

9. David Armstrong, "Epicurean Virtues, Epicurean Friendship: Cicero vs. the Herculaneum Papyri," in *Epicurus and the Epicurean Tradition*, ed. Jeffrey Fish and Kirk R. Sanders (New York: Cambridge University Press, 2011), 124.

10. Epicurus, *Principal Doctrines*, princ. 27.

11. Eric Brown, "Politics and Society," in *The Cambridge Companion to Epicureanism*, ed. James Warren (New York: Cambridge University Press, 2011), 182.

12. Armstrong, "Epicurean Virtues, Epicurean Friendship," 124.

13. To read more about the journey narrative in the Muppets' movies, see Tara K. Parmiter, "The American Journey Narrative in the Muppets Movies," in *Kermit Culture: Critical Perspectives on Jim Henson's Muppets*, ed. Jennifer C. Garlen and Anissa M. Graham (Jefferson, NC: McFarland, 2009), 129–41.

14. Epicurus, *Principal Doctrines*, princ. 5.

15. Armstrong, "Epicurean Virtues, Epicurean Friendship," 124.

16. "Jim Henson's Letter to His Kids Reminds Us All to Enjoy Life," *Huffington Post*, September 24, 2013, www.huffingtonpost.com/2013/09/24/jim-henson-letter_n_3983895.html.

13 . MY (UN)FAIR LADY

1. Brian Jay Jones, *Jim Henson: The Biography* (New York: Ballantine Books, 2013), 390.

2. Ibid., 122–23.

3. Ibid., 391.

4. Aljean Harmetz, "'*Star Wars*' and Muppet Wizards Team Up in '*Labyrinth*,'" *New York Times*, September 15, 1985.

5. Martha Nussbaum, *Not for Profit: Why Democracy Needs the Humanities* (Princeton, NJ: Princeton University Press, 2010), 99–100.

6. Ibid., 35.

7. Jones, *Jim Henson*, 163–64.

8. Martha Nussbaum, *Love's Knowledge: Essays on Philosophy and Literature* (New York: Oxford University Press, 1990), 67.

9. Martha Nussbaum, *Cultivating Humanity: A Classical Defense of Reform in Liberal Education* (Boston: Harvard University Press, 1997), 85.

10. Nussbaum, *Love's Knowledge*, 86.

11. *Labyrinth*, directed by Jim Henson (1986, Culver City, CA: Columbia TriStar Home Video, 2000), DVD.

12. Mark Johnson, *Moral Imagination: Implications of Cognitive Science for Ethics* (Chicago: University of Chicago Press, 1993), 192.

13. Michel Foucault, *Discipline and Punish* (New York: Vintage Books, 1977), 18.

14. Ibid., 214.

15. Ibid., 136.

16. Des Saunders, "Inside the Labyrinth," *Labyrinth*, DVD.

17. Ibid.

18. Martha Nussbaum, "Education and Democratic Citizenship: Capabilities and Quality Education," *Journal of Human Development* 7, no. 3 (2006): 390.

19. Jones, *Jim Henson*, 367.

20. Ibid., 387.

14. YOU COULDN'T HANDLE REAL LIFE

1. Jean-Paul Sartre, *Existentialism Is a Humanism*, trans. Carol Macomber (New Haven, CT: Yale University Press, 2007), 29.

2. Ibid., 26.

3. Augustine, *On Free Choice of the Will*, trans. Thomas Williams (Indianapolis, IN: Hackett, 1993), 8.

4. Nicholas P. White, trans., *Epictetus: The Handbook (The Encheiridion)* (Indianapolis, IN: Hackett, 1983), 12.

5. Ibid.

6. Bhikku Ñaṇamolí, trans., "Saccavibhanga Sutta: The Exposition of the Truths," in *The Middle Length Discourses of the Buddha: A Translation of the Majjhima Nikāya*, ed. Bhikkhu Bodhi, 2nd ed. (Boston: Wisdom Publications, 2001), 1098.

7. Sartre, *Existentialism*, 25.

15. MEEP IS THE WORD

1. Immanuel Kant, *Groundwork of the Metaphysics of Morals*, ed. Mary Gregor and Jens Timmerman, rev. ed. (New York: Cambridge University Press, 2012), 4:440, 4:445–61.

2. Kant, *Groundwork*, 4:429.

3. See Peter Singer, *Animal Liberation* (New York: HarperCollins, 2009).

4. Ecophilosophy (also environmental philosophy) is the study of the relationship between humans and the Earth, the environment, and the nonhuman elements contained therein. See Andrew Brennan and Yeuk-Sze Lo, "Environmental Ethics," in *The Stanford Encyclopedia of Philosophy* (Fall 2011 edition), ed. Edward N. Zalta, http://plato.stanford.edu/archives/fall2011/entries/ethics-environmental/. See also the writings of Henry David Thoreau, Rachel Carlson, and John Muir for the foundations of ecophilosophy.

5. See John Locke, *Essay Concerning Human Understanding*, Books I and II, http://oregonstate.edu/instruct/phl302/texts/locke/locke1/Essay_contents. html. See also Jeremy Bentham, *An Introduction to the Principles of Morals and Legislation*, chapters 2 and 4, www.econlib.org/library/Bentham/bnthPML1. html#.

6. See Aristotle, *Politics*, Book 1, http://classics.mit.edu/Aristotle/politics.1. one.html, and Jean Jacques Rousseau, "Sophy," in *Emile*, http://oll.libertyfund. org/titles/rousseau-emile-or-education.

7. *The Muppet Show*, season 2, episode 22 (Burbank, CA: Walt Disney Home Entertainment, 2007), DVD.

8. Ibid., season 2, episode 2.

9. Ibid., season 2, episode 21.

10. *The Muppet Show*, season 3, episode 4 (Burbank, CA: Walt Disney Home Entertainment, 2008), DVD.

11. Ibid., season 3, episode 19.

12. *Experiment in Television* (NBC, 1969), www.youtube.com/watch?v=d4kEYg67Ujg.

13. Camille Paglia, "No Law in the Arena," in *Vamps and Tramps* (New York: Vintage Books, 1994); Christina Hoff Sommers, *Who Stole Feminism: How Women Have Betrayed Women* (New York: Simon & Schuster, 1995).

14. See Jacques Derrida, "The End of the Book and the Beginning of Writing" and "From/Of the Supplement to the Source: The Theory of Writing," in *Of Grammatology* (Baltimore: Johns Hopkins University Press, 1997).

15. Karl Marx, "Economic and Philosophical Manuscripts of 1844," "The Coming Upheaval," and "The Possibility of Non-Violent Revolution," in *The Marx-Engels Reader*, ed. Robert C. Tucker, 2nd ed. (New York: W. W. Norton, 1978). This framework is seen in the writings of feminist philosophers in the mid- to late twentieth century; cultural critics like Michel Foucault, Derrida, and Noam Chomsky; and activist philosophers like (Ernesto) Che Guevara, Cesar Chavez, and Paulo Freire.

16. Paulo Freire, *Pedagogy of the Oppressed* (New York: Continuum, 2008), 45.

17. Paul Carus, *Buddha, the Word*, www.sacred-texts.com/bud/buddha2.htm. The Four Noble Truths are as follows: life is suffering, we are the source of our suffering, the end of suffering is attainable, and there is a path to enlightenment (the end of suffering).

16. "WHATEVER"

1. *Mythbusters* (2003–, Discovery Channel).

2. Rizzo the Rat, sometimes a companion of Gonzo, especially after the movie *The Muppet Christmas Carol*, directed by Brian Henson (Burbank, CA: Walt Disney Studios, 1992). Rat Fink was the cartoon creation of Ed "Big Daddy" Roth; see www.ratfink.com.

3. Born after his mother died, from *The Muppet Show*, episode 210; born from a block of foam, from MuppetFest 2001, *Gonzo the "Thing"* (both found at http://muppet.wikia.com/wiki/Gonzo, accessed January 2, 2014).

4. *Muppets from Space*, directed by Tim Hill (1999, Culver City, CA: Columbia TriStar Home Entertainment, 2005), DVD.

5. We will only touch upon the questions and thought experiments that many have conducted surrounding the idea of personal identity. Consult the *Stanford Encyclopedia of Philosophy* for both a comprehensive look at the topic of personal identity and an extensive bibliography that features many seminal works on the subject. Available at http://plato.stanford.edu/entries/identity-personal/.

6. William Shakespeare, *Hamlet*, act 2, scene 2.

7. *The Muppet Show*, episode 101.

8. Two journal articles give perspective to this process over a considerable period of time. Michael S. Gazzaniga, "Review of the Split Brain," *Journal of Neurology* 209, no. 2 (1975); Michael Gazzaniga, "The Split Brain Revisited," *Scientific American*, June 16, 1998.

9. Disclaimer: Not from any mind or Muppet associated with Jim Henson Productions or Walt Disney Studios. It is pronounced "Fronkenmupp."

10. Adapted from a thought experiment explained in Derek Parfit, "Personal Identity," *Philosophical Review* 80, no. 1 (1971).

11. Mootant is pure fiction and bears no resemblance to anything Jim Henson Productions or Walt Disney Studios has yet to create (or at least let the world see).

12. Adapted from a thought experiment explained in Parfit, "Personal Identity."

13. The ships, their names, the Muppet characters' ranks, and the scenes are fictional and not from Jim Henson Productions or Walt Disney Studios.

14. Adapted from the Star Trek Transporter thought experiment in Jaegwon Kim, *Philosophy of Mind* (Boulder, CO: Westview Press, 2011), 8.

15. "Further fact" term from Derek Parfit, "Personal Identity and Rationality," *Synthese* 53, no. 2 (1982): 227.

16. *A Beautiful Mind*, directed by Ron Howard (2001, Universal City, CA: Universal Studios Home Entertainment, 2005), DVD.

17. Evad Zleog: a fictional Muppeteer, not associated with Jim Henson Productions or Walt Disney Studios.

18. From Andrew Guttele, *What's a Gonzo?* (New York: Crown Books, 1986).

19. And his voice was not provided by Dave Goelz, but rather Russi Taylor. Hmmm. The plot thickens.

20. "The Weirdo Zone," *Muppet Babies*, episode 303.

21. *The Great Muppet Caper*, directed by James Bobin (1981, Burbank, CA: Walt Disney Home Entertainment, 2005), DVD.

22. *The Muppets*, episode 223.

23. You are probably familiar with the American comedic actor Robin Williams (1951–2014) and John Cleese (1939–), known for films and the British TV series, *Monty Python's Flying Circus* (1969–1974), but what you might not be familiar with is that the Python cast was at least partially inspired by the antics of Spike Milligan (1918–2002) in the British comedy series *The Goon Show* (1951–1960), which also starred British actor Peter Sellers (1925–1980).

24. William Shakespeare, *Hamlet*, act 3, scene 1.

17 . KERMIT'S RAINBOW CONNECTION

1. Paul Williams and Kenneth Ascher, "The Rainbow Connection," in *The Muppet Movie*, produced by Jim Henson, David Lazar, Lew Grade, and Martin Starger, directed by James Frawley (1979, Los Angeles: Buena Vista Home Entertainment, 2005), DVD.

2. David Hume, *An Enquiry Concerning Human Understanding* (New York: Oxford University Press, 1999).

3. Immanuel Kant, *The Critique of Pure Reason*, trans. Werner S. Pluhar (Indianapolis, IN: Hackett, 1993).

4. Williams and Ascher, "The Rainbow Connection."

5. Jean-Paul Sartre, "Existentialism Is a Humanism," in *Existentialism from Dostoyevsky to Sartre*, ed. Walter Kaufman (London: Meridian, 1989).

6. Simone de Beauvoir, *The Ethics of Ambiguity*, trans. Bernard Frechtman (New York: Citadel Press, 1976).

18 . THE PASSION, WILL, AND FREEDOM OF KERMIT, MISS PIGGY, AND ANIMAL

1. Steven Nadler, "Baruch Spinoza," Stanford Encyclopedia of Philosophy, http://plato.stanford.edu/entries/spinoza/.

2. Ibid.

3. Steven Nadler, "Baruch Spinoza: Ethics," in *Central Works of Philosophy* (Montréal: McGill-Queen's University Press, 2005), 37–66.

4. Benedictus de Spinoza, *Ethics*, ed. and trans. G. H. R. Parkinson (Oxford: Oxford University Press, 2000).

5. Ibid.

6. Nadler, "Baruch Spinoza: Ethics," 51.

7. *The Muppets*, directed by James Bobin (2011, Burbank, CA: Buena Vista Home Entertainment, 2012), DVD.

8. Spinoza, *Ethics*.

9. Ibid.

10. Ibid.

11. Ibid.

12. Ibid.

13. Ibid.

14. Ibid.

15. Ibid.

16. Nadler, "Baruch Spinoza: Ethics," 43.

17. Spinoza, *Ethics*, 20.

18. Ibid., 33.

19. Ibid., 29.

20. Nadler, "Baruch Spinoza: Ethics," 44.

19 . "LIFE'S LIKE A MOVIE"

1. *The Great Muppet Caper*, directed by Jim Henson (1981, Burbank, CA: Walt Disney Home Entertainment, 2005), DVD.

2. By Muppet, I am considering the core group of Kermit, Miss Piggy, Fozzie Bear, Gonzo, and others, excluding *Sesame Street* characters. Though crossover exists, I would argue that Kermit and his troupe have a consistent and different aesthetic.

3. *The Muppet Show*, seasons 1–3 (1976–1979, Burbank, CA: Buena Vista Home Entertainment, 2005–2008), DVD.

4. *The Muppet Movie*, directed by James Frawley (1979, Burbank, CA: Walt Disney Home Entertainment, 2013), DVD.

5. *The Muppets Take Manhattan*, directed by Frank Oz (1984, Culver City, CA: Columbia TriStar Home Entertainment, 2001), DVD.

6. Judith Butler, *Gender Trouble* (New York: Routledge, 1990).

7. Jean Baudrillard, *Simulations* (New York: Semiotext(e), 1983).

8. John Hodgman, *The Areas of My Expertise* (New York: Penguin, 2005), 83.

9. *The Muppets*, directed by James Bobin (2011, Burbank, CA: Buena Vista Home Entertainment, 2012), DVD.

10. Baudrillard, *Simulations*, 25.

20. TRAVELING MATT'S ADVENTURES
IN OUTER SPACE

1. Jacques Derrida, *Limited Inc.*, trans. Samuel Weber and Jeffery Mehlman (Evanston, IL: Northwestern University Press, 1988), 12.

2. Jacques Derrida, *Writing and Difference*, trans. Alan Bass (Chicago: University of Chicago Press, 1978), 289, 292.

3. "Brown Book," *Fraggle Rock: The Complete First Season* (1983, Los Angeles: HIT, 2005), DVD Insert.

4. "Brown Book."

5. Roland Barthes, *The Pleasure of the Text*, trans. Richard Miller (New York: Hill and Wang, 1975), 7.

6. "The Minstrels," *Fraggle Rock: The Complete First Season*, directed by Jim Henson (1983, Los Angeles: HIT, 2005), DVD.

7. "Boober Rock," *Fraggle Rock: The Complete Second Season*, directed by Norman Campbell (1984, Los Angeles: HIT, 2009), DVD.

8. "Wembley and the Gorgs," *Fraggle Rock: The Complete First Season*, directed by Jim Henson (1983, Los Angeles: HIT, 2005), DVD.

9. "Brown Book."

21. ONTOLOGY AND SUPERPOSITION

1. With gratitude and love to my sister, Clio, for all of the wonderful, nonfictional times we spent laughing with fictional characters.

2. "Academy Awards," Muppet Wiki, accessed March 15, 2014, http://muppet.wikia.com/wiki/Academy_Awards.

3. "Ellen Meets Kermit!" *The Ellen Show*, YouTube video, 5:15, November 9, 2011, www.youtube.com/watch?v=1_AUn5poOmA.

4. "Appearances in Outside Fictional Universes," Muppet Wiki, accessed March 11, 2014, http://muppet.wikia.com/wiki/Appearances_in_outside_fictional_universes.

5. J. J. A. Mooij, *Fictional Realities: The Uses of Literary Imagination* (Amsterdam, Philadelphia: J. Benjamins, 1993), 105. Incidentally, correct statements about second-tier fictionals can only be authoritatively said or implied by the first-tier fictionals, who are attributed with their fabulation (see section on *n*-tier fictionality). The former can only be described by the latter. For instance, that Sherlock Holmes has a colleague called John H. Watson is authoritatively said by the only person who can have that authority as Holmes's fabulator: Arthur Conan Doyle. That Mr. Snuffleupagus's first name is Aloysius is authoritatively

said by the only person who can have that authority as Mr. Snuffleupagus's fabulator: Big Bird. To know something definitive and accurate about Mr. Snuffleupagus, who is twice removed from us, we must defer to Big Bird.

6. Ibid., 113.

7. Michael Davis, *Street Gang: The Complete History of Sesame Street* (New York: Viking, 2008), 240.

8. David Borgenicht, *Sesame Street Unpaved: Scripts, Stories, Secrets, and Songs* (New York: Hyperion, 1998), 41.

9. I use "fabulate" rather than "create," because one can create a nonfictional or physical object, whereas one fabulates only "made-up" entities.

10. If Snuffy were to have an imaginary friend of his own, this imaginary friend would be a further embedded, fabulated fictional character, and thus a third-tier fictional.

11. Even if the viewer were to ferry Fallon onto the ontological stratum of the Muppets and view *Late Night* as a world of fiction, this argument would still hold.

12. John Gribbin, *In Search of Schrödinger's Cat: Quantum Physics and Reality* (Toronto: Bantam Books, 1984), 205, and John M. Charap, *Explaining the Universe: The New Age of Physics* (Princeton, NJ: Princeton University Press, 2002), 58–59.

13. Gribbin, *In Search of Schrödinger's Cat*, 205. The "Copenhagen interpretation" refers to a "collection of ideas—uncertainty, complementarity, probability, and the disturbance of the system being observed by the observer" (121).

14. Charap, *Explaining the Universe*, 58.

15. Ibid., 59.

16. Ginger Stelle, "'Starring Kermit the Frog as Bob Cratchit': Muppets as Actors," in *Kermit Culture: Critical Perspectives on Jim Henson's Muppets*, ed. Jennifer C. Garlen and Anissa M. Graham (Jefferson, NC: McFarland, 2009), 93.

17. Ibid., 93.

18. Ibid., 94.

19. Ibid., 96.

20. "Watch Maddow's Cameo in *House of Cards*," video, 3:55, February 14, 2014, www.msnbc.com/rachel-maddow-show/watch/maddow-angers-kevin-spacey-153350211885.

21. Alex Segura, "DC Comics and Neil Degrasse Tyson Put Krypton on the Map with Historic Superman Story," *Fan News* (blog), November 5, 2012, www.dccomics.com/blog/2012/11/05/dc-comics-and-neil-degrasse-tyson-put-krypton-on-the-map-with-historic-superman.

22. THE METAPHYSICS OF MUPPETATIONALITY

1. "A Fish Called Selma," *The Simpsons*, directed by Mark Kirkland and written by Jack Barth (March 24, 1996, Fox).

2. Of course, Muppets aren't the only things that make us laugh. Homer himself is not a Muppet, although he does have some Muppet-like features that allow us to call him a "Muppet" in a metaphorical sense that I will explain later.

3. Like Lisa, our curiosity about lots of different things involves questions about the nature of the world around us. We can often learn things about how to go about addressing such questions about one subject matter from thinking about another carefully. And why not think about methodology with the most fun subject matter we can find?

4. Advertisement for *Afternoon with Inga*, December 1955.

5. *The Dark Crystal*, directed by Jim Henson and Frank Oz (1982, Culver City, CA: Columbia TriStar Home Entertainment, 1999), DVD.

6. The obsession here must be *de dicto*—that is, the kind of obsession I'm talking about here doesn't require that Cookie Monster be able to demonstratively pick out a particular cookie, as he might not be acquainted with all the cookie varieties. Similarly, Gonzo might be obsessed with chickens generally speaking, even if he cannot form singular thoughts about every existing chicken.

7. It also isn't entirely clear whether it tells us anything about the nature of being Cookie Monster. It seems that, according to a 2004 episode on *Sesame Street*, Cookie Monster is only contingently obsessed with cookies—after all, he could have failed to eat that first cookie. "The First Time Me Eat Cookie," *Sesame Street*, directed by Emily Squires, Ted May, Victor DiNapoli, Ken Diego, Lisa Simon, and Jim Martin, and written by Lou Berger (head writer) (April 7, 2004, PBS). Thanks to Jonathan Jenkins Ichikawa for pointing me to this.

8. "What Is a Muppet?" Muppet Wiki, last modified February 13, 2014, http://muppet.wikia.com/wiki/What_is_a_Muppet%3F.

9. This definition only gives us a necessary condition for being a Muppet—a condition that all Muppets meet—it does not also give us a sufficient condition. A sufficient condition for being an X is a condition such that, if something meets it, it is definitely an X. Being Oscar the Grouch is sufficient for loving a particular piece of trash, although it is not necessary (some other people might *also* love that piece of trash, such as the Junk Lady from *Labyrinth*, although she might love it because it is useful junk rather than because it is dingy, and dirty, and dusty).

10. Similarly, a dictionary might define David Bowie as a British musician, singer-songwriter, record producer, and actor. But none of these qualities are essential to David Bowie—he might have decided to construct puppets instead.

11. In fact, this will be judgment dependent (see Richard Holton, "Response-Dependence and Infallibility," *Analysis* 52, no. 3 [1992]: 180–84), not just response dependent, as the relevant response in determining what has the property is the judgment concerning what has this property. I prefer the phrase "response-dependent property" rather than "response-dependent concept," because here we are talking about instances of the property being fixed by people's responses—things have the property because people respond in that way. I suspect that a property like being fashionable is a response-dependent property, but not straightforwardly a response-dependent concept, but I set that aside for the purposes of this chapter.

12. If the property of being funny is in fact response dependent, it would probably be a more complicated response than this—usually response-dependent accounts of a property will specify that the relevant response must be given by a certain sort of subject in particular conditions. The fact that I won't laugh at a joke when I'm feeling incredibly down doesn't count against its funniness. Furthermore, tickling makes many people laugh, but tickling is not funny.

13. Who gets to be an appropriate Muppet authority is explicitly part of the view. I take no firm stand on this matter, except to say that there are clear examples of non-Muppet authorities, like myself. Perhaps even the Muppets themselves could be Muppet authorities according to this view; however, I will not argue for this. The circularity involved in this view is appealingly Muppety, though.

14. Although, perhaps, I could have had a Muppet coffee table (however, like most Muppet furniture, it probably would have tried to devour anyone nearby, and so would not be very useful as a coffee table). But that is not quite the same as the claim that this very coffee table could have been a Muppet.

15. *The Muppets*, directed by James Bobin, written by Jason Segel and Nick Stoller (2011, Burbank, CA: Buena Vista Home Entertainment, 2012), DVD.

16. Of course, *The Muppet Movie* has a double layer of complexity, as it involves a fiction (well, an "approximate" representation, according to Kermit) within a fiction.

17. *The Muppets: A Celebration of 30 Years*, directed by Peter Harris, written by Jerry Juhl (January 21, 1986, CBS).

18. Dispositions and tendencies are not exactly the same, but for the purposes of this chapter, I put this complication aside.

19. However, it is not generally thought that dispositional ascriptions are equivalent to these conditionals—"the glass is fragile" doesn't mean exactly the same thing as "the glass would break when physically stressed." See C. B. Martin, "Dispositions and Conditions," *Philosophical Quarterly* 44 (1994): 1–8.

20. *The Muppets*. The song was written by Bret McKenzie, who, as a New Zealander, would be familiar with this metaphorical use of the word.

21. A puppet character like Aughra is less clear, but she does have elements of absurdity (such as removing her eyeball to see Jen when he is suspended in the trap) that I think seem to be enough to qualify her as a Muppet.

22. Thank you to Lewis Powell for raising this objection.

23. Her character was performed, however, by a puppeteer in a full-body puppet costume in the stage show *Muppet Babies Live!*

24. This does require that there is a difference between what is true in the fiction and what is true outside of the fiction—it is true in the fictional world of *Muppet Babies* that they are Muppets, but this is not true in the real world.

25. Thank you to J. Robert G. Williams for pressing me on this point.

26. "References to Being Puppets," Muppet Wiki, last modified January 21, 2014, http://muppet.wikia.com/wiki/References_to_being_puppets.

27. *The Muppets Celebrate Jim Henson*, directed by Don Mischer, written by Jerry Juhl, Bill Prady, and Sara Lukinson (November 21, 1990, CBS).

28. I am unsure, however, whether this makes the disposition to engage in Muppetry an *extrinsic* disposition. This depends on whether the puppet character stops at the edge of the felt or fur, or whether the puppeteer is part of the character. I take no stand on this matter, but note that dispositions may be extrinsic. See Jennifer McKitrick, "A Case for Extrinsic Dispositions," *Australasian Journal of Philosophy* 81 (2003): 155–74.

29. One issue remains: A character like Robin does not seem to engage in much Muppetry. I wonder, however, whether Robin is in fact disposed toward having this disposition but has simply not grown into it yet. But this may, depending on whether this is sufficient for having the disposition, involve denying that Robin is a Muppet if he is not yet so disposed. This doesn't worry me—not everyone involved in Muppet productions is himself or herself a Muppet. Thank you to Lewis Powell for raising this objection.

30. Thank you to everyone whose conversations have helped in developing this chapter, especially Ross Cameron, Brian Chick, Andy Egan, Ginger Hoffman, Tina Holt, Jonathan Jenkins Ichikawa, Daniel Nolan, Lewis Powell, Alex Skiles, Daniel Star, Jason Turner, and J. Robert G. Williams.

INDEX

absurdity, Muppets and, 209, 210, 215, 217
actors, Muppets as, 206–208
Adams, Amy, 175
Adiswarananada (swami), 40
aesthetics, Muppets and, 89–97
affects. *See* emotions
age, and identity, 157–158
agency, moral, 140–141; *Labyrinth* and,
 119–127
always already, term, 184
ambiguity: existentialism on, 170;
 ontological, 199–208
anarchism, 27, 33, 221n1
Animal, and restraint of emotions,
 173–180
animals, Singer on, 141
Anti-Helena, 83, 86, 130, 131, 132, 135,
 136
appreciation, *Labyrinth* and, 122–124
Aquinas, Thomas, 71
Aristotle: on community, 59; on definition,
 226n15; on humor, 71; and *The Muppet
 Show*, 92–94; and *Sesame Street*, 96–97
Arjuna, 37, 39, 40, 223n7
Armstrong, Jeannette, 105
art: Plato on, 67, 90–91, 94. *See also*
 fiction/fictionality
assumptions, *Labyrinth* and, 122–124
athleticism, Miss Piggy and, 22–23
audience: fourth wall and, 184; as God,
 180

Augustine (saint), 133–134
authenticity: and community, 55–62;
 Sesame Street and, 56–58
authority: appeals to, 66; and definition of
 Muppets, 212; and fictionality, 201,
 237n5; *Fraggle Rock* and, 197; nature
 of, 240n13
autonomy, Kierkegaard on, 58

bad faith, existentialism on, 135, 169–170
Barthes, Roland, 193
Bartky, Sandra, 21–22
Baudrillard, Jean, 185–187, 188
Beaker, 23, 142, 146
Bear in the Big Blue House, 12
A Beautiful Mind, 157
Beauvoir, Simone de, 169, 170, 183
Bechdel, Alison, 25
Bechdel test: definition of, 24–25;
 Muppets and, 25
"Bein' Green," 45–46
belief, nature of, 164–168
belonging, *Fraggle Rock* and, 38–39
Bentham, Jeremy, 141
Berlin, Isaiah, 219n6
Bert, 70, 95
Bhagavad-Gita, 37, 39, 40, 223n7
Big Bird, 65, 95, 116, 200; and
 community, 60; and *n*-tier fictionality,
 202–203, 237n5

ABOUT THE CONTRIBUTORS

Lauren Ashwell is assistant professor of philosophy at Bates College, and she writes on metaphysics, epistemology, and feminist philosophy. The very first television show she saw in color was *The Muppet Show*, and she has been transfixed by Jim Henson's work ever since. She also sometimes performs with and designs puppet couture for the adorable puppets of the Improvised Puppet Project in Maine, even though they are not Muppets.

Kimberly Baltzer-Jaray is an independent scholar whose area of expertise is early phenomenology and existentialism but who has interests in just about every area of philosophy. She even likes Kant, and she often admits that fact out loud, in public. She is a lecturer at King's University College, president of the North American Society for Early Phenomenology, writer for *Things & Ink* magazine, and author of the blog *A Tattooed Philosopher's Blog: Discussion of the Type I Ink, Therefore I Am*.

Samantha Brennan is professor of philosophy in the Department of Philosophy at Western University, Canada. She is also a member of the Rotman Institute of Philosophy, an affiliate member of the Department of Women's Studies and Feminist Research, and a member of the graduate faculty of the Department of Political Science. In addition, she holds the rank of 5th kyu in Yoshikan Aikido and blogs about feminism and fitness at http://fitisafeministissue.com.

David R. Burns, associate professor at Southern Illinois University, focuses his research on digital media art and animation and pushes the boundaries of artistic expression by exploring visual music, memory, and the relationships between technology, culture, and society. Burns's research/creative work has been published in the *Leonardo Electronic Almanac* (*LEA*) and exhibited widely at international venues including the International Symposium on Electronic Art (ISEA), National Film Theater in London, National Media Museum in England, Red Stick International Animation Festival in Baton Rouge, and Chelsea Art Museum in New York City. Burns holds an MFA in Design + Technology from Parsons School of Design and is a U.S. Fulbright Senior Research Scholar Award recipient.

Deborah R. Burns, instructor at Southern Illinois University, earned a PhD in education from Southern Illinois University, an MA in higher education leadership from New York University, and an MA in English and comparative literature from Columbia University. Her research interests include media studies, higher education, and surveillance. Dr. Burns has published her work in *Leonardo Electronic Almanac* (*LEA*) and presented her research at the International Society of Electronic Arts (ISEA) and Educational Studies Association (AESA) conferences.

Amanda Cawston earned a BA in philosophy and humanities from Simon Fraser University, and a PhD in philosophy from the University of Cambridge. She has research interests in ethics, feminism, and political philosophy, specifically the topics of violence and pacifism. "Peoples is peoples," of course, but one day, perhaps, peoples will all be able to follow their dreams, and only use cannons for daredevil stunts.

Brooke Covington is a graduate student pursuing a master of arts degree in writing, rhetoric, and technical communication from James Madison University. Her research interests include public writing, reform rhetoric, and feminist rhetoric. Brooke's work on the reemergence of Aspasia of Miletus is published in the *Colonial Academic Alliance Undergraduate Research Journal*. She has presented at national conferences in Indianapolis and Chicago, and her recent writing has focused on the healing power of tattoos as inscriptions of meaning on the body.

Ryan Cox teaches English literature and film at Keyano College in Fort McMurray, Alberta. His research focuses on the intersections of identity, culture, and poetics.

Christopher M. Culp is a philosopher, musicologist, activist, and clarinetist with a research focus on twentieth-century aesthetics, particularly the position of subjectivity within modernist and postmodernist frameworks. He is a Muppets fan with a special affinity for Gonzo, whom he admires for his strength and commitment to passion, creativity, and a strong existential project.

Timothy M. Dale is assistant professor of political science at the University of Wisconsin–La Crosse. He teaches in the area of political philosophy, and his research interests include democratic theory and political messaging in popular culture. He is coeditor of the collections *Homer Simpson Ponders Politics: Popular Culture as Political Theory* (2013) and *Homer Simpson Marches on Washington: Dissent through American Popular Culture* (2010), and he is coauthor of *Political Thinking, Political Theory, and Civil Society* (2009).

When not tending to her Muppet shrine, **Natalie M. Fletcher** works as a philosophical practitioner in Montreal, Canada, pursuing interdisciplinary doctoral research in philosophy and pedagogy at Concordia University. She teaches philosophy at John Abbott College and is the founding director of Brila Youth Projects (www.brila.org), an educational charity that uses the internationally recognized, UNESCO-endorsed Philosophy for Children model to foster critical thinking, creativity, and social responsibility in young people.

Joseph J. Foy serves as the associate vice chancellor for academic affairs at the University of Wisconsin Colleges. He is the editor of *Homer Simpson Goes to Washington: American Politics through Popular Culture* (2008) and *SpongeBob SquarePants and Philosophy: Soaking Up Secrets Under the Sea* (2011), and coeditor of *Homer Simpson Marches on Washington: Dissent through American Popular Culture* (2010) and *Homer Simpson Ponders Politics: Popular Culture as Political Theory* (2013).

Victoria Hubbell is a professor of composition and literature in Missouri, as well as being a published author and editor. She has written two books on Missouri history, and she just completed a young adult novel.

Dena Hurst holds a bachelor's degree in economics from Stetson University and a master's degree and doctorate in philosophy from Florida State University. She is a project manager and researcher for the Florida Institute of Government, where she has worked for the past eighteen years. She also teaches philosophy courses, specifically applied philosophy courses, in the areas of feminism, philosophy of economics, political philosophy, philosophy of class, radical and revolutionary philosophy, ethics, and philosophy of technology.

Christopher Ketcham is a reformed academic living in Pennsylvania. Sometimes he has problems with his own identity. He does writing and work on social justice, philosophy, popular culture, and—here's a Gonzonian twist—risk management, where he has contributed to and edited two books.

S. Evan Kreider is associate professor of philosophy at the University of Wisconsin–Fox Valley. His areas of interest include ethics, aesthetics, and popular culture. He is the coeditor of and contributing author for *The Philosophy of Joss Whedon* (2011), and a contributing author for *The Philosophy of the X-Files* (2009) and *Homer Simpson Ponders Politics: Popular Culture as Political Theory* (2013).

Shaun Leonard is originally from Galway in Ireland, but for now he resides in sunnier climes while completing his master of fine arts at the University of Nevada, Las Vegas. He is an accomplished playwright, screenwriter, and poet—an all-around writer/talker. Find him podcasting for film and television at www.isitabicycle.com or on Twitter @shaun_leonard.

Jennifer Marra is earning her PhD at Marquette University in Milwaukee, Wisconsin. She specializes in philosophy of culture and humor, modeling her career entirely on the cultural commentaries of Statler and Waldorf.

Michael J. Muniz has an MA in philosophy from Liberty University. Apart from adjuncting at local colleges, he is currently teaching high school English and philosophy at Doral Academy in Miami. In addition to being a philosopher and an educator, Michael enjoys writing stories while relaxing on the white sandy beaches in South Florida.

Laurel Ralston is a writer, musician, and earnest—if not consistent—yogi from Ottawa, Ontario. She holds an MA in philosophy from the University of Alberta and a BMus from the University of Ottawa. Laurel shares Boober Fraggle's love of quiet and laundry.

Sheryl Tuttle Ross is associate professor of philosophy at the University of Wisconsin–La Crosse. She has published articles on art propaganda, the aesthetics of motherhood, and feminist aesthetics. She is currently working on articles about guilty pleasures and postmodern postmillennial romantic comedies.

Rhona Trauvitch received her PhD in comparative literature from the University of Massachusetts–Amherst in 2013. She is a digital instructor in the Department of English at Florida International University, where she teaches courses in science fiction, literary theory, and popular culture. Rhona recently published a chapter, "Charting the Extraordinary: Sentient and Transontological Spaces," in *Literary Cartographies: Spatiality, Representation, and Narrative* (ed. Robert T. Tally Jr., 2014). Her research interests include narratology, popular culture, literature and science, and biblical hermeneutics.